D0587017

THE STYLE OF THE CENTURY

0056693

BEVIS HILLIER

THE STYLE OF THE CENTURY

1900-1980

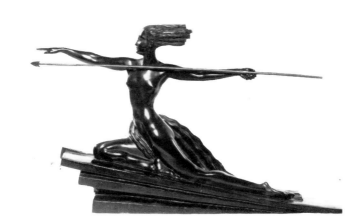

THE HERBERT PRESS

London

56693

To Elizabeth Tollinton

Copyright © 1983 Bevis Hillier
Copyright under the Berne Convention

First published in Great Britain 1983 by
The Herbert Press Ltd, 46 Northchurch Road, London N1 4EJ
First paperback edition 1986
Reprinted 1990

Designed by Trevor Vincent

Illustration on title page:
The Javelin Thrower
by M.A. Bouraine,
silvered bronze, 1920s

Typeset in Great Britain by BAS Printers Limited
Printed and bound in Hong Kong by South China Printing Co. (1988) Ltd

All rights reserved. No part of this publication may be
reproduced in any form or by any means – graphic, electronic
or mechanical, including photocopying, recording, taping or
information storage and retrieval systems – without permission
of the publishers.

This book is sold subject to the Standard Conditions of Sale
of Net Books and may not be resold in the UK below the net price.

A CIP catalogue record for this book is available
from the British Library.

ISBN 0 906969 65 4

CONTENTS

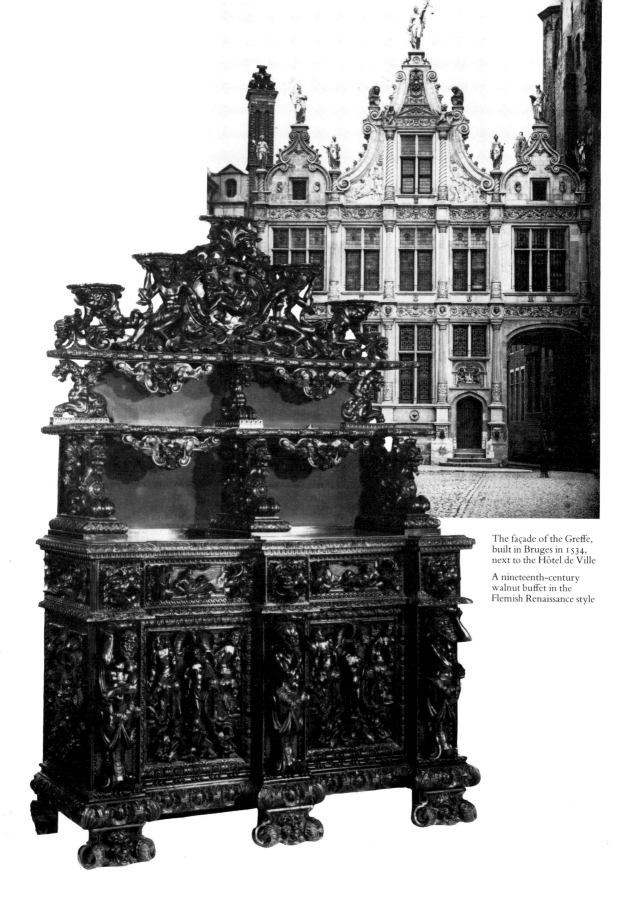

The façade of the Greffe,
built in Bruges in 1534,
next to the Hôtel de Ville

A nineteenth-century
walnut buffet in the
Flemish Renaissance style

INTRODUCTION

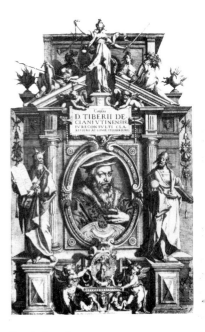

The art historian Max J. Friedländer said that a shoe can tell us as much about a civilization as a cathedral.

The idea is exaggerated for effect: as so often, converting a reasonable assertion into an epigram has damaged its validity. But the idea behind the *mot* could actually be carried further still: an object of everyday use (not necessarily a shoe – say, a teapot or a chair) can often tell us *more* about a civilization than masterworks of art or architecture. For the masterpieces are expressions of individual genius; the humbler objects are more likely to typify the *zeitgeist*, the spirit of the time. Not that geniuses are immune to period mood or style, which they may also help to form, or change.

This book attempts to convey the *pervasiveness* of style, and to show its close relation to 'lifestyle'. (I apologise for that disagreeable neologism, debased by colour supplements and fashion magazines: it is the best single word we have to cover those aspects of life which are not intended as 'art' or 'decorative art'.)

My canvas is the whole of the twentieth century so far; but let me first pluck some examples from the more distant past to show what I mean. The Flemish renaissance of the sixteenth century was of an overwhelming floridity. For that reason, it appealed to that second age of excess and generosity-to-a-fault, the late nineteenth century – when this walnut buffet was made in imitation of a Flemish model. Everything was encrusted, embellished, swamped in ornament.

Now look at two works which actually date from the sixteenth century: the frontispiece of a book, engraved by Raphaël Sadeler after Judocus van Winghe; and the façade of the Bruges Greffe, built in 1534 next to the Hôtel de Ville. They both have the same aspiring, pyramidal shape as the buffet; they are both crawling with cherubs and figures of classical mythology; they even have in common the crowning figure of Justice with her scales. So here architecture, furniture and literature are all affected by elaboration and superfluity.

Frontispiece of
Consilia Tiberii Deciani Utinensis,
engraved by Raphaël Sadeler
after Judocus van Winghe, 16C

7

Decorated letter 'R' by
Théodore de Bry, 16C

Sign supported by a wrought-
iron bracket, Bruges, Marché
du Vendredi, at the inn 'in de
Roskam' at l'Etrille, 17C

Fifteenth-century lead spire
from Lille

Balustrade and loge crowning
the principal façade of the
Hôtel de Ville at the Hague,
16C

We observe the same gleeful indulgence in excess in the decorated
letters by Théodore de Bry, also sixteenth-century, and the lead spires
from demolished churches in Lille, of roughly the same time; also
in the magnificent wrought-iron sign from Bruges, which is slightly
later in date.

Particular elements of design are carried over from one discipline
to another. Still in the sixteenth- and seventeenth-century Low Coun-
tries, for example, balustrading recurs in the stone of the Hotel de
Ville at the Hague, sculpted wood in the great church at Haarlem,
copper on a wooden door in the Cathedral of St Jean at Bois-le-Duc;
and in oak on a bench, a library lectern and a communion bench,
the last in the church of St Jacques, Louvain.

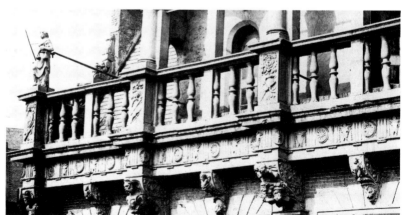

Sculpted wood balustrade in
the great church of Haarlem,
16C

Oak *clôture* in the Cathedral of
St Jean at Bois-le-Duc: the
balusters are of copper. 16C

Bench in oak with ebony inlay, 17C

Library lectern of oak, 17C

Communion bench in oak in the church of St Jacques, Louvain, 17C

Much more flamboyantly baroque and 'mannerist' than these simple balusters are the barley-sugar columns or *salomónicas* – Solomonic columns – derived from a column in the baldachin above the altar of St Peter's, Rome. (According to legend, this column is from the ancient Temple of Solomon, Jerusalem.) They occur in Raphael's great tapestry cartoon of 'Peter and John Healing the Lame Man'; in Bernini's *baldacchino* in the Vatican; in architecture of the Spanish baroque, known as Churrigueresque after the Churriguera family of five architect brothers (for example, in the fanciful *salomónicas* by Jose Benito Churriguera on the retable behind the altar of the church of St Esteban, Salamanca, or those in the Hospital de la Caridad, Seville, by Bernardo Simón de Pineda and others, 1670–79); and in a series of plates representing the theological Virtues, engraved by A. Collaert after Martin De Vos. The 'barley-sugar' shape happened to lend itself to the art of wood-turning, so we find it also in the legs of a Charles II walnut cabinet (*c*.1685) and the supports of a Joseph Knibb table clock (*c*.1672–3). Survivors such as these twisted columns help us to conjure up the years in which they first existed. Take, for example, those of St Mary's Church in Oxford.

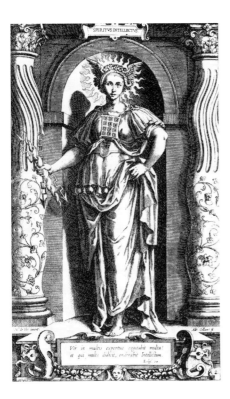

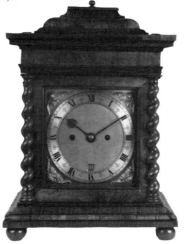

One of seven plates
representing the theological
Virtues: engraved by
A. Collaert after Martin De Vos,
17C

Charles II walnut Dutch-striking
clock, signed by Joseph Knibb,
1672–3. Height 20 in.

A Charles II walnut cabinet
standing on six 'barley sugar'
legs with shaped stretchers,
c. 1685

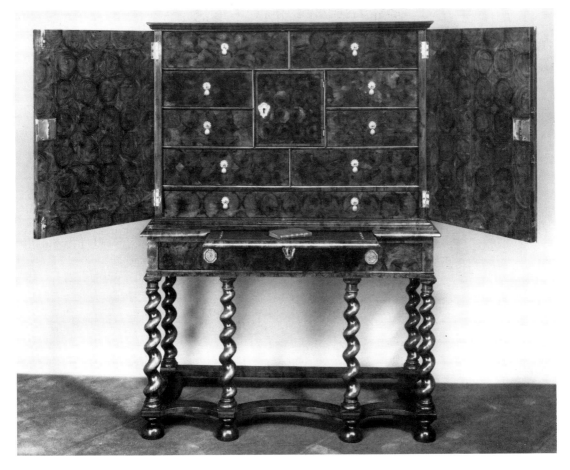

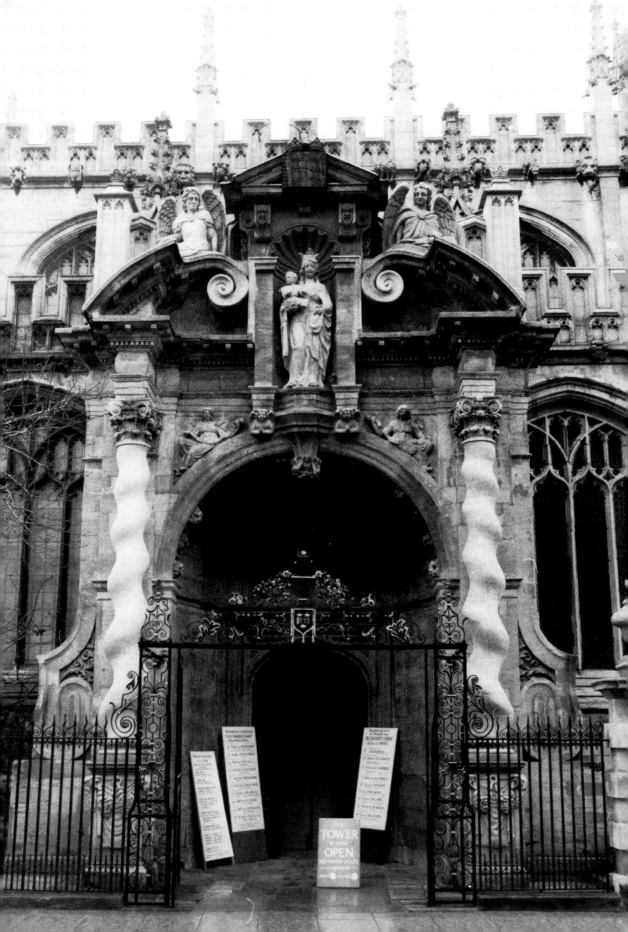

Dame Veronica Wedgwood begins an essay on 'The English Tin-toret' (*Velvet Studies*, 1946):

> At Oxford, opposite St Mary's Church in the High, with its new porch on barley-sugar columns and Our Lady in a baroque attitude, the painter William Dobson improvised a studio during the noisy years of the Royalist occupation. Sociable, gifted, extravagant, the painter flickers briefly across the darkening scene of England's Civil War, the most striking of Van Dyck's followers and the most talented English painter of the seventeenth century. . . . With what insight he fixed the features of this lost generation against the dark background, of these young soldiers who carried assurance on their brows and defeat in their hearts, of this whole doomed society which maintained to the last its interrupted culture, while the green college quadrangles were trampled bald by drilling feet, and Rupert's squadrons wheeled and formed in Christ Church meadows.

The baroque movement, of which St Mary's writhing columns and King Charles's wheeling cavaliers were part, has been associated with the Catholic Counter-Reformation and with monarchical absolutism. Essentially, it was a power movement. Palace and opera were its natural art forms. Carl J. Friedrich and Charles Blitzer wrote in *The Age of Power* (1957):

> Baroque architecture produced the richly ornamented façade, the sweep of magnificent staircases, the ornamental garden as a setting of the palace and a foreground of a distant view. Baroque painting revelled in the effects of light and shadow. . . . Theatre and drama, especially the form of the heroic tragedy, seemed peculiarly adapted to the baroque spirit in the field of letters. . . . Finally, in baroque music the expressive depicting of emotional states and sentiments reached a high level, first in the solo parts of opera and oratorio, soon afterwards in the varying combinations of stringed instruments, and finally in gigantic combinations of human voices and instrumental music, both in the oratorio and in the opera.

The figure of Satan in Milton's *Paradise Lost* is the type of baroque man, the overreacher:

> *. . . aspiring*
> *To set himself in Glory above his Peers,*
> *He trusted to have equalled the most High,*
> *If he oppos'd; and with ambitious aim*
> *Against the Throne and monarchy of God,*
> *Rais'd impious War in Heav'n, and Battel proud,*
> *With vain attempt.*

The general overweening was seen also in personal adornment which exaggerated reality – vast wigs, flowing beards, elaborate costumes, dramatic clashes of honour, excesses of eating and drinking, sexual swagger and debauch. The *uomo universale* – Renaissance Man – had not died out. Vanbrugh was as capable of writing exuberant plays as he was of designing grandiose buildings such as Blenheim Palace. The baroque had intensity, passion and movement. (Bernini, the great-est genius of the baroque, insisted on watching Louis XIV play tennis

St Mary the Virgin, Oxford,
south porch, 1637

13

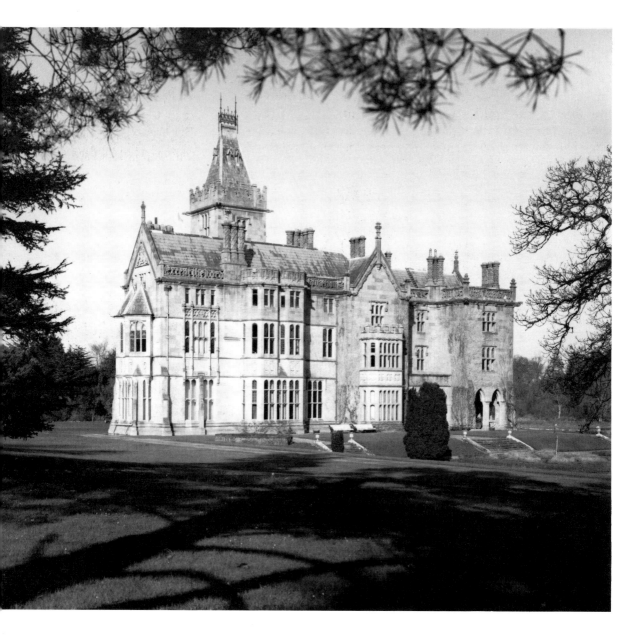

Adare Manor from the
south west

before sculpting his bust.) Power and force run through the baroque
like an electric shock.

Now let us leap forward to the early years of our own century
– over the eighteenth-century rococo, Gothick and neo-classical and
the nineteenth-century neo-Gothic; just pausing to note how politics
too can become intertwined with the arts (in the French Revolution
Jacques-Louis David became the first great artist to be elected a head
of government) – or religion (the Gothic chair, right, was probably
designed by L. N. Cottingham, an ardent medievalist who worked

14

with A. W. N. Pugin on Adare Manor, Ireland, left, in the 1840s.)

Style penetrates into the unlikeliest places. One might not expect the army to be sensitive to changes in the decorative arts. But on 31 December 1914, when the Military Cross was instituted as a decoration for army officers, the design was an ornamented silver cross with narrow straight arms which widen at the extremities: it is exactly in the rectilinear Art Nouveau style pioneered by Charles Rennie Mackintosh. The flanged arms are similar to those of the uprights and legs of many Liberty cabinets and pianos.

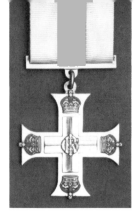

The Military Cross, instituted in 1914

Oak bureau by C. F. A. Voysey (1857–1941), made for W. Ward Higgs, London. Height 7 ft. 2 in.

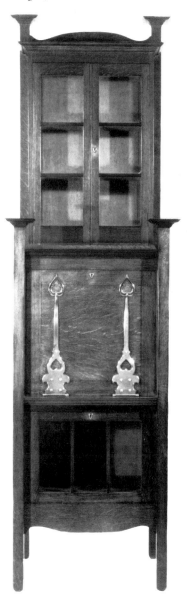

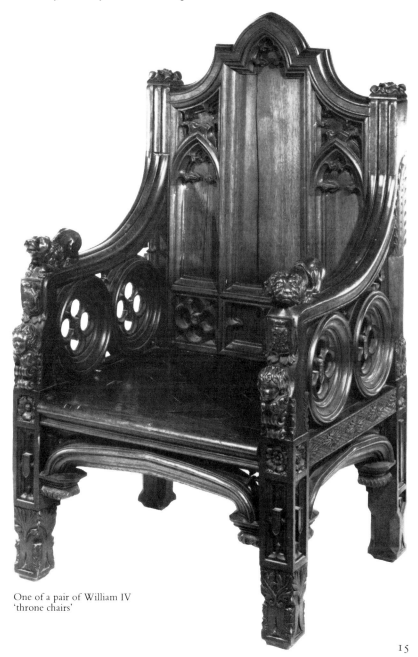

One of a pair of William IV 'throne chairs'

In the first section of this book, I relate the new straight-and-narrow design of 'rectilinear' Art Nouveau to the masculine reaction against the 'decadence' of the Naughty Nineties. In the next section, on the 1920s and 1930s, we again see style communicated from one discipline to another, when the fashionable 'streamlining' of transport shows up in the automobile-like front of a refrigerator. And the jazzy Art Deco style affects more or less everything, from cinemas, ocean liners and hotel foyers to handbags, lamp-posts and letter-boxes. The insouciance of early Deco is related to the 1920s' need to forget the horrors of the Great War in hectic enjoyment of life. Again in the 1950s, we see individual motifs, such as the palette, the 'cocktail cherry' and the television screen shape, recurring in many different objects. And in the late 1960s the 'mind-expanding' designs on John Lennon's Rolls-Royce are mimicked in a 'psychedelic' bathtub sold in the Hampstead Antiques Emporium; and that style is related back to the Art Nouveau revival – part of the 'Nostalgia' movement – and to the drugs culture encouraged by Dr Timothy Leary.

Without history we would be like babies left in baskets on doorsteps – with no idea of our origins. In the jargon of the 1960s, we would have an 'identity crisis'. And without the buildings and artefacts which manage to survive in the débris of history, it would be hard for us to believe in the history of the history books (it is hard enough, sometimes, in any case!). William Blake wrote of seeing the world in a grain of sand. Even without his mysticism, a barley-sugar pillar may help us to visualize the Oxford of King Charles I, or a painted bathtub the 1960s of Jimi Hendrix and *OZ*. Style and lifestyle are indivisible. And history without the physical relics of history is just a jumble of hieroglyphs.

1900-1920

Edwardiana | Art Nouveau | World War I

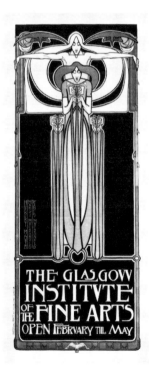

OVERLEAF

Poster for the Glasgow
Institute of Fine Arts: to the
left appear the names of
Herbert McNair and Mary
and Frances Macdonald, who
with Charles Rennie
Mackintosh made up the
'Glasgow Four'

The 1890s were the first decade in which a cadre of intellectuals began a kind of count-down to a new century, and saw themselves as participants in the definitive end of something, the *fin de siècle*. Some committed themselves to 'decadence', debauchery and *dégringolade*; others committed suicide. As John Betjeman wrote in his introduction to *The Eighteen Nineties* (1948), a period anthology of verse and prose, it was a world 'which ended in prison and disgrace for Wilde, suicide for Crackanthorpe and John Davidson, premature death for Beardsley, Dowson, Lionel Johnson, religion for some, drink and drugs for others. . . .' The prevailing art style of the decade was in sympathy with this mood: languishing, swooning Art Nouveau. The prince of Art Nouveau was Aubrey Beardsley, who died of tuberculosis in 1898, aged 25. 'Even his lungs are affected,' was Wilde's callously smart comment.

The world was winding down; 1900 was to be the magical year in which it would be wound up again. The Twentieth Century! It was a good, round number. A metaphysical fascination with Time itself became apparent. H. G. Wells jumped the gun in 1895 with *The Time Machine*, which enabled one to speed into the past or the future. Louis Klopsch, an enterprising New York publisher, issued a fold-out Two Century Calendar, valid from 1801 to the year 2000. In the British Midlands, cotton kerchiefs were printed with 'Coming Events in the Present Century', every one of which, from 'wireless telegraphy in naval warfare' to 'Having a talk with the man in the moon', was to be achieved by 1970.

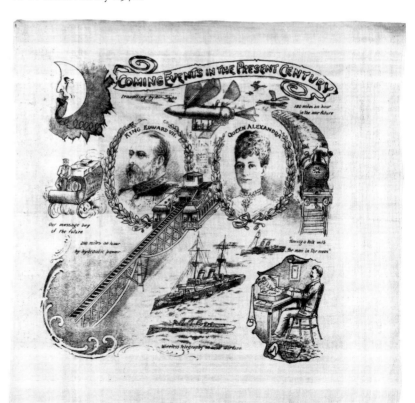

'Coming Events in the Present
Century': cotton pocket
handkerchief, printed in blue,
English *c.* 1899–1900

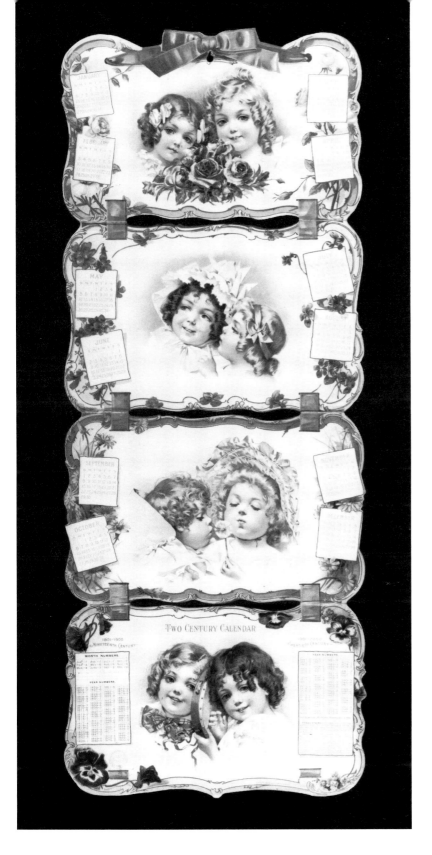

Two-century calendar printed
by Louis Klopsch, New York,
1900

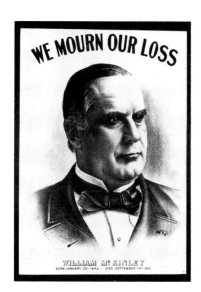

Memorial card for President
McKinley, assassinated in 1901

And, as if the chronological triumph and caesura of 1900 were not enough, in 1901 both America and Great Britain lost their heads of state. The death of the American President, by assassination, was the more shocking. The 58-year-old President McKinley was fatally shot in the Temple of Music at the Pan-American Exposition at Buffalo, by an anarchist called Czolgosz, in the middle of a Bach sonata. He died eight days later, and the Vice-President, Theodore Roosevelt, was sworn in. There were five days of mourning, of crêpe-shrouded buildings and tolling bells, newspapers framed in black, and a respectful touch of panic on Wall Street.

Queen Victoria died on January 22. Queen for over sixty years, she was 81, and had been ailing for some time. Journalists gathered round the gates of Osborne, on the Isle of Wight, where she lay dying. Starved of information, they invented their own, as Eric Parker, who was present, recalled in *Memory Looks Forward* (1937): "'What have you said her last words were?" asked the one. "I've made her say 'God Bless my people'," answered the other. "I thought of that," said his friend, "but I thought I'd get something better. I've made her send for her favourite Pomeranian dog.'" The four o'clock bulletin the next day, signed 'James Reid, R. Douglas Powell, Thomas Barlow', was short: 'The Queen is slowly sinking.' At 6.45 pm an official of the Royal Household came to the gates to make a simple announcement: 'Gentlemen, I deeply regret to say that the Queen passed away at half-past six.' What happened then is indignantly described by Parker:

> At the words a number of representatives of newspapers dashed for their bicycles, and rode off helter-skelter, yelling and shouting, down the road to the Cowes post office.
>
> It was the most disgraceful thing of the kind I have ever seen. It was described afterwards by the representative of *The Times* as more like a fox-hunt than anything else.

Queen Victoria in her donkey carriage on her last visit to Ireland. In the spring of 1900 the Queen gave up a much-needed holiday in the warm, soft air of the Riviera to show, by a long and busy stay in Dublin, her gratitude for the bravery of the Irish soldiers in South Africa. She died the following year

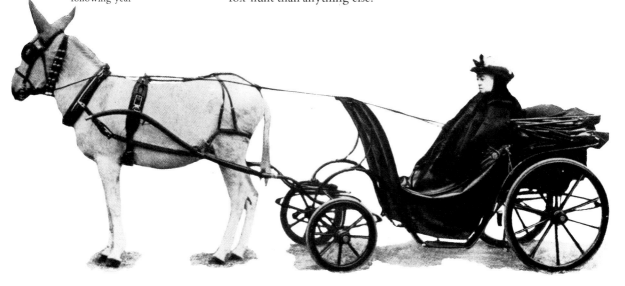

Bernard Falk, also present at Osborne, recalled in *Bouquets for Fleet Street* (1951) that one reporter was sacked because 'the goody-goodies' reported to his editor that he had sung out, as he raced for the post-office, *'All right, boys, the old woman has gone!'*

Others went to the opposite extreme. Falk recalls that one journalist was so overpowered that the message he filed began: 'That great lady, Queen Victoria, is dead. Never since the eternally lamented death of Jesus Christ has so much sorrow been caused in the land.' And even Lytton Strachey, whose mission twenty years later was to debunk the Victorians, and whose portrait of Victoria herself was hardly flattering, paid tribute, in the famous peroration to his *Queen Victoria* (1921) to the position she had held in the country, and the effect of her death on her people:

> When . . . the news of the approaching end had been made public, asto-nished grief had swept over the country. It appeared as if some monstrous reversal of the course of nature was about to take place. The vast majority of her subjects had never known a time when Queen Victoria had not been reigning over them. She had become an indissoluble part of their whole scheme of things, and that they were about to lose her appeared a scarcely possible thought.

In America, the reaction to McKinley's death was similar. There, too, a firm, unquestioning, simple upholder of the faith had passed a life of Christian fortitude. 'Nearer, my God, to Thee,' were his last words, and the strains of that hymn were heard in every city and town in the days of mourning. He had helped to bind the States and their diverse peoples together, as Victoria's stolid majesty encompassed the lands of the British Empire. Chiefs Geronimo, Blue Horse, Flat Iron and Red Shirt, and the 700 braves of the Indian Congress at the Pan-American Exposition, had thought of him as their good friend. Many of them went to see him lying in state in Buffalo City Hall. Margaret Leech recorded the scene in *In the Days of McKinley* (1959):

> Like visitants from an earlier day, the men with painted faces had filed past the flower-banked casket, sharing the nation's grief; and, among the gathered cards, was the big crudely lettered square of pasteboard that had come with their wreath of purplish evergreen leaves.
> 'The rainbow of Hope is out of the sky. Heavy clouds hang about us.
> 'Tears wet the ground of the tepees. The palefaces too are in sorrow. The great Chief of the Nation is dead. Farewell! Farewell! Farewell!'

In both America and Britain, there was an immediate transfer of power, though the Coronation of Edward VII was to be delayed by an operation for the removal of his appendix after an attack of peritoni-tis. If there was a similarity between the two heads of state who died in 1901, there were also affinities between the two who succeeded them. Roosevelt's admirers may think it outrageous to draw parallels between him and the royal hedonist. The *Encyclopaedia Americana*

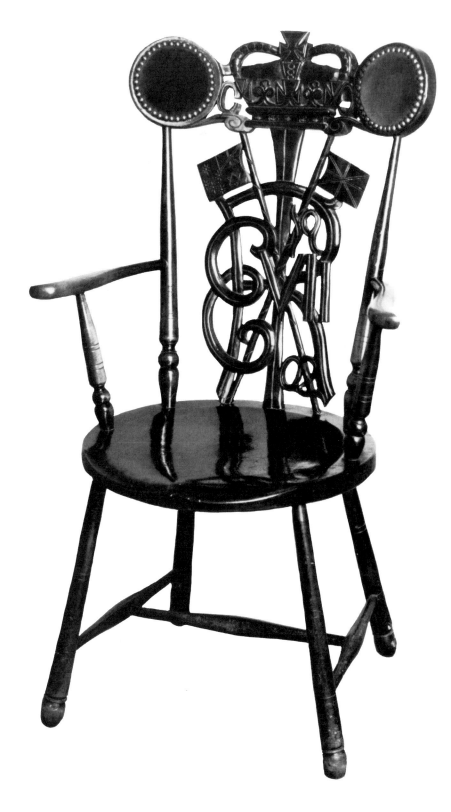

Country chair made to
celebrate Edward VII's
Coronation in 1902

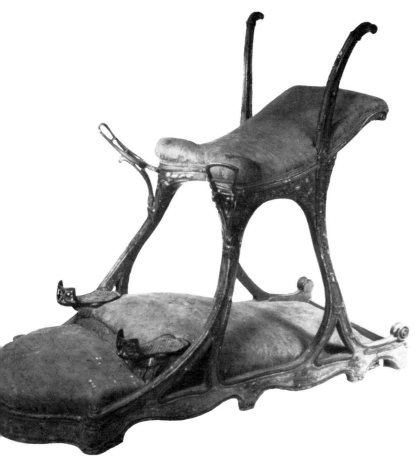

Edward VII's *siège d'amour* specially made for him about 1890 when, as Prince of Wales, he patronized the Chabanais *bordello* at 6 rue des Moulins, Paris. The Chabanais, founded in 1878 by Madame Kelly, a friend of the principal members of the Jockey Club, had a Chef du Protocole to attend to visiting royalty and presidents, a torture chamber, a Japanese room, and a copper bath in the form of a dragon in the Pompeiian room where Toulouse-Lautrec had left medallion designs in payment

roundly declares: 'No more virtuous or clean-living man ever existed; the temptations which wreck the lives of so many human beings simply did not exist for him.' No scandals have been disinterred since his death. He was even made the subject of a book, by James E. Amos, titled *Theodore Roosevelt: a Hero to His Valet* (1927). Not that he was immune to the attractions of women. He was twice married and had five children, of whom the eldest, Alice (born 1884), survived until 1980 as Mrs Alice Longworth – best remembered (to her disgust) as the inspiration of the twee pop song 'Alice Blue Gown'.

As early as 1876 – twenty-four years before he ascended the throne – Albert Edward, Prince of Wales, was lampooned in a lurid pamphlet boldly titled *Edward VII*. It predicted that this repressed son of a dowdy, mourning widow would be a king of spectacular raffishness – a gambler, *bon viveur* and voracious womanizer. The prediction was abundantly fulfilled. Edward took his revenge on the years of repression and educational force-feeding by his militaristic German father, Prince Albert, in predictable fleshly excesses. It has been said of him that he 'formularized seduction into a pattern almost as rigid as court etiquette'. He exercised a kind of *droit de seigneur* over the wives of his aristocratic friends. Then there were actresses and luxurious courtesans in Paris, including Mademoiselle Maximum, Cora Pearl and La Barucci. A special *siège d'amour*, in high Art Nouveau

23

style, was made for him when, as Prince of Wales, he patronized the Chabanais *bordello* at 6, rue des Moulins, Paris. And there were steady mistresses – Lillie Langtry, Lady Warwick and Mrs Keppel. Edward's consort Alexandra was not exactly *complaisante*. She objected particularly to an American girl, Miss Chamberlayne, whom she called 'Miss Chamberpots'; and she had to be kept out of his bedroom in 1871 when he was delirious from typhoid fever, because in his ravings he was naming too many names. But she did accept Mrs Keppel, to the extent of leading her in to see Edward's dead body in 1910.

Twice Edward was subpoenaed to appear in unsavoury court cases: Sir Charles Mordaunt's divorce suit and the Tranby Croft Baccarat case. In addition he had a gargantuan appetite ('Tum Tum' was his nickname on the Continent) and gambled fiercely in European casinos and on the racecourse. In its leading article of 23 January 1901 (the day after Queen Victoria's death), *The Times* commented that the new King 'must often have prayed "Lead us not into temptation" with a feeling akin to hopelessness'.

Theodore Roosevelt was not a voluptuary, like Edward; but in other ways the two had much in common. Both were virile men who enjoyed the outdoor life, especially hunting. Shooting stags at Balmoral was one of the King's favourite sports. In 1883 Roosevelt had bought a ranch in the Bad Lands of west Dakota, where he lived the life of the Wild West. Five years later he wrote a book illustrated by the artist and sculptor Frederic Remington – *Ranch Life and the Hunting Trail*. The 'teddy bear' got its name from a hunting exploit in 1902, when the cartoonist Clifford Berryman showed Roosevelt refusing to shoot a small bear. King Edward was also popularly known as 'Teddy'.

The two Teddies were men of action. Both believed in courage, manliness and self-respect. The regimes of both men promised a new

Caricature of King Edward VII by 'Max' [Max Beerbohm]

beginning. Edward, at 52, was not youthful; but he was an energetic, not to say lusty, man succeeding a feeble old woman. Roosevelt was only 43 – then the youngest President in American history. After the decorous McKinley, Roosevelt, according to Henry Adams, was 'pure act'. He was self-confident and informal. 'Every day or two,' said one reporter, 'he rattles the dry bones of precedent and causes senators and heads of departments to look over their spectacles in consternation.' One example was his issuing a White House invitation, on the very day he took office, to the Negro educator Booker T. Washington – a move which outraged the South. Edward, too, quickly made changes. He revived pageantry, opening Parliament with the full state ceremony which had not been seen at Westminster for forty years. He gave Osborne to the Navy for cadet training, though his mother's will had stipulated it should remain in the family. And he abandoned Victoria's afternoon 'drawing rooms' in favour of evening courts.

Edward VII dispensed his favours between aristocratic ladies and (as here) ladies of the town

The promise held out by new rulers and a new century was fulfilled in the years before World War I. It was an innovatory age. In the first decade of the century, great scientific advances were made, which were to determine much of the future of the world, and perhaps to presage its end. In 1900 Sigmund Freud published what he had described in 1899 as 'a work to which every effort of thought has to be given . . . which gradually absorbs all other capacities . . . a sort of neoplastic substance that infiltrates into one's humanity and then replaces it.' This was *The Interpretation of Dreams*, generally regarded as his most important work. Freud's theories had an effect on art: his emphasis on the instinctual side of human behaviour led artists to try to express what they felt rather than what they saw. It was said of Franz Marc, of the *Blaue Reiter* group, that when he painted a tiger, he painted the 'tiger quality', tigerishness, the emotion aroused by a tiger. Abstract art was a natural development of such ideas.

The earliest model of the atom was proposed by an English physicist, Lord Kelvin, in 1902, but was supported so strongly by J. J. Thomson that it became known as the Thomson atom. After Frederick Soddy came to McGill University in 1900, he and Ernest Rutherford created the modern theory of radioactivity. In 1902 they discovered that the atom was not immutable. Here too science affected art. Dr Jacob Bronowski wrote in *The Ascent of Man* (1974):

Physics becomes in these years the greatest collective work of science – no, more than that, the great collective work of art of the twentieth century. I say 'work of art' because the notion that there is an underlying structure, a world within world of the atom, captured the imagination of artists at once. Art from the year 1900 on is different from the art before it, as can be seen in any original painter of the time: Umberto Boccioni, for instance, in *The Forces of a Street* or his *Dynamism of a Cyclist*. Modern art begins at the same time as modern physics because it begins in the same ideas.

And in 1905 Einstein published four papers, each of which contained a great discovery in physics: the creation of the special theory of relativity; the establishment of the mass-energy equivalence; the creation of the theory of Brownian motion; and the foundation of the photon theory of light. These papers symbolized the three main directions in physics to which Einstein contributed the most: the theory of relativity, statistical mechanics and the quantum theory of radiation.

There were also important advances in what would later be called automation. The motor car was passing from infancy to youth. In James Bishop's phrase, it 'ceased to be an adventure and became a convenience'. The first Rolls Royce Silver Ghost purred on to the road in 1907; by 1912, many small businessmen had Ford's 'General Utility Car', the Model T – the original 'Tin Lizzie'. The Model T was the first mass-produced cheap motor car, and the beginning of the Ford empire. The registration of cars was first introduced in England in 1903. King Edward, an enthusiastic motorist, gave his blessing to the

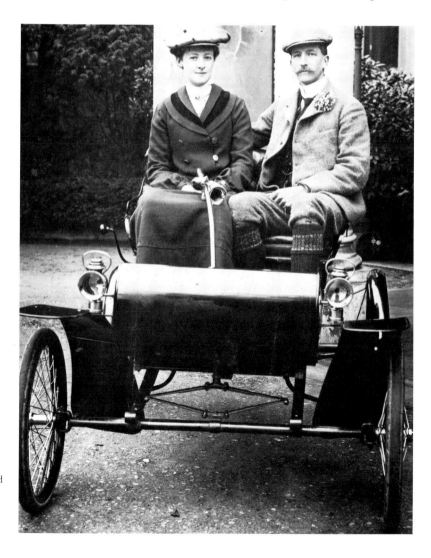

Early motor-car (before registration plates) at Eastwood Manor, Somerset

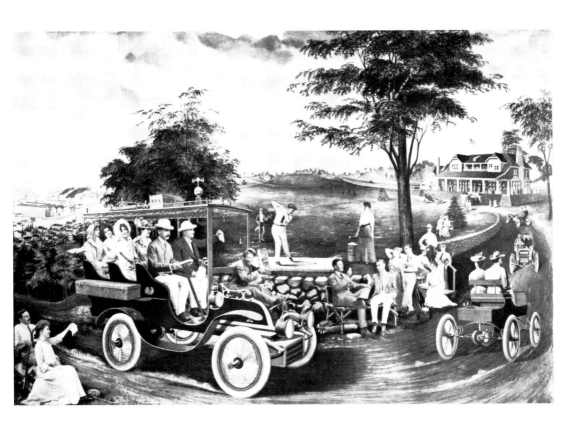

Royal Automobile Club, whose premises in Pall Mall (1908–11, by Arthur J. Davis and Charles Mewès), including the lofty neo-classical swimming bath, are, with the Ritz Hotel, London, by the same architects, among the most sumptuous relics of Edwardian architecture. Buses and taxi-cabs were increasingly motorized rather than horse-drawn. The first motor taxi-cabs appeared in the streets of London in 1903; by 1910 they outnumbered horse-drawn cabs by 6,300 to 5,000.

Edwardian advertisement for Goodrich rubber tyres

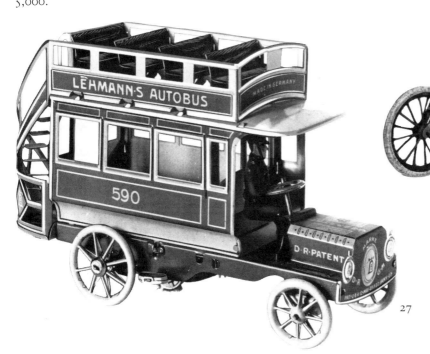

Lehmann motor-cyclist, Germany, 1905

Lehmann autobus, Germany, 1907

Expanding railways meant more jobs at Swindon and other locomotive works

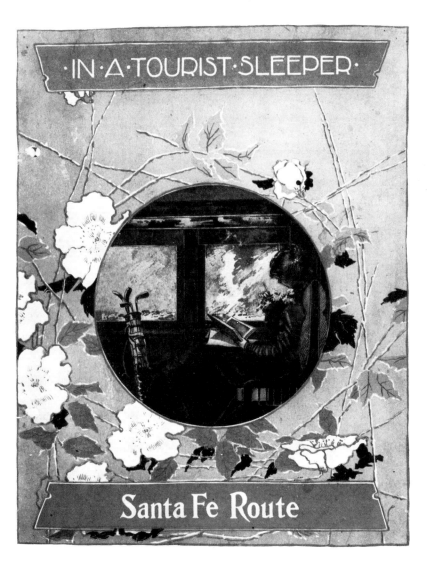

·IN·A·TOURIST·SLEEPER·

Santa Fe Route

Travel on the Santa Fe route was luxurious by American standards

The railways were expanding. The new Great Western Railway express service from Penzance to London was inaugurated in July, 1901. The Brighton Railway Company opened Victoria Station in 1908: from it, millions of young men would go off to their deaths in France and Flanders in World War I. Luxurious Pullman cars were introduced on the London, Brighton and South Coast Railway in 1906. In America, too, railroad travel was becoming less spartan. There was every comfort for travellers on the Santa Fe Route. The Underground railway systems (subways) were also growing fast. The Hampstead Line (1907) was the last to be opened in London until the Queen opened the Jubilee Line in 1969: the Edwardian station, with its Art Nouveau ticket guichets, is still in use. The first completed section of electric tramways in west London was inaugurated in July 1901.

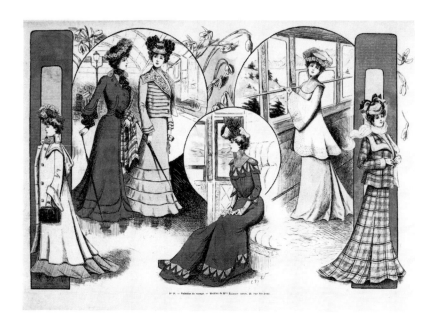

Balmain Soeurs, Paris,
designed *toilettes de voyage* –
travel costumes

Maxwell Armfield, *The Tube*.
Oil on board, $10\frac{1}{2} \times 13\frac{1}{2}$ in.

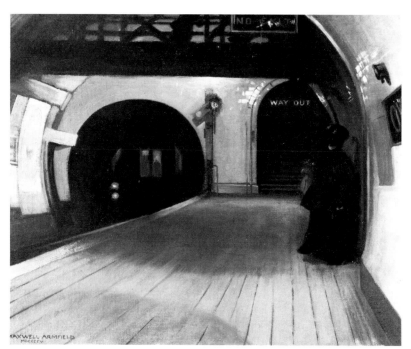

The first petrol-driven tractor was built at Biggleswade in 1902. The Lawrence-Kennedy electric cow milker, viewed with suspicion by some farmers, was introduced in 1904. The first motor lawn mower came on to the market in 1905. The Post Office set up automatic slot machines for stamps in 1907. Telephones, typewriters, wireless, gramophones and electric kettles were all successfully developed in the Edwardian period.

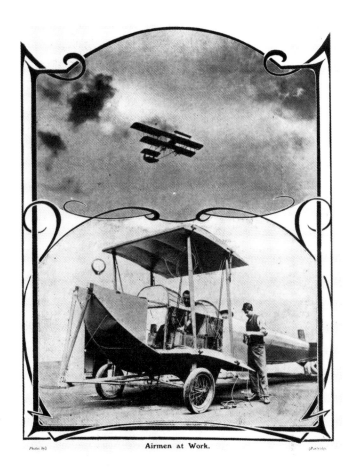

An Art Nouveau advertisement, with a Celtic flavour, for the Wyoming-Richmond steam ship service

Photo by]　　　　**Airmen at Work.**　　　　*[Partridge*

Shipping became bigger and faster, though the sinking of the *Titanic* in 1912 was a grievous setback. The *Mauretania* (1907) recaptured for England, from Germany, the blue riband for the fastest transatlantic voyage. There was still thought to be a future for airships (before the R101 and Hindenburg disasters finally destroyed faith in them): Graf Zeppelin was developing the dirigibles which would bomb London in the coming war. And Those Magnificent Men in their Flying Machines were opening up further possibilities of air travel: the first successful flights were made by Orville and Wilbur Wright in their giant box kite in North Carolina in 1903; and the Frenchman Blériot made the first Channel crossing by aeroplane on 25 July 1909. The *Daily Mail* offered £10,000 for the first flight between London and Manchester, and the reward was claimed in 1910. More significant to most Edwardians was the transition from horse to bicycle. This was *the* bicycle age. Women pedalled through the countryside as well as men; jolly bicycling clubs were formed; and the couple in the music-hall song 'Daisy, Daisy' who could not afford a carriage, settled for a tandem, a 'bicycle made for two'.

Air travel seemed novel, daring and slightly cranky to the Edwardians

31

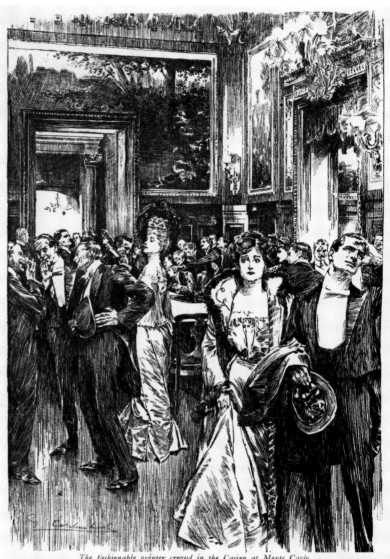

The fashionable winter crowd in the Casino at Monte Carlo.

OPPOSITE

The coveted football colours
of English public schools:
team spirit and the uniform
mentality were inculcated
from an early age

Board game of the Boer War

With all this speeding up of life, some things remained just the same. In England, society was almost as rigidly stratified as ever. It was still dominated by the landed aristocracy, who set the tone and the fashions and ruthlessly maintained the *status quo* although the consistency of society was altered by King Edward's encouragement of the Jewish millionaires to whom the ageing Lady Dorothy Nevill, in her memoirs, took such exception. The events of 'the Season' were religiously attended, and the conventions strictly observed. In the winter months there was a mass evacuation, an Anglo-Saxon *volkerwänderung*, to the French Riviera and to watering-places such as Baden-Baden,

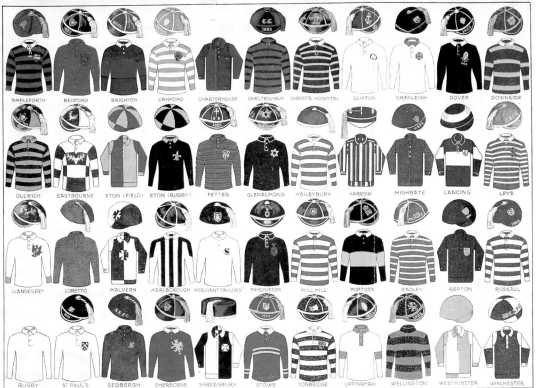

AMPLEFORTH BEDFORD BRIGHTON CANFORD CHARTERHOUSE CHELTENHAM CHRIST'S HOSPITAL CLIFTON CRANLEIGH DOVER DOWNSIDE

DULWICH EASTBOURNE ETON (FIELD) ETON (RUGBY) FETTES GLENALMOND HAILEYBURY HARROW HIGHGATE LANCING LEYS

LLANDOVERY LORETTO MALVERN MARLBOROUGH MERCHANT TAYLORS' MERCHISTON MILL HILL PORTORA RADLEY REPTON ROSSALL

RUGBY ST PAUL'S SEDBERGH SHERBORNE SHREWSBURY STOWE TONBRIDGE UPPINGHAM WELLINGTON WESTMINSTER WINCHESTER

THE BOY'S OWN PAPER. FOOTBALL COLOURS OF SOME OF OUR PUBLIC SCHOOLS. 4 Bouverie Street, London E.C.

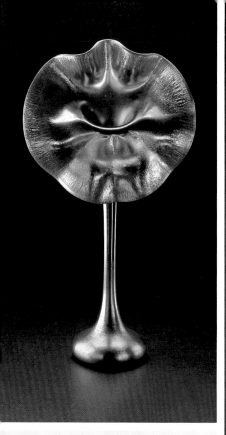

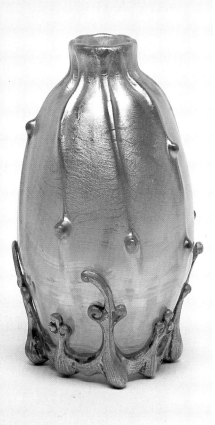

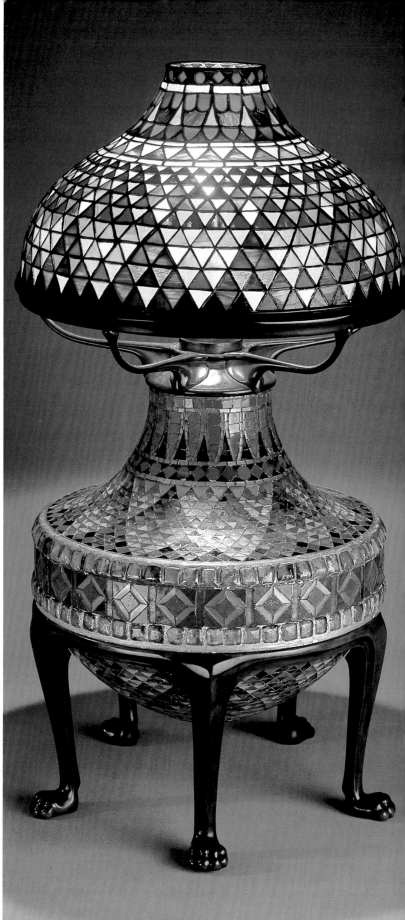

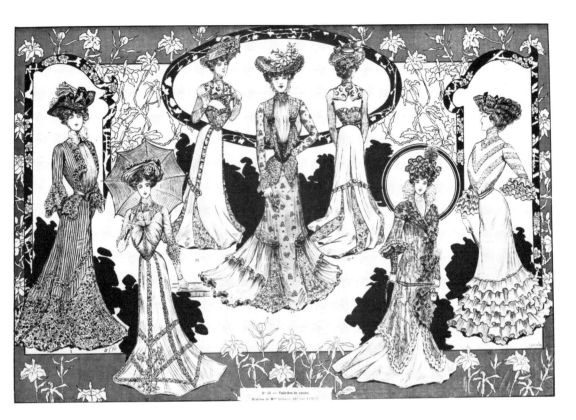

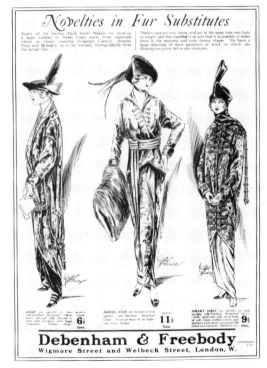

Mme Guillot, Paris, designed *toilettes de casino* for wear at Monte Carlo, Aix-les-Bains, Baden-Baden and the other European gambling centres

OPPOSITE

Favrile glass vase by Louis Comfort Tiffany, New York

Glass vase by Louis Comfort Tiffany, New York

Lamp by Louis Comfort Tiffany, New York

Extravagant 'picture hats' were the rage in pre-Great War England

Ladies' fashions on sale at Debenham's just before World War I

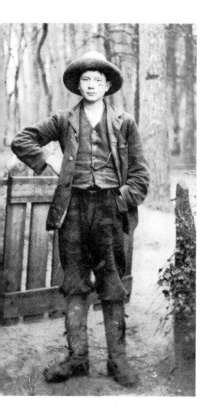

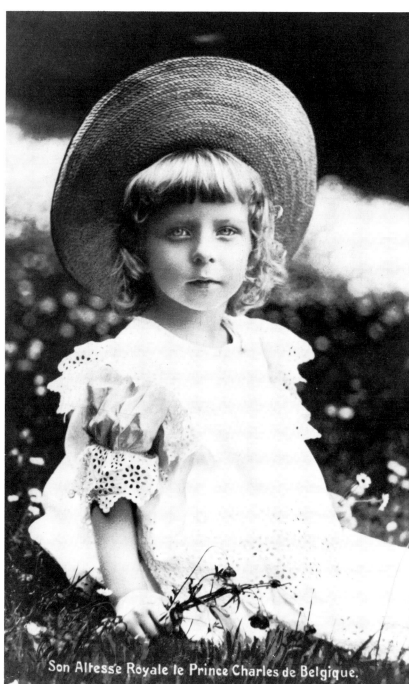

Rich boy, poor boy . . .
sailor suits were *de rigueur*
for Edwardian boys

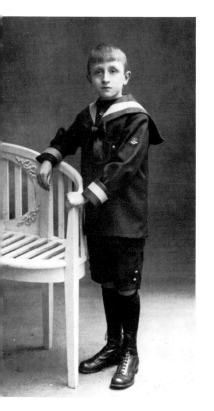

Son Altesse Royale le Prince Charles de Belgique.

Prince Charles of Belgium in
lace petticoats and sun-hat

Edwardian Board School
attendance medal, 1904

'Take him home and whip
some arithmetic into him':
the British public school
educational technique

where the year's dissipation was expiated in steam baths and with foul
draughts of mineral waters, and fortunes were lost on the gaming
tables – and occasionally won, as by the hero of the song 'The Man
who broke the Bank at Monte Carlo'.

The aristocracy and upper middle class sent their sons to public
schools (in America, to private schools, the same thing). But for lower-
middle-class and working-class English children, there was only the
inadequate education offered by the Board Schools established by W.
E. Forster's Education Act of 1870, and little enough of that before
they were thrust out into the world to earn a living and bring home
a pay packet to help their parents bring up the rest of the family –
usually a family of the proportions approved by President Roosevelt,
with six or more children. (Birth control was still rudimentary, though
by 1918 Marie Stopes was campaigning for better public information
on contraceptives and for their responsible use.) Many of the lower-
class children were destined to 'go into service'.

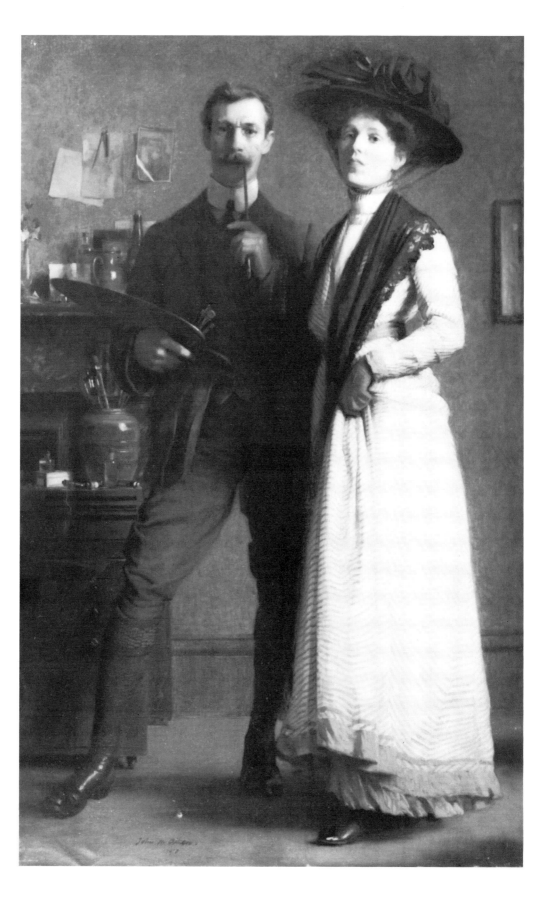

"**Never heard of her,**" exclaimed the astonished maid, "and if there's any more bother about strange women in this house I'll give notice. It don't look right."

Notice to quit, 1901

'Service' was the only possible career for many working-class girls

Pawn ticket, 1901

Of a total population of 33 million, fewer than one million were liable to income tax, even though that (at 1s in the pound) was only levied on incomes of £160 a year or more; and fewer than 400,000 people had incomes of more than £400 a year. The illustrator E. H. Shepard, who married in 1904, wrote in his 1961 memoir *Drawn from Life*: 'It may surprise some of my readers to hear that when I married, my wife and I were able to live perfectly comfortably on twenty-one shillings a week, of which only 2s 3½d went on the rent of our cottage in Surrey.' With no welfare state, there was widespread poverty. The three illustrated volumes of George R. Sims's *Living London* (1901–3) gave a depressing picture of conditions in the East End, where evictions were common and the pawnshop was the first resort for those in urgent need of funds to provide the next meal for their children or pay a doctor's bill. The pub and the music-hall offered temporary solace, and some of the finest examples of both were built in the first decade of the century.

But it would be wrong to portray the Edwardian age in England as a stark *chiaroscuro* of indecently rich and indecently poor. The new means of transport – buses, trams and Underground – were opening up suburbia. There, small urban cottages with inglenooks were built

OPPOSITE

The Artist and his Wife
by John M. Aiken, 1910

39

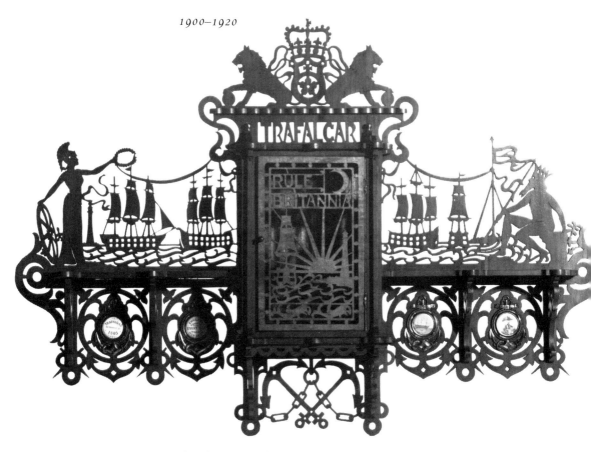

Fretwork shelf
commemorating the centenary
of the Battle of Trafalgar, 1905

for the rising class of shopkeepers and other small businessmen – the type depicted by H. G. Wells (himself the son of a housemaid) in *Kipps* (1905), *Tono-Bungay* (1909) and *The History of Mr Polly* (1910); and earlier, by Jerome K. Jerome in *Three Men in a Boat* (1889) and by George and Weedon Grossmith in *The Diary of a Nobody* (1892). These books are useful correctives to the more 'up-market' view of society in Galsworthy's *Forsyte Saga*, of which the first part, *The Man of Property*, was published in 1906. Between the rich man in his castle and the poor man at his gate were these house-proud *petit-bourgeois* with their brass door-knockers and door-plates, dusty hydrangeas in tubs, gasoliers and electroliers, beaten copper coal-scuttles and Art Furnishings from Waring & Gillow (1905) and Selfridge's (1908). They had leisure for do-it-yourself hobbies, such as fretwork. (In 1905, the centenary of Nelson's victory at Trafalgar, one magazine offered a pattern for a wonderfully elaborate celebratory fretwork shelf.) Or they would knock together a child's wooden motor car or a so-called 'washing machine' – a glorified tub – for the wife. They had pianos in Art Nouveau taste with piano candles for family performances of songs such as 'The Voyagers', 'Homing', 'Because', 'A Brown Bird Singing', 'The Deathless Army' and 'Has Anybody Seen My Tiddler?' The better-off might invest in a pianola player-piano whose keys were depressed as by ghostly fingers as they rattled off ragtime favourites or Rachmani-

nov preludes played (on the perforated rolls) by Rachmaninov. They had their own individual transport, the bicycle. Wearing jaunty boaters, they rode to riverside resorts and took their mutton-chop-sleeved young ladies on the river in skiffs with basketwork seats and cushions. With the newly invented 'Thermos' vacuum flask, hot tea or coffee could be served at picnics or on bicycling and boating excursions. Or a visit could be made to the newly opened Victoria and Albert Museum (opened 1909) or the two London museums which are masterpieces of late Art Nouveau architecture, the Whitechapel (by C. H. Townsend, opened 1899) and the Horniman Museum (also Townsend, opened 1901). There was roller-skating at Alexandra Park, ballroom dancing at Earl's Court and wrestling at Olympia. On Sundays, most people went to church, including new Art Nouveau churches such as the extraordinary one at Great Warley, Essex, or that of Holy Trinity, Sloane Street, London; for those outside the fold of the Church of England, there were travelling evangelists and the caravan of the Church Army.

Masculinity was dominant, and jingoism its national expression. President Roosevelt's favourite expression was 'Don't flinch, don't foul, hit the line hard.' He further declared: 'I am the father of three boys . . . and if I thought any one of them would weigh a possible broken bone against the glory of being chosen to play on Harvard's football field I would disinherit him.'

Roosevelt was known as a jingo both in the Spanish War and in

Church Army caravan: preaching the gospel in the West Country, England, first decade of the twentieth century

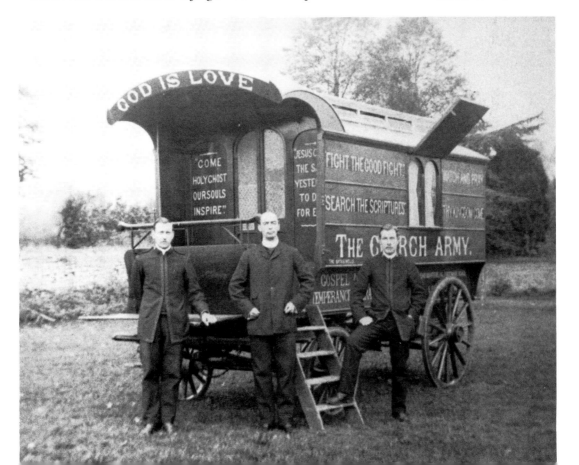

'Baden-Powell': march
composed by Ezra Read

'I Will Repay': song in
memory of Edith Cavell,
by F. V. St Clair

the Great War, and had seen active service. Queen Victoria had dressed Edward in a variety of uniforms, and he loved parading in them or any other kind of fancy dress; but although the early 1900s were years of the Boer War, it was unkindly remarked that the nearest he ever got to battle was the annual Battle of the Flowers at Cannes. However, given the chance, there is no reason to suppose he would have been other than 'plucky', to use the favourite *Boy's Own Paper* cant of the day. He was certainly prepared to fight a duel for his honour; though Lord Randolph Churchill, whom he challenged, declined on the grounds that it would be improper for a gentleman to bear arms against the Prince of Wales.

The Edwardian code of honour was implacable; many plays of the time hinged on the conflict between the code and the conduct dictated by instinct. It was the age of the stiff upper lip, of penitentially short haircuts for men, of high starched collars like white manacles, of Elgar's 'Land of Hope and Glory', Kipling's jingo poetry and Henry Newbolt's exhortations to 'Play up, play up and play the game!' The code was inculcated from infancy at the preparatory and public schools with their flogging and cold showers, their taboos against 'sneaking' and their public odium for 'cads'. It was further encouraged by the Boy Scout Movement founded by Sir Robert (later Lord) Baden-Powell, the hero of Mafeking, in 1907; by 1911 the movement had grown to such a size that 40,000 scouts attended a rally in Windsor Great Park for inspection by the King. The code favoured chest expansion and outlawed masturbation. It was the code which caused losers at Monte Carlo to shoot themselves, and Edith Cavell to go to her death with calm dignity. There were many fates worse than death, including White Slavery, cowardice in battle and being caught cheating at cards, whether rakehell baccarat or a cosy suburban whist drive.

The glorification of masculinity must have helped to fire the Votes for Women campaign of the Suffragettes who chained themselves to railings, threw themselves under racehorses, slashed the Rokeby Venus because Velasquez was seen (to adopt the jargon of half a century later) as treating woman as a 'sex object', or endured imprisonment and force-feeding. The rights were not accorded to them until – like men – they had 'proved themselves' in World War I. Women writers chose male *noms de plume* such as John Strange Winter, or eliminated the femininity of their given names by abbreviating them to initials, as did E. Nesbit. The 'New Woman' as she was admiringly or scornfully known, might smoke cigarettes, ride a bicycle in knickerbockers, or, if she could afford one, drive and repair her own motor car. The Press, too, was becoming more assertively masculine. 'Auntie' *Times* was taken over by the Napoleonic Northcliffe. The *Daily Mail*, founded in 1896, and the *Daily Express*, first printed in 1900, were brash and jingoist. In America, the sobersides *New York Times* now had a raucous rival in Joseph Pulitzer's *New York World*.

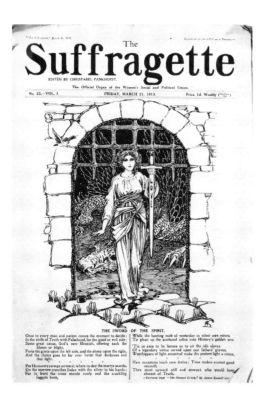

Alfred Harmsworth
(Lord Northcliffe) with the
Daily Mail

The Suffragette magazine,
edited by Christabel Pankhurst,
21 March 1913

William Randolph Hearst and
his mother, *c.* 1905

An advertisement for an Art Nouveau chimneypiece

Charles Rennie Mackintosh, clock of wood, ivory and erinoid, $13 \times 5 \times 5\frac{1}{2}$ in.

The new masculinity, which was partly a reaction against 1890s 'decadence', had a bracing effect on the decorative arts. The old, sinuous 'curvilinear' Art Nouveau was superseded during this decade by a new 'rectilinear' Art Nouveau. The single designer most responsible for the change was Charles Rennie Mackintosh (1868–1928), arguably the supreme genius of European design during this period. He was a Scot, born in Glasgow and trained at the Glasgow School of Art, for which he was to design a noble new building, completed in 1909. The main inspiration of the revised direction he gave to Art Nouveau was Celtic – though like earlier Art Nouveau artists, he was also captivated by Japanese art, while the logical structure of architecture – each element supporting another – also underlies all his work, even delicate watercolour drawings of blackthorn (1910) or fritillary flowers (1915). Although some English origins have been suggested for the earlier, 'curly' Art Nouveau style (William Blake etchings, Walter Crane book illustrations) it was undeniably Continent-based. Always excepting the drawings of Beardsley and the glass of the American Louis Comfort Tiffany, its masterpieces are by Continental artists: the furniture of Majorelle, the ironwork of Hector Guimard (as in the science-fiction entrances to the Paris Métro), the glass of Gallé, the posters of Alphonse Mucha, the extraordinary architecture of the Spaniard Antonio Gaudí. It is tempting, then, to suggest that the new Art Nouveau of Mackintosh, with its Celtic inspiration, represents some patriotic urge, a kind of aesthetic jingoism. But Mackintosh was a prophet unhonoured in his own country. The Glasgow School of Art was one of his few major commissions. Without the patronage of Catherine Cranston, who commissioned interiors for her Glasgow Tea Rooms and in 1909 for her own home, Hous'hill, he would have brought in little work to his firm, Honeyman, Keppie and Mackintosh.

He was acclaimed by German periodicals such as *Dekorative Kunst* and *Deutsche Kunst und Dekoration*. But Scottish and English magazines gave him little coverage after his appearances in *The Studio* in 1896 and 1897. His *succès d'estime* at exhibitions in Vienna (1900), Turin (1902), Moscow (1903) and Dresden (1904) was not matched in Glasgow or London.

All his best work was executed between 1896 and 1906 – in particular, the Tea Rooms he decorated and furnished for Miss Cranston in Glasgow. Some critics – notably P. Morton Shand – have deplored the fact that Mackintosh was tied for so long to Miss Cranston's apron-strings, devoting himself to novelty, trivia, bric-à-brac, stencils, twisted wire, leaded glass and flower arrangements, when he could have been designing magisterial architecture. And the same critics have thought it a tragedy that his style was 'emasculated' by his marriage in 1900 to Margaret Macdonald, who, Thomas Howarth has written, 'seems to have lived in a world of roses, love-in-a-mist, cherubs and falling petals'. But decoration was really Mackintosh's forte, and it

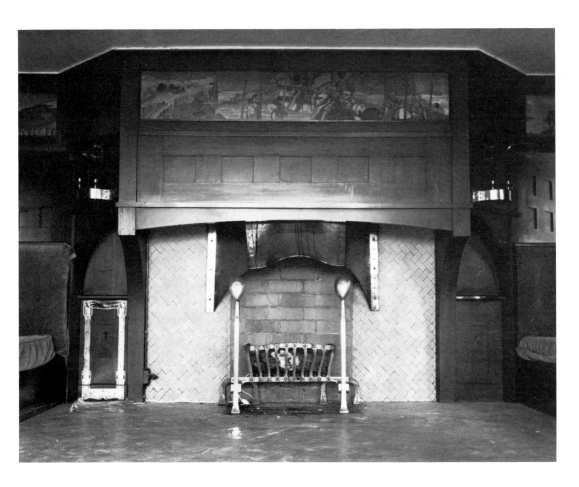

was his decorative skills, with those of his collaborators who made up the 'Glasgow Four' (himself, his wife, Herbert and Frances McNair) that made the deepest impression on the Continent, especially in Austria.

Mackintosh did not regard his style as a variety of Art Nouveau. Mrs Mary Sturrock, daughter of his patron Fra Newbery, recalls: 'My parents did not like *art nouveau* and Mackintosh didn't like *art nouveau*. He fought against it with these straight lines – against these things you can see for yourself are like melted margarine.' And the same was true of Professor Otto Wagner (1814–1918), the great Viennese architect who laid the foundations for the rectilinear style on the Continent. His seminal work *Moderne Architektur* (1895) makes no mention of Art Nouveau, though all the important Viennese Art Nouveau architects belonged to his school and were influenced by the box-like simplicity of his designs. But Wagner's chief pupils, the architects and designers Joseph Hoffmann (1870–1955), Joseph Olbrich (1867–1908) and the designer Koloman Moser (1868–1916) were still more powerfully influenced by Mackintosh and the Glasgow school.

The inglenook in the drawing room at 'Chetwynd', *c.* 1902. The panel over the fireplace was painted by J. Butler in 1926. A designer at A. J. Wilkinson, Staffordshire, he created the Tibetan and Oriflamme ranges of pottery

Art Nouveau lettering on a box for gentlemen's collar-studs and cufflinks

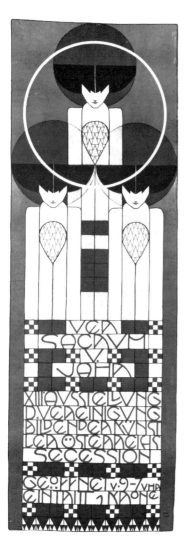

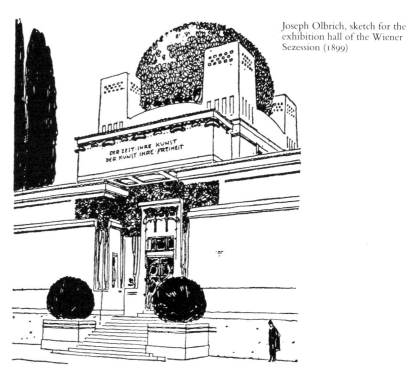

Joseph Olbrich, sketch for the exhibition hall of the Wiener Sezession (1899)

Poster by Koloman Moser

China souvenir plate of the Glasgow International Exhibition, 1901. Charles Rennie Mackintosh, Glasgow's finest designer, had little showing there. The mock-rococo style of the plate's pierced border shows the state of popular taste at the turn of the century

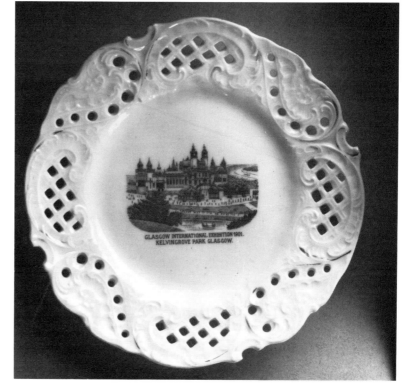

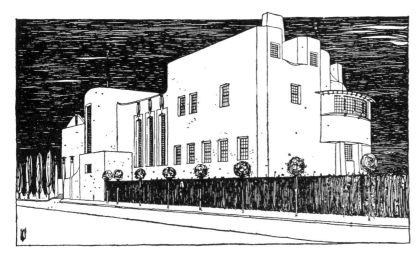

Charles Rennie Mackintosh, sketch for the 'House for a Lover of the Arts', 1901

Chair by Joseph Hoffmann

In April 1897 nineteen members had seceded from the Viennese Academy and launched an independent society, the Viennese Secession. They included Hoffmann, Olbrich and the painter Gustav Klimt. In 1900 these men invited the Mackintoshes to visit Vienna to furnish an apartment in the Secession House designed by Olbrich in 1898. Students met them at the station on their arrival and drew them through the city in a flower-decked carriage – a scene reminiscent of Lord Leighton's first Royal Academy painting, *Cimabue's Celebrated Madonna is Carried in Procession through the Streets of Florence* (1855). Hoffmann and Mackintosh met at the Secessionist Exhibition of 1900 and shared two clients, Dr Hugo Henneberg and Fritz Wärndorfer, for whom Mackintosh designed an acclaimed music room. Hoffman designed Henneberg's house and the study contained a Mackintosh cabinet from the Secessionist Exhibition. Hoffmann's Palais Stoclet, built in Brussels between 1905 and 1907, was strongly influenced by Mackintosh's designs for a *Haus eines Kunstfreundes* (a competition held in 1901), which arrived too late to win, but were published in the folio *Meister der Innen kunst* (1902). The rectilinear style spread from Austria through Germany. The extent of its victory can be seen in a book such as *Der Innendekorateur* by W. Engelhard (Berlin, 1908). Contrast all this success for the style inspired by Mackintosh with his showing in the Glasgow International Exhibition of 1901, in Kelvingrove Park. His design for the exhibition building lost out to a 'jolly outburst of sugar-cake architecture' in the Spanish renaissance manner by James Miller; and his only contribution to the interior was the design of a few exhibition stands – for the School of Art, Pettigrew & Stephen, Francis Smith and Miss Cranston's White Cockade Tea Rooms.

Almost single-handedly, through the force of his genius, Charles Rennie Mackintosh gave the decorative arts a new direction. The

Bronze mythological head in the curvilinear Art Nouveau taste

An early electric kettle, designed by W. A. S. Benson (Managing Director of Morris & Co. from the mid-1890s)

Hammered silver coffee pot designed by Arthur S. Dixon and made by the Birmingham Guild of Handicrafts, 1901. Finial and handle of fruitwood. Height 8.6 in.

curvilinear, Paris-based Art Nouveau of the 1890s had freed design from 'historicism' (the reliance on period ornament, such as Renaissance lambrequins or neo-classical anthemions). Mackintosh, in turn, had rescued it from the 'melted margarine' – though indeed his style was a fusion of puritan severity and symbolist sensuality. At about the same period, the lessons he was giving the design world were being reinforced by the English Arts and Crafts Movement. This was a highly moralistic movement which had its origins in the nineteenth-century reaction against the Industrial Revolution, led by A. W. N. Pugin, who wanted a return to medieval craftsmanship, in which the workings of the craftsman would be left open to view, not furtively concealed by veneers or other stratagems; by Henry Cole and his 'Summerly's Art Manufactures' founded in 1847 with similar ideals; and above all by the teaching and work of John Ruskin and William Morris. The Great Exhibition of 1851 had been a severe disappointment to its organizers, who included Cole. For the most part, the exhibits seemed meretricious, obscenely over-ornamented. 'We have no principles,' wrote the designer Owen Jones, 'no unity'.

In 1857 Ruskin sounded the clarion in a speech to the Lancashire and Yorkshire Mechanics' Institutes. They had, he said, new responsibilities. They must turn to nature for inspiration: field and factory could have little in common. He founded the abortive St George's Guild to realize the idea of a just society, in which all machinery driven by steam would be banned. Steam hammers, he declared, were 'the toys of the insane'. Guilds – the medieval prototypes of trades unions – became increasingly popular. Mackmurdo formed the Century Guild in 1882; the Art Workers Guild was founded in 1884; C. R. Ashbee established his Guild and School of Handicraft in the East End of London in 1888; Birmingham and Bromsgrove had their guilds of handicraft, celebrated by John Betjeman in his poem 'The Metropolitan Railway: Baker Street Station Buffet':

Early Electric! With what radiant hope
 Men formed this many-branched electrolier,
Twisted the flex around the iron rope
 And let the dazzling vacuum globes hang clear,
And then with hearts the rich contrivance fill'd
Of copper, beaten by the Bromsgrove Guild.

William Morris put Ruskin's theories into practice at the Red House. His Pre-Raphaelite Brother, Edward Burne-Jones, spoke of 'a Crusade and Holy Warfare against this age'. Morris's collaborator Philip Webb added the idea of the *vernacular* – 'a common tradition of honest building'. That meant oak beams, large English chimney-pieces, Horsham slabs and local stone to harmonize with the local environment. (Mackintosh's architecture was derived from the *Scottish* vernacular: crow-stepped gable and sturdy chimney-stack; newel stair; silver-grey harl-

ing or rough-casting; small windows against the weather, giving an appearance of unbroken wall surface; steeply pitched roofs and sweeping eaves-lines often interrupted by dormers. This tradition had been obscured by the Adam Brothers and the Greek Revival of William Playfair.)

And Morris himself added the idea of the democracy of art. He looked forward to the day when 'millions of those who now sit in darkness will be enlightened by an Art made by the people and for the people, a joy to the maker and the user.' Morris's beliefs led him inevitably to socialism – to collaboration as opposed to competition, which in turn would bring about the longed-for 'unity' of the arts. Morris's disciple Walter Crane also joined the Socialist League.

To the Arts and Crafts men, such as Charles Robert Ashbee, Charles Annesley Voysey and Ernest Gimson, society was as important as its art. Ashbee wrote in *Craftsmanship in Contemporary Industry* (1908): 'The Arts and Crafts Movement means standards, whether of work or of life; the protection of standards, whether in the product or the producer, and it means that these things must be taken together.' They saw industrialization as the destroyer of 'purpose, sense of life': it had led to the dark satanic mills, to slums and shoddy mass-produced products; and it had exploited the many for the profit of the few. They could not come to terms with the machine. And they could not see the essential flaw in their thinking – which was, that fine craftsmen-made goods could only be afforded by the well-off. That was the fatal paradox of the Arts and Crafts idealism.

Ashbee, whose own attempt to set up a Utopian craftsman community in Chipping Campden, Gloucestershire, was a failure, did finally see the paradox. In his unpublished memoirs he wrote: 'We have made of a great social movement, a narrow and tiresome little aristocracy working with great skill for the very rich.' Only by coming to terms with the machine could the paradox be resolved. In 1912 the Italian Futurist Marinetti urged a London audience to 'disencumber yourselves of the lymphatic ideology of your deplorable Ruskin . . . with his hatred of the machine, of steam and electricity, this maniac for antique simplicity resembles a man who in full maturity wants to sleep in his cot again. . . .'

Hanging open bookcase/ display shelves of walnut by Ernest Gimson

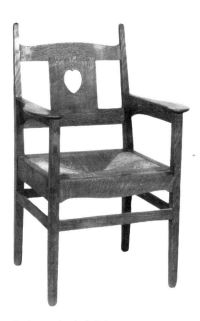

Rush-seated oak chair by C. F. A. Voysey, *c.* 1905

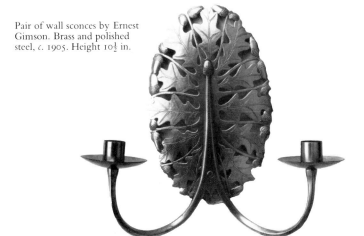

Pair of wall sconces by Ernest Gimson. Brass and polished steel, *c.* 1905. Height 10½ in.

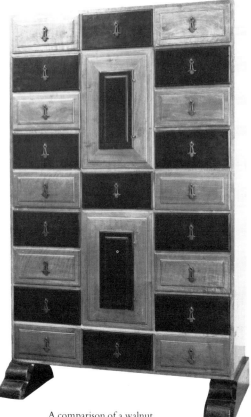

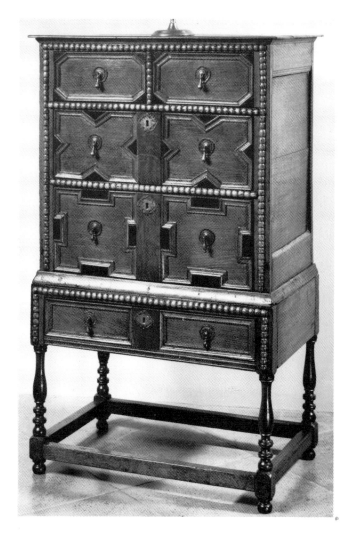

A comparison of a walnut and ebony cabinet by Ernest Gimson, *c.* 1905, with a chest of drawers, *c.* 1690, inlaid with walnut, the bobbin-turned mouldings in elm, shows clearly the debt of the Cotswold school to English tradition

OPPOSITE

French fashions of 1901

Poster for Kodak: in the early 20th century, photography ceased to be a laborious ceremony performed in studios, and the 'snapshot' came in

The Pop Art of an Edwardian railway pension scheme certificate

Tea-Time Tango by Henry E. Pether

Ashbee designed some silver vessels of great beauty in the old sinuous Art Nouveau, but most Arts and Crafts products are in the rectilinear style, which sorted better with the earnest morality of the Movement. Both the architecture and the works of art of its leaders show a fondness for the vernacular. Long Orchard at Budleigh Salterton, Devon, built by Ernest Gimson in 1911, had walls of cob and timbers of English chestnut. In furniture, native woods – oak, elm, walnut and the yew which medieval bowmen used for their bows – were favoured. Some of the cabinets made by Gimson and his assistant Peter Waals are almost unimaginatively derivative of English seventeenth-century examples. As with Mackintosh, a Celtic influence is also apparent in much Arts and Crafts design, in *entrelacs* and complex interlacements, especially in the jewelry of John Cooper and Arthur Gaskin and the silver of Omar Ramsden and Alwyn Carr.

ÉDITION D'AMATEUR N° 32. — 11 Août 1901.

LA NOUVELLE MODE

Abonnez-vous à notre Édition des
Couturières, deux aquarelles hors texte
par semaine.

Notre Supplément musical publie
cent Morceaux de Musique chaque année.
SIX francs par an.

A holiday without a
Kodak
is a holiday wasted.

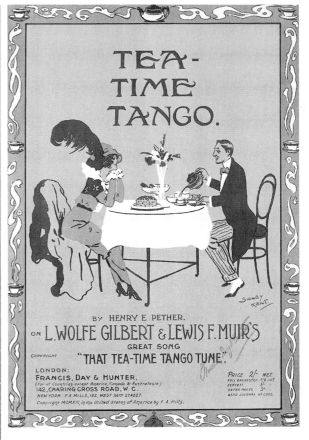

TEA-
TIME
TANGO.

BY HENRY E. PETHER.
ON L.WOLFE GILBERT & LEWIS F. MUIR'S
GREAT SONG
"THAT TEA-TIME TANGO TUNE."

LONDON:
FRANCIS, DAY & HUNTER,
(for all Countries except America, Canada & Australasia.)
142, CHARING CROSS ROAD, W.C.
NEW YORK: F.A. MILLS, 122, WEST 36TH STREET.
Copyright MCMXIII, in the United States of America by F. A. Mills.

PRICE 2/- NET.

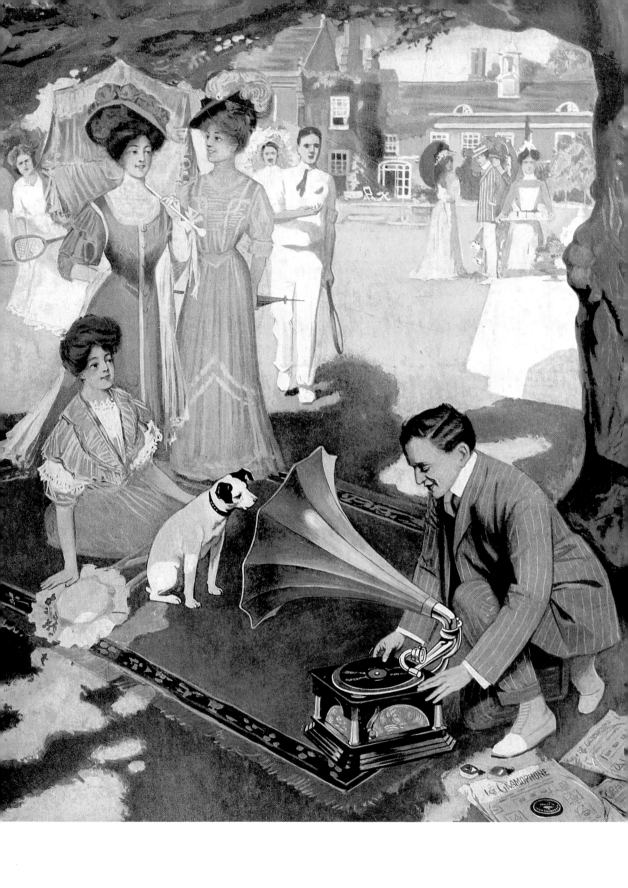

Though Mackintosh and a number of the Arts and Crafts men were commercial failures as individuals, their styles were absorbed into the decorative bloodstream through the big stores. Liberty, in particular, sold a huge variety of cabinets and other furniture (much of it made in Manchester) in the rectilinear style, often ornamented with stained glass and marquetry motifs. Liberty also popularized Celtic motifs, in their stoneware garden furniture; in silver by Archibald Knox (who had Celtic antecedents, being born at Torode on the Isle of Man of Scottish parents) and Reginald (Rex) Silver; in the 'Cymric' range of silver and jewelry and the 'Tudric' pewter manufacture. Liberty's sold a richly printed silken lawn with the Celtic-sounding name of 'Tana' (not far from the Irish 'Tara') – which, however, derived from the original cost of the cloth per yard, 6d, or 'a tanner'.

OPPOSITE
A gramophone provides the background music to an Edwardian country house garden party. His Master's Voice advertisement, c. 1909

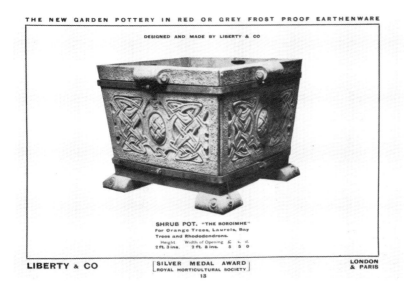

THE NEW GARDEN POTTERY IN RED OR GREY FROST PROOF EARTHENWARE

DESIGNED AND MADE BY LIBERTY & CO

SHRUB POT. "THE BOROIMHE" for Orange Trees, Laurels, Bay Trees and Rhododendrons.

LIBERTY & CO SILVER MEDAL AWARD ROYAL HORTICULTURAL SOCIETY LONDON & PARIS
13

Liberty's garden furniture, in frost-proof earthenware, showed a clear Celtic influence

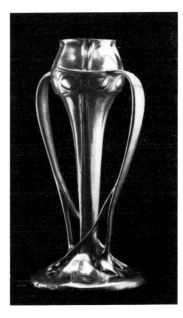

Pewter 'Tudric' vase, Liberty, c. 1903–4. Marked: '6/TUDRIC/029'

The Edwardian period was the zenith of the department store. The American, Gordon Selfridge, opened his store in Oxford Street in 1909 with an army trumpeter blowing a fanfare from the parapet over the main entrance. Harrod's responded disdainfully and with ostentatious Good Taste in the same week, holding a series of concerts conducted by Landon Ronald to celebrate their Jubilee. They issued a sumptuous catalogue titled *Fashionable Rendezvous*. Debenham and Freebody was given grandiose new premises in 1907 (and in 1905 Sir Ernest Debenham commissioned the architect Halsey Ricardo to build him the large house which still stands in Addison Road, Kensington, a 'ceramic palace' with many tiles by Ricardo's former partner William De Morgan: it was the last year of De Morgan's work as a potter, and the business he had founded came to an end in 1907.) The Army and Navy Stores cleverly exploited snob-appeal by making its customers 'members'. Philippe Garner has well commented:

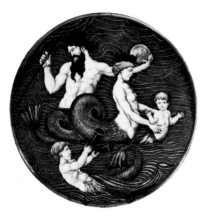

'The Neptune Dish' designed by William de Morgan, 1901. Diameter 20 in.

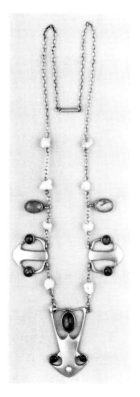

Necklace of gold set with opals, wood opals and freshwater pearls, made for Liberty & Co. *c.* 1905, probably from a design by Archibald Knox.

What better place than the Army and Navy Stores to observe the buying habits of imperialist Edwardians, or indeed of Indian Princes, for in 1901 branches were opened in Bombay, Delhi, Calcutta and Karachi, and catalogues were issued with price lists in Indian currency. The page of the catalogue dealing with hats is an education in itself: 'The Viceroy' at 17s 6d, 'The Colonial' at 10s 6d, 'White drill and khaki canvas Shikar helmet' at 13s 6d or the 'Cawnpore Tent Club' pith hat at 14s 6d. Colonial chairs and other furnishings in cane or bamboo were clearly very popular.

Asprey of Bond Street, the 'fancy goods' store, was also in its heyday. Mr Percy Hubbard, who was still working there in 1980, came to the firm in 1905 and had vivid memories of those days when I interviewed him for the official history of Asprey's:

Bond Street presented a very different appearance then. All traffic was horse-drawn. There was no omnibus or taxi. The customers arrived in carriages – broughams, phaetons and dog-carts, and invariably had footmen. During one day, I would see customers in here in three different modes of dress: morning, afternoon and evening – we kept open until half-past six in those days. Some customers would call in on their way to a party to buy gifts. Of course all the men wore silk hats, which they doffed as they came in the door – the same door that you see today. At that time, when Guards officers were men of means, it was a common sight to see them in the late hours of the morning in their long black frock coats, escorting actresses from the Gaiety, Daly's and other theatres.

Asprey's was only for the rich; but on the site in Tottenham Court Road where Heal's expanded in the 1850s and 1860s (and where it still stands today) Ambrose Heal junior was offering a range of furniture and decorative goods which ordinary people could afford but which still met with the approval of the Arts and Crafts Movement. Heal, who had trained as a cabinet-maker in Warwick, had been influenced by the Movement. In 1898 he had issued his first *Catalogue of Plain Oak Furniture*. Plain it was: the reduction of furniture to its most basic elements. His own salesmen were not smitten by it, calling it 'prison furniture'; but the beautiful dressing-tables, sideboards and other furniture in unpolished oak which he designed and sold in the Edwardian years anticipated by more than fifty years the similarly simple furniture for young couples which Terence Conran's Habitat would be selling, also in Tottenham Court Road, in the 1960s.

Sam Wanamaker, who opened his store in Philadelphia in 1861, was the first to present Paris and Berlin fashions in the United States, the first to light his store with electricity and the first to install the Bell telephone system. The first private branch exchange was installed in Wanamaker's in 1900. The construction of the present building was begun in 1902, a steel-framed skyscraper of the kind pioneered by Sullivan in his Wainwright Building, St Louis, 1890–91. (The wafer-thin 'Flatiron' building, still one of New York's finest ornaments, was also under construction in 1902.)

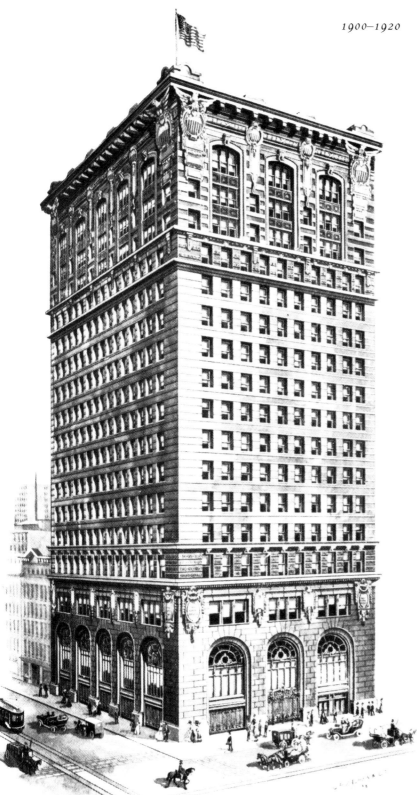

Poster by Will Bradley for the
Ault and Wiborg Company,
1900

A Chicago skyscraper: florid
touches of Belle Epoque relieve
the starkness of metal-skeleton
construction

Frog plaque by the American
Encaustic Tiling Co., *c.* 1905

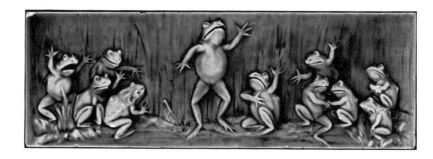

America might be pioneering the skyscraper – its most important contribution to twentieth-century design – but it was still taking most of its decorative inspiration from Europe. It lagged behind a little as a result; Arts and Crafts theory and rectilinear Art Nouveau took some time to cross the Atlantic. Louis Comfort Tiffany, the great American glassmaker, for example, was still working almost exclusively in the Parisian curvilinear style, with its lilies and languors. He had begun his career as a painter in Paris, and the Paris influence continued to outweigh that of Morris and Ruskin to which he had been exposed on several trips to London, where his father's firm had a branch in Regent Street from 1868 onwards. In 1880 he had patented his Favrile glass, an iridescent technique which involved exposing hot glass to a series of metallic fumes and oxides. This technique alone encouraged motifs such as shimmering dragonfly wings or peacock tails, both part of the stock-in-trade of Parisian Art Nouveau; and the pliancy of glass also favoured coils and curves and whiplashes rather than verticals, squares and rectangles. Besides, Ashbee's and Heal's simplicity was not likely to find a welcome in the land of mushroom fortunes. The *nouveau riche* did not necessarily go for the *nouveau* art. They wanted Renaissance floridity to show off their wealth.

All the same, there was as much a puritan tradition in America as there was in Mackintosh's Scotland, and Arts and Crafts ideas had 'taken' with some American designers, notably the eccentric Elbert Hubbard, who had made a modest fortune as a salesman and advertising agent in Chicago. In the 1880s Hubbard went to England, met and hero-worshipped William Morris, and returned home to found the Roycroft Institution in East Aurora, New York. By the 1920s it employed 300 workmen, producing, among other arty-crafty goods, 'wrought copper and modeled leather'. Hubbard also met Ashbee, and thoroughly approved Ashbee's move to Chipping Campden in 1902. 'I am glad to know,' he wrote to Mrs Ashbee, 'that you have gotten out of the city into God's country. It may be a little lonesome for some of your workers at first. . . .' His own community had a Roycroft Inn for 'tired businessmen, . . . honeymooners, travelers and congenial souls'. Pubs were very Arts and Crafts: good wholesome ale, not the absinthe and hock-and-seltzer of the wicked 1890s.

Ashbee had one American admirer far more distinguished than Elbert Hubbard: the architect Frank Lloyd Wright. The two met in December 1900 when Ashbee was in the middle of his second visit to the States. 'Wright', he wrote from Chicago, 'is far and away the ablest man in our line of work that I have come across in Chicago, perhaps in America. He not only has ideas, but the power of expressing them, and his Husser House, over which he took me, showing me every detail with the keenest delight, is one of the most beautiful and individual creations I have seen in America.' Husser House was designed in 1899 – a long horizontal structure with Sullivan-like terracotta decoration under the eaves. It, too, was 'vernacular'.

Wright took the occasion to tell Ashbee a home truth. 'He threw down the glove to me in characteristic Chicagoan manner,' Ashbee wrote, 'when we discussed the Arts and Crafts. "My god", he said, "is machinery, and the art of the future will be the expression of the individual artist through the thousand powers of the machine . . ."'. And in 1901 Wright delivered his lecture 'The Art and Craft of the Machine' in Hull House. He called the machine 'the tool of our civilization', and thus, as Gillian Naylor has written, 'bridged the gulf between the nineteenth and twentieth century'. 'Genius,' Wright said, 'must dominate the work of the contrivance it has created.'

Ashbee found himself agreeing with much that Wright said, though in retaliation he asked what would become of the workmen, and he was not enamoured of the strong Japanese influence on Wright's work. He was fair enough to accept that the American city created new problems, which needed new solutions. 'Yes, it was the great drive, the strain and stress of this terrible and wonderful city that set him [Wright] moving with the rest. . . . He introduced me to his master, Sullivan, in whom the Chicago spirit finds such anxious and restless experiment.' One can see that would appeal to Ashbee in Sullivan's work, such as the rectilinear Owatonna Farmers' Bank (1907) or the Bradley Residence, Madison, Wisconsin (1900), where Sullivan's taste for Romanesque and Byzantine style was abandoned for the Voysey/Mackintosh manner.

But, as with Mackintosh, it was in Austria and Germany, not in America, that Ashbee's ideas really took root. In 1897 the Grand Duke of Hesse sent an envoy from Darmstadt to see his work in London, and as a result the architect Baillie Scott was commissioned to decorate the Grand Duke's palace, the designs being carried out by Ashbee's Guild of Handicraft. The Guild was also the direct inspiration for Hoffmann's Wiener Werkstätte (founded 1903) and for the Werkbund established in 1907. William Morris was the main influence on the Belgian theoretician and designer Henri van de Velde who founded the Weimar Kunstgewerbeschule (School of Arts and Crafts) in 1906. Van de Velde was succeeded as its head, at his own suggestion, by Walter Gropius, who in 1919 amalgamated it with the Weimar Hochs-

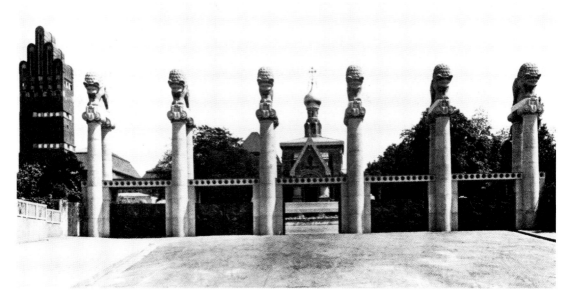

Darmstadt: *left*, the Hochzeitsturm (Marriage Tower) by Joseph Olbrich, 1908; *centre*, the Russian Chapel by Alexandre Benois's father, 1898 (the Czarina was the sister of the Grand Duke of Hesse-Darmstadt); *foreground*, the Lion's Gate by Bernhardt Hoetger, 1914

chule für Bildende Kunst (Academy of Fine Art) under the name of Das Staatliche Bauhaus Weimar.

As Gillian Naylor has written, the Bauhaus 'set out, in a resurgence of optimism and idealism after the First World War, to train a generation of architects and designers to accept and anticipate the demands of the twentieth century; and to use all its resources, technical, scientific, intellectual and aesthetic, to create an environment that would satisfy man's spiritual as well as his material needs.' She adds that the Bauhaus was 'cut off before it had time either to consolidate or betray its early ideals'; but, for better or worse, Gropius's architecture of the 1920s, and the furniture created in sympathy with it by Marcel Breuer, Marianne Brandt, Mies van der Rohe and Wilhelm Wagenfeld, would still be the dominant influence on European design half a century later. Spare and mechanistic, it made a clean break with the pomp and fussiness of the Belle Epoque; and contempt for the political system of the *ancien régime* was implicit in its shining severity. The great differ-

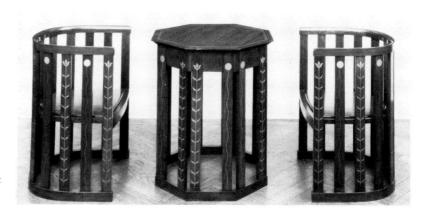

Two chairs and a table designed by M. H. Baillie Scott and made by C. R. Ashbee's Guild of Handicraft

ence between the Continental movement and the English Arts and Crafts Movement was that from van de Velde onwards (he was one of the first artists to turn his talents to designing functional railway carriages and steamships) there was a real attempt to come to an accommodation with the machine. In England there was no Werkbund or Bauhaus – just the Omega Workshops with their daffy Bloomsbury decorations and Boris Anrep mosaics.

In the first decade of the century, France rested on her laurels. Paris was still the centre of fashion; but the Paris Exposition of 1900 was overwhelmingly *belle époque* in conception, neo-baroque at its most florid – as Nigel Gosling has called it, 'the last frothy eruption of the nineteenth-century volcano of creativity'. It had a few touches of Art Nouveau, but like the Art Nouveau of the new Métro and of Loïe Fuller's dances which were delighting Parisians at the time, they were of the old swirling style. The only future-looking contributions were Eliel Saarinen's Finnish pavilion (the British pavilion, Sir Edwin Lutyens's pastiche of an Elizabethan manor house, hardly qualified) and some scientific novelties – the microscope in the Optical Pavilion which magnified a drop of Paris water 1,000 times ('a horrid spectacle', one reporter noted) and examples of X-ray photography, wireless telegraphy and cinematographic technique.

Still, there were signs that the decadence of the *fin de siècle* was on the way out. The painter Gustave Moreau, whose jewelled fantasies had made him a dominant figure of the Symbolist movement, had died in 1898 aged 72. The personal museum he had egocentrically made of his house, which he left to the state in his will, was such a flop with the public that the ageing Degas changed his mind about leaving his studio to the nation. Another Symbolist, Puvis de Chavannes, also died in 1898. Oscar Wilde, who to many symbolised the 1890s decadence, died in a Paris hotel in 1900 (alleged last words: 'Either that wallpaper goes, or I do!'). Even his death provoked a scandal, over the Epstein tomb for the Père Lachaise cemetery (1912) which had to have a bronze plaque fitted over its too prominent genitalia. Toulouse-Lautrec, whose paintings and posters immortalized the can-can nineties in Paris, also died in 1900, at only 37. Whistler, who had dissolved reality in the grey mists of his *nocturnes*, died in London in 1903. In the same year the symbolist magazine *La Revue Blanche*, for which Bonnard had designed a delicate Japanesey poster, went bankrupt. Jean Lorrain, the most flamboyant Parisian decadent – drug-taking, homosexual, sado-masochist and a part-original of Proust's Baron Charlus (he once fought a duel with Proust) – died in 1905. In 1911 Proust heard Debussy's opera *Pelléas et Mélisande* on the theatrephone, a device which enabled one to listen at home to live performances at the Opéra. ('The scent of roses in the score is so strong,' he wrote, 'that I have asthma whenever I hear it.') *Pelléas et Mélisande*, and the Diaghilev ballet based on Mallarmé's poem, *La Spectre de la Rose*

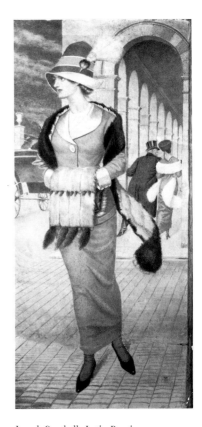

Joseph Southall, *In the Rue de Rivoli, Paris*. Buonfresco, signed with monogram and dated 1912

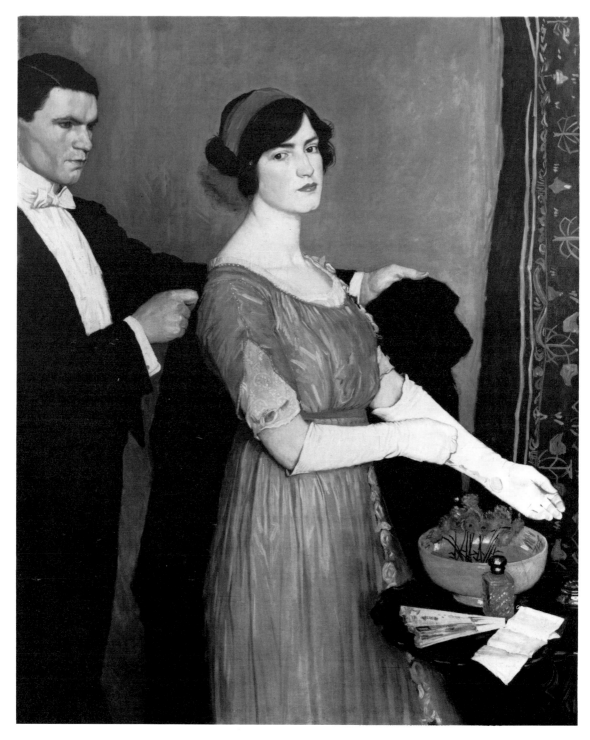

William Strang, RA,
The Opera Cloak, oil on canvas,
1913. 48 × 40 in.

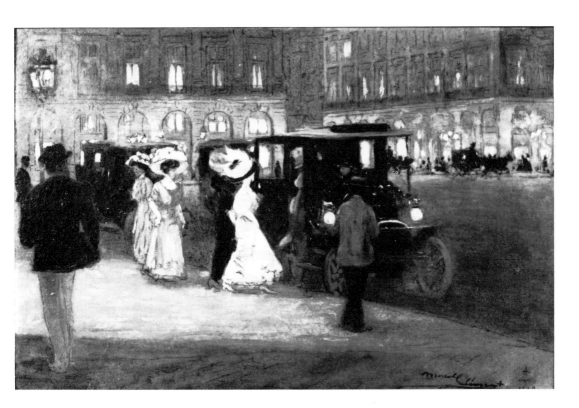

Amédée Marcel-Clément,
La Montée en Auto, signed
and dated 1908. Oil and
pencil on board. $8\frac{3}{4} \times 13$ in.

(1911), also d'Annunzio's *Le Martyre de Saint Sébastien*, with Ida Rubinstein in the title role, were the last perfumed breaths of symbolist decadence. Proust's great novel *A La Recherche du Temps Perdu* rather satirizes the decadence than is engulfed by it; though the valetudinarian *fin de siècle* mood of its opening books may account for their rejection by the *Nouvelle Revue Française* in 1911. (The celebrated episode of the dunked *madeleine* had happened to Proust in 1909; *Du Côté de Chez Swann* was finally published by Grasset, at Proust's own expense, in 1913.)

As the Symbolists retreated or died, the Fauves, the Cubists and Futurists moved in. Braque came to Paris from Le Havre in 1900 and entered an art school. The 1900 Salon contained one of his paintings, *Salome*. Picasso arrived from Spain in 1901, in knickerbockers and holding a portfolio – a scene he caught in a humorous self-portrait. In this year the influence of Cézanne was reinforced by that of Van Gogh, with a big Van Gogh retrospective exhibition staged by the Galérie Bernheim-Jeune; Matisse exhibited his first painting in public at the Salon des Indépendants; Fernand Léger, aged 20, enrolled at the Ecole des Beaux Arts; and Gertrude Stein and her brothers arrived from Pennsylvania. Picasso painted the first truly cubist work, *Les Demoiselles d'Avignon*, in 1907. The new art outgrew national frontiers: a Russian, Kandinsky, painted the first wholly abstract work; for-

An attacked German zeppelin crashes in flames: fretwork design from *Hobbies Weekly*

eigners such as the Futurists from Italy, Gerald Kelly and Augustus John from England, Arthur Dove, Alfred Maurer, Max Weber and Patrick Bruce from the United States and Foujita from Japan came to Paris to see what all the fuss was about; and Edward Steichen introduced Americans to cubist works (including Duchamp's *Nude descending a Staircase*) in the Lexington Avenue Armory, New York, in 1913. As Nigel Gosling says, 'Within fifteen years the whole relationship between man and appearances . . . had been changed' and Paris had become the cradle of 'the whole vast, varied and troublesome family of modern art'. But for the delayed-action effects of that revolution in the *decorative* arts, we must look to the 1920s and 1930s, when Cubism was domesticated.

In February 1909, Gino Severini handed in to the office of *Le Figaro* a long manifesto signed 'F. T. Marinetti' which declared: 'We are young, strong, living – we are FUTURISTS.' The Futurist Manifesto of *Destructive Incendiary Violence*, as it called itself, glorified war, 'the only health-giver of the world', and demanded militarism, patriotism and 'ideas that kill'. It was perhaps inevitable that the male-oriented ethos which superseded the 1890s decadence would end in fighting and bloodshed. (The Italian Futurists' ideas were based directly on those of Nietzsche. They believed in dynamism, virility, the cult of the superman: female nudes are rare in their work, and muscleman worship is suggested in Boccioni's *Muscular Dynamism* drawings of 1910.) The Futurists' demand for war and destruction was to be met only too soon. On 28 June 1914 the heir to the Austrian throne, the Archduke Ferdinand and his wife were assassinated by a nineteen-year-old Serbian student at Sarajevo. On 23 July Austria declared war on Serbia. 'We are getting ready to enter a long tunnel of blood and darkness,' André Gide wrote in his diary on 31 July in Normandy.

In its perverted way, war fulfilled another of the Futurists' ambitions: to involve art with the machine. The art of war, at least, had to come to terms with the machine. Those who remembered the Franco-Prussian War pictured a war of musketry and cavalry, with squares formed, sabres brandished and gunners firing at targets they could see. But the machine gun swept infantry and cavalry from the earth. And eventually the deadlock of trench warfare was broken by the tank, of which the lozenge shape was reproduced in many different *souvenirs de guerre*, from watch-holders to inkwells, crested china, moneyboxes ('Bank in the Tank') and cigarette lighters (lift the turret). After Jutland the submarine – previously considered 'ungentlemanly' – was an essential factor in sea warfare. And this was also the first war fought in the air.

Like most wars, World War I pushed 'fine art' into the background and fostered the popular arts. Canvases of ravaged landscapes by Paul Nash and C. R. W. Nevinson, François Flameng's heroic *Troupes Ecossaises Revenant du Combat* and Laboureur's stylized etchings of soldiers

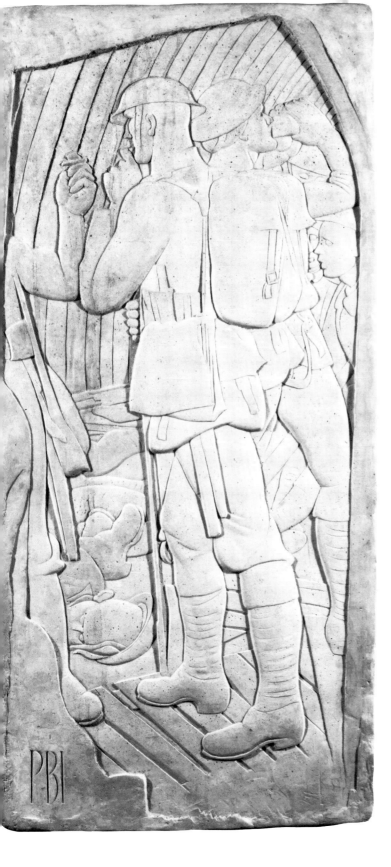

Eric Kennington,
Poor Bloody Infantry (PBI),
plaster, *c.* 1920. $48\frac{1}{2} \times 23$ in.

bathing are among the few expressions of the war by 'gallery' artists; but as Barbara Jones and Bill Howell wrote in their *Popular Arts of the First World War* (1972):

> . . . In the trenches, hospitals and prison camps, bored and frustrated men, taken from their trades, sat down and fiddled with used shell cases and bully-beef tins, making and decorating things to pass the time. These objects reflected the war as they wanted (as the only way they dared) to see it. It was a decorative and decorated war; little brass aeroplanes made of cartridges, with arabesques incised on their wings; tanks made of wood with flower designs inlaid in brass.

The war was commemorated in millions of picture postcards; in crested china of the Goss type; in a fine series of Doulton 'toby' or character jugs representing the French and British war leaders; in caricatures by Bruce Bairnsfather (''Ole Bill') and Heath Robinson. National flags, especially the Union Jack, appeared on many trumpery objects. Some of the souvenirs were grotesquely *kitsch*: a bust of Lord Kitchener was modelled in Margerison's White Windsor Soap; *Hobbies Weekly* published a fretwork design of a burning zeppelin and, after the Armistice, another design for a 'Fretwork Home Cenotaph', based on Lutyens's design for Whitehall. The Germans put photographs of their war heroes in metal frames decorated with the Iron Cross, oak leaves, flags and eagles, and lettered in relief: *'Er starb als Held den Todt ürs Vaterland'*. Across Europe, war memorials were carved with the countless names of the fallen – those who would grow not old, those who might have been the Grand Old Men of today. It was a good time for the sculptors.

1920-1940

Art Deco | The Crash | Streamlining

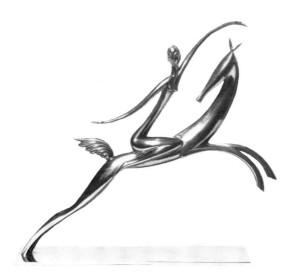

n the early 1920s, the western world was still convalescing from World War I. Millions were dead; millions more would never fully recover from the emotionally maiming experience. For the moment, what most people craved was an antidote to the horror and pain – fun, frivolity, razzle, a kicking over the traces. Anthony Powell, in *A Buyer's Market* (1952), speaks of 'the illusion of universal relief that belonged to that historical period: of war being, surprisingly, at an end; of the imminence of "a good time".'

Literature and the other arts reflected the new mood. Cyril Connolly in *The Modern Movement* (1965) said of Lytton Strachey's *Eminent Victorians* (1918):

> It might be described as the first book of the 'twenties. He struck the note of ridicule which the whole war-weary generation wanted to hear, using the weapon of Bayle, Voltaire and Gibbon on the creators of the Red Cross and the Public School System. It appeared to the post-war young people like the light at the end of a tunnel.

Strachey's book introduced a new style of 'flip' biography (which Philip Guedalla was to practise with more archness and less talent) in which the actual events of the subjects' lives became just a sampler-canvas for imaginative embroidery. The appeal of *Eminent Victorians* went beyond the bravura of Strachey's style. His sparkling raillery was directed against idolized Victorians such as Dr Arnold, Florence Nightingale and General Gordon, against the hypocrisy and prudery of Victoria's reign and the jingoism which had led to the war. So the appeal of the book was not only to Bright Young Things with a taste for history without tears. Even a man as politically committed as Bertrand Russell, who was in gaol as a conscientious objector when he read it, found it irresistible.

In poetry, Sitwellism was rampant. The poems of Edith and her brothers were full of contrivance and exotic imagery; and, being aristocratic as well as 'advanced', the Sitwells had a genius for publicizing their antics in that 1920s art-form, the gossip column. (Lord Beaverbrook's 'The Talk of London' column and *Time*'s 'People' column were already flourishing before Tom Driberg wrote the first 'William Hickey' column in 1933.) The Sitwells also staged what would later be called 'happenings', such as *Façade*, a kind of avant-garde pantomime of verse with musical accompaniment, which most satisfactorily outraged the middle classes. The music, by William Walton, perfectly matched the rhythmic inconsequence of the words. Lord Berners, another aristocrat turned artist, wrote music with a similar cadence – which came from spicing quite traditional musical forms, such as the waltz and minuet, with a little jazz syncopation, the unexpected bray of saxophone or yelp of piccolo. The same enlivening or 'jazzing-up' of traditional art-forms is seen in the novels of Aldous Huxley, Ronald Firbank and Evelyn Waugh, which are again in the frivolous,

OVERLEAF

Statuette by Hagenauer.
Austrian, 1930s

iconoclastic twenties mood. Rex Whistler drew brilliant pastiches of
the eighteenth-century rococo; John Austen, Beresford Egan and Allan
Odle of the 1890s Beardsley style. Whistler in his picture of the Prince
Regent at Brighton, and Henry Lamb in his attenuated, tubular por-
trait of Lytton Strachey, claimed for caricature the status of 'gallery'
art.

It was easy to misinterpret the jubilant 'decadence' and craving for
luxury which followed the regimentation and privations of war as
a mere revival of the *fin de siècle*. Wyndham Lewis, who hated the
Bright Young Thingery of the 1920s, wrote in *Blasting and Bombadier-
ing* (1937): 'The "post-war" in a sense was a recrudescence of "the
Nineties".' He quoted the poet Roy Campbell, who was determined
to be 'twentieth-century':

> 'I won't be a Nineties man!' he was vociferating. 'I won't be a Nineties
> man!' He was glaring at somebody – for this was a personal defiance: and
> I think it must have been Ronald Firbank – who was the very *genius loci*
> of the 'post-war', and the reincarnation of all the Nineties – Oscar Wilde,
> Pater, Beardsley, Dowson all rolled into one and served up with *sauce créole*.

Oscar Wilde was being mentioned again in polite society. (John
Betjeman's poem 'The Arrest of Oscar Wilde at the Cadogan Hotel'
was written in the late twenties.) 'Aesthetes' such as Harold Acton
and Brian Howard at Oxford – the type was immortalized in Anthony
Blanche of Evelyn Waugh's *Brideshead Revisited* – flauntingly
modelled themselves on Wilde. 'I must go into the fields and slap raw
meat with lilies,' sighed Acton, who used to entertain his Oxford con-
temporaries by reciting Eliot and the Sitwells through a megaphone
from his rooms overlooking Christ Church Meadows.

But reacting against all the frenetic frivolity and decadence which
Wyndham Lewis contemptuously called 'the post-war' was a rigorous,
taut, uncompromising style which had survived the war, indeed had
been annealed by it. It was a style which had nothing to do with
anachronisms, pastiches or worn-out traditions. Cubism, which had
spread beyond the immediate circle of Picasso and Braque, mainly
through the propaganda of the French critic Guillaume Apollinaire,
from 1911, was partly an attempt to reconcile art with a world that
was speeding up and being 'fragmented'. The same tendency could
be observed in literature, and here too the initial impulse could be
traced back to before 1914. T. S. Eliot's *The Waste Land*, 'the text
of despair for a generation', was published in 1922; but the sense it
conveys of weariness, impotence and failure is already apparent in 'The
Love Song of Alfred J. Prufrock', which he completed in 1911 (though
it was not published until 1917). Here, as in painting, was a drastic
pruning of lyricism, an end to Rupert Brookeism with its heroic cor-
ners of foreign lands and idyllic teatimes at Grantchester. In 'The Hol-
low Men' (1925) Eliot would write of a 'valley of dying stars', a world

Bookplate by Rex Whistler

'Les Libertines', drawing by
Beresford Egan from *The Sink
of Solitude* (Hermes Press,
London, 1928) – a parody of
Radclyffe Hall's lesbian novel
The Well of Loneliness

Gustave Miklos, gouache for a
champlevé enamel design,
signed, 1922. 19 × 24 cm.

Cover by John Banting for
First Poems (1930) by Brian
Howard (part-original of
Anthony Blanche in Evelyn
Waugh's *Brideshead Revisited*).
Printed at Nancy Cunard's
Hours Press in rue Guénégaud,
Paris

devoid of will – 'shape without form, shade without colour, paralyzed force, gesture without emotion'. That part of the world which had not already ended with a bang, threatened to end with a whimper.

Edmund Wilson later described what happened in post-war America as 'the liquidation of genteel culture'. The war had begun that process. 'The plunge of civilization into this abyss of blood and horror,' Henry James wrote in 1914, 'so gives away the whole long age during which we have supposed the world to be, with whatever abatement, gradually bettering, that to have to take it all now for what the treacherous years were really making for and *meaning* is too tragic for any words.' The war, he added, was 'an unspeakable giveaway of the whole fool's paradise of our past'.

In *The Ordeal of Mark Twain* (1920) Van Wyck Brooks wrote of life in America in the Gilded Age as 'a horde-life, a herd-life, an epoch without sun or stars, the twilight of a human spirit that had nothing upon which to feed but the living waters of Camden and the dried manna of Concord.' Twain, he suggested, had been corrupted and crushed by the distorted values of that society. In 1922 Harold Stearns edited his *Civilization in the United States*, a symposium of thirty writers who took the gloomiest view of the state of the country. After delivering the typescript, Stearns sailed for France – among the first of a trail of émigré intellectuals who left America, as Ezra Pound said, 'in disgust', and made their home in Paris.

Paris was the place to be. In its pure intellectual ether, the impurer books unpublished in England or America could appear – such as James Joyce's *Ulysses*, published by Sylvia Beach's Shakespeare & Co. in the rue de l'Odéon in 1922. (Lawrence's *Lady Chatterley's Lover* also had to make its debut abroad, but was privately printed in Florence in 1928.) Nancy Cunard's Hours Press, by which Brian Howard's poems were first published in book form, flourished in the rue Guénégaud. Gertrude Stein was administering a series of aesthetic shocks to literature. Her *The Making of Americans* was serialized in *the translantic review*, which was edited in Paris by the American Ford Madox Ford, author of *The Good Soldier*. Ezra Pound was in Paris, too, and took boxing lessons from Hemingway. Scott Fitzgerald came there with his wife Zelda, and Hemingway took him to look at the private parts on the statues in the Louvre, to reassure Fitzgerald about his virility. Paris was also a base for the American gentlemen publishers with their finely printed limited editions – men such as Harry Crosby, founder of the Black Sun Press (one of the many who committed suicide in New York in the Crash year, 1929); Robert McAlmon, whose wife was Annie Winifred Ellerman, better known as the writer 'Bryher', and William Bird, whose Three Mountains Press published Hemingway's *in our time* in 1924.

In Paris too were the great couturiers, including Paul Poiret, who helped spread the fashions inspired by the Ballets Russes. Here the

Cubists, led by the Spaniard Picasso and the Frenchman Braque, had formed what would ever afterwards be called the School of Paris. And Paris was the setting for the great 1925 exhibition which indirectly gave Art Deco its name – the *Exposition Internationale des Arts Décoratifs*.

Half a century later, Anthony Burgess summed up the importance of post-war Paris:

> Paris had presided over the Modern Movement, which expressed itself as a rejection of the doctrine of Liberal Man – man progressing, mastering his environment, finding salvation in science and the rational organization of society. European liberal optimism had foundered in the war. The human instincts were now to be more important than the reason: Natural or Animal or Unconscious Man replaced the H. G. Wells *Uebermensch* and the open conspiracy of the planning intellect. The men who came out of the war were weary, but only of worn shibboleths; they had energy enough to build new art based on rejection of the pre-war heritage. Everything had to be re-made – the language of literature, the sonorities of music, the phenomenography of the visual arts.

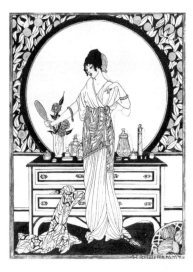

La Toilette by Robert Dammy, French 1913

Cubism had aimed to take art away from the lyrical muzziness of Impressionism and from the tame 'illusionism' of academic painting. Through Cubism, art now tried to come to terms with an increasingly 'fragmented' world – metaphorically fragmented by the speed of new means of transport and the flickering images of the cinematograph; all too literally fragmented by the shells of the Great War. The Cubists felt that a cataclysmically changed world demanded a cataclysmically changed art to express it. The Cubist Fernand Léger wrote in 1914:

> The thing that is imaged does not stay as still, the object does not exhibit itself as it formerly did. When one crosses a landscape in an automobile or an express train, the landscape loses in descriptive value, but gains in synthetic value. . . . A modern man registers a hundred times more sensory impressions than an eighteenth-century artist. . . . The condensation of the modern picture, its variety, the breaking up of forms, are the result of all this.

Léger practised what he preached: his own brand of Cubism made more explicit use of machine images – cogs, sprockets, pistons and flywheels – than that of any of his colleagues in the movement. Artists in parallel movements were also obsessed with speed and 'fragmentation' – Franz Marc and the *Blaue Reiter* (Blue Rider) group which also included Kandinsky and Klee; Severini and the other Italian Futurists (Severini painted *Autobus* in 1912 and *Treno Blindato*, Armoured Train, in 1915); and Wyndham Lewis with the English Vorticist group, who deplored what he called 'the static side of cubism . . . its *tours-de-force* of taste, and dead arrangements. . . .' But like crystals of copper sulphate dropped into the waterglass of a 'chemical garden', the hard-edge motifs of Cubism, when translated into the prevailing mood of the 1920s, produced strange new conformations – fronds,

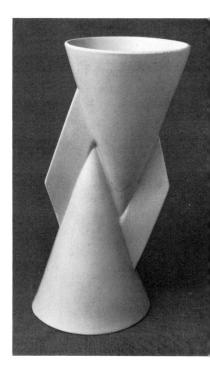

Cubism interpreted: English ceramic vase by Clarice Cliff, *c.* 1930

bubbles, fissures, jagged outcroppings. The style now known as Art Deco was in essence tamed Cubism. It was Cubism domesticated for public consumption. Even those whose idea of art was a framed blue-bell wood, and who found abstract art merely childish or perverse, were prepared to buy wallpaper linoleum with cubist motifs: that was consigning Cubism to its proper place, interior decoration.

If Cubism gave Art Deco its characteristic shapes, the Russian Ballet – a virtually contemporary phenomenon – gave it its colours. The prevailing colours of Art Nouveau had been pastel shades – Alphonse Mucha had used them even in posters, which are supposed to be eye-catching. The Russian Ballet introduced new, shocking colours – garish orange, emerald and jade green – the gemological hues which, with liberal gold and silver, enriched the sensuous and exotic poems and plays of James Elroy Flecker at that time.

Sir Osbert Lancaster has described the effect of the Ballet on decoration in the section of *Homes Sweet Homes* (1938) titled 'First Russian Ballet Period':

> So far-reaching were the changes that this remarkable theatrical venture brought about in the drawing-rooms of the great world that Napoleon's conquest of Egypt (which also littered the salons of London and Paris with boat-loads of exotic bric-à-brac) provides the only possible, though inadequate, parallel. Before one could say Nijinsky the pale pastel shades which had reigned supreme on the walls of Mayfair for almost two decades were replaced by a riot of barbaric hues – jade green, purple, every variety of crimson and scarlet, and, above all, orange.

Here again, Paris had been the centre of operations. In 1907, the rising young Russian impresario Diaghilev organized a series of concerts at the Paris Opéra. Glazunov, Rachmaninov and Rimsky-Korsakov came to conduct their own works and Chaliapin had a great success in operatic excerpts. This encouraged Diaghilev to take a complete Russian opera to Paris (Moussorgsky's *Boris Godunov*) with elaborate settings and costumes. And in 1909 Diaghilev took Russian ballet to Paris for the first time – *Le Pavillon d'Armide, Les Sylphides, Le Festin* and *Cléopatra*, all choreographed by Fokine, and the last designed by Léon Bakst. The Diaghilev Ballet gave its first performance at the Châtelet Theatre on 19 May 1909 (with a public final rehearsal the night before). Pavlova, Nijinsky, Fokine and Karsavina all had star parts. Eight of the dancers, including Karsavina, moved on to the London Coliseum, London, where they were billed as 'The Russian Dancers – recently the rage of Paris'.

In 1910 Diaghilev's company spent more than a month in Paris, preceded by a fortnight in Berlin. The programme included *Carnaval, Les Orientales, Schéhérazade, Giselle* and *The Firebird*, in which Lydia Lopokova was greatly admired. But it was in 1911 – a key year for Cubism too – that the Russian Ballet was established on a continuing basis. The London season was especially successful.

Vaslav Nijinsky as the Blue God in *Le Dieu Bleu*, 1912. Costume designed by Léon Bakst for the Russian Ballet

70

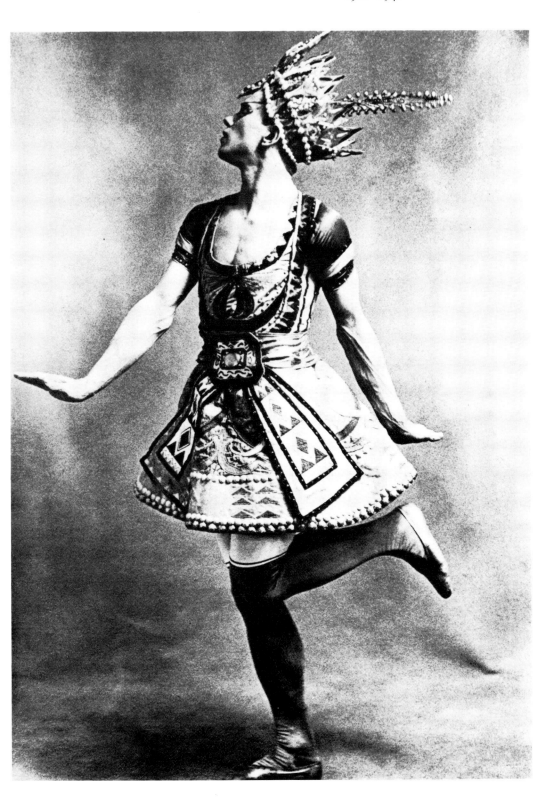

In 1916 the company performed for the first and last time in New York. And in the same year Picasso and Cocteau joined the Diaghilev circle and the cubist fantasy *Parade* was performed. Picasso, as a Spaniard, appropriately designed Massine's 'Spanish' ballet, *The Three Cornered Hat* (1918) and *Cuadro Flamenco* (1921). Most of the leading artists of the 1920s worked for Diaghilev. (De Chirico and Léger designed ballets for the rival company Les Ballets Suédois between 1920 and 1925.) But it was three Russian artists, two of them particularly associated with Diaghilev, who gave his ballets their greatest effect on popular taste: Alexandre Benois, Léon Bakst and Erté.

Alexandre Benois liked to tell people he was not really Russian at all, but Italian. His father was a skilled architect in the Gothic style; he designed the gigantic Imperial stables in Peterhof. As a child in St Petersburg Benois witnessed the 'barbarian' fairs in Easter Week and Carnival, or Butter Week, with their *Commedia dell'Arte* harlequinades, merry-go-rounds, windmills, gingerbread and sweetmeat stalls and steaming samovar. (He later drew on these scenes in his setting for *Petrouchka*.) His first visit to the ballet was to the Bolshoi Theatre to see *La Bayadère* with its simulated tropical park, bejewelled elephant and gilt idols. 'But what enchanted me more than anything – more than the warriors in their golden armour, more than the beautiful veiled maidens whose arms and ankles jangled with bracelets – was the group of blackamoors who approached dancing, twirling and tinkling their bells.'

In the 1890s he and his friends became infatuated with the music of Tchaikovsky. It 'was what I seemed to have been waiting for since my earliest childhood.' His friends included Bakst and the young Diaghilev, a country boy from Perm who then seemed very gauche to Benois's condescending eye, though Benois later admitted 'he was the only businessman amongst us'. The first ballet Benois designed was *Le Pavillon d'Armide*, which opened in St Petersburg in November 1907 to acclaim. Benois's style was a mixture of European eighteenth-century pomp, 'Hoffmannish' fairy tales, the Old Russia of (as he put it) 'palaces, cupboards, fairytales and *bylinas* [old hero ballads]', and the nineteenth-century Chopinesque romanticism he conveyed in *Les Sylphides* – 'the languid vision of spirits of dead maidens, dancing their dreamy dances among the moonlit ruins and mausoleums'.

Benois was not such an instinctual draughtsman as Léon Bakst, of whom Benois himself had the grace to remark that 'his ornamental resourcefulness is inexhaustible'. Bakst was born about 1866, probably in Grodno; some writers have ascribed to his Jewishness his taste for orientalism. He had a thorough training in life and cast drawing at the St Petersburg Academy of Arts before he was dismissed for painting a 'too Jewish' interpretation of 'the Madonna Weeping over Christ' for a competition. He met Benois in 1890. His first ballet designs were for *Le Coeur de la Marquise* (1902) and *La Fée de Poupées*

(1903). As with Benois, mixed influences are seen in his designs: again old Russian folk art; the paintings of Mikhail Vrubel with their peacock colours and thinly veiled eroticism; an archaic Greek influence from his journey to Greece in 1905; and a touch of Siamese mannerism from having seen (and painted) the Bangkok dancers who performed in St Petersburg in 1901. His was the name that was associated with the 'Russian Ballet style' in Europe, partly because of the phenomenal success of *Schéhérazade*, which he designed, and partly through exhibitions of his work, from 1912, at the Fine Art Society in London. Because of Bakst, James Laver wrote, 'every woman was determined to look like a slave in an oriental harem'. His outrageous colour combinations gave Cartier in London the courage to set sapphires with emeralds. The art historian R. H. Wilenski wrote: 'The dilettanti and all fashionable Paris were now completely fascinated by the Russian Ballet. Fortuny and Paul Poiret draped Greco-Russian-Ballet gowns and turbans on the ladies who appeared in the evenings with pink and purple wigs.'

The third artist, Erté, who is still, at the age of 90, practising his vivacious stylization which has hardly changed since the 1920s, never worked for Diaghilev. He once had the chance to, but the company

Erté with a group of friends, in the 1920s

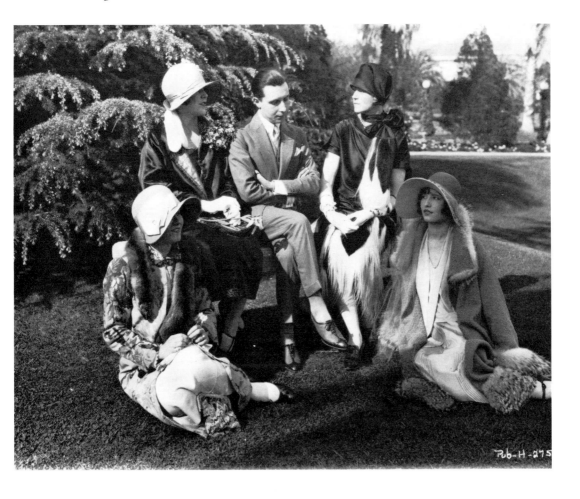

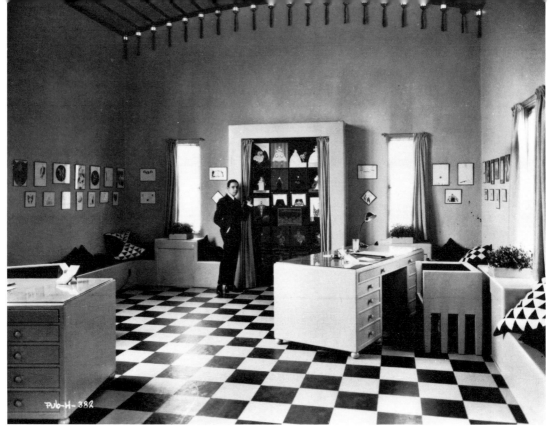

Erté in his apartment

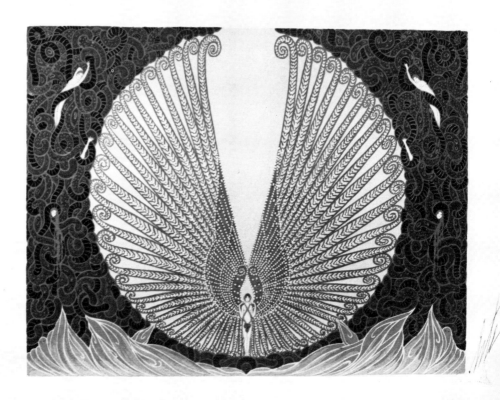

A characteristically sensuous design by Erté

was in debt as usual and a more tempting offer came from New York. 'It is one of my few regrets,' he concedes. Erté was born Romain de Tirtoff in 1892, the son of a Russian admiral. (His professional name is made up of his initials – RT.) His education in ballet and in theatre costumes was in St Petersburg; he witnessed all three of the Nijinsky stage scandals; he was designing dresses for Paul Poiret in 1913; and, as with Benois and Bakst, his work blended old Russian and new European traits. By the end of World War I, he was already famous internationally as a fashion and theatre designer, and he had begun to contribute covers to the American *Harper's*, again helping to spread the Russian Ballet style.

If the vernacular was an important ingredient of the last phase of Art Nouveau before World War I, exoticism was rampant in the Art Deco of the 1920s, in a way it had not been since the greenery-yallery Japonisme of the Aesthetic Movement in the 1880s. The Russian Ballet itself was full of exoticism: caliphs' palaces, jewelled blackamoors, melodramatic mandarins. It accounted for the plague of coloured cushions which descended on the 'studios' of Mayfair, London. Turbans became the rage in Paris in 1910, after *Schéhérazade*; though an aggrieved Paul Poiret pointed out that he had been selling the things since 1906 – they were, he said, based on Indian turbans he had seen in the Victoria and Albert Museum, London, when designing costumes for Gaby Delysia in Cochran's show *Afgar*.

Mock-Egyptian exoticism had been affecting European design for centuries, and large books have been devoted to tracing that influence, such as Richard C. Carrott's *The Egyptian Revival, its Sources, Monuments and Meaning 1808–1858* (1978) and James Stevens Curl's wider-ranging book *The Egyptian Revival* (1982) which discusses the absorption of Egyptian religion in the Graeco-Roman world, Egyptianisms in Western art during the Roman Empire; the Egyptian revival after Napoleon's campaign in Egypt; the interior designs of Thomas Hope; and the Egyptian revival in funerary architecture from the nineteenth century (among many other manifestations of the revival) as well as the twentieth-century fashion for Egyptian style. The new stimulus to Egyptian revivalism in the twentieth century was the discovery of Tutankhamun's tomb in 1922. In that year Grauman's Egyptian Theater preceded Grauman's Chinese (1927) in Los Angeles. Much more 1920s architecture was in the Egyptian style: the Hoover Building, the Carreras Building and Ideal House in London had touches of it; the Carlton Cinema, Upton Park, Essex (George Coles, 1929) was entirely in it. Theda Bara and Helen Gardner in the 1920s, and Claudette Colbert in 1934, were filmed as Cleopatra.

In 1925 Harvey Wiley Corbett (1873–1954, of Helmle & Corbett, architects) suggested that a full-scale replica of King Solomon's Temple and Citadel should be built at the 1926 Sesquicentennial Exhibition in Philadelphia. It was to be manned by people dressed as ancient Israel-

Egyptian ornament recommended by Maurice Thireau in his *Modern Typography*, Paris, 1926

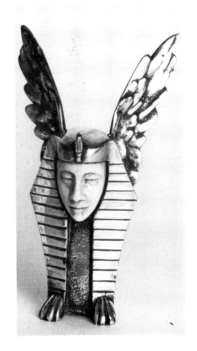

Egyptian figure by Sertorio, *c.* 1925

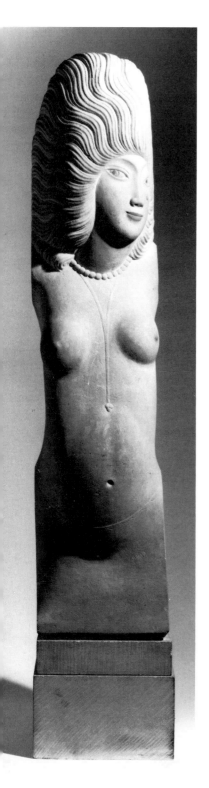

Eric Gill, *Headdress*, beer
stone. Height 42 in. Exhibited
at the Goupil Gallery, 1928

ites and at regular intervals the public would see it go up in simulated flames. This Cecil B. De Mille vision was never realized, but in 1939 Corbett came close to it in his design of New York's Criminal Courts Building, the Tombs.

Cheney Brothers of New York, a go-ahead textiles firm, actually sent a fashion designer to Egypt as a kind of industrial spy. In Paris, Pierre Legrain made Egyptian thrones in palmwood and parchment. The Spanish artist J. J. Garcia designed a book-binding stamped with a majestic ringletted sphinx. Albert Cheuret made a clock in the shape of a Cleopatra coiffure. Scarab pendants, Cleo earrings, 'mummy' propelling pencils and powder compacts decorated with hierophants and hieroglyphs, were among the cheaper products of the new Egyptian revival.

Equally powerful, especially in America, was the influence of Pre-Columbian and other American Indian art. It has been rightly pointed out that a stepped shape was a natural response to the New York zoning laws introduced in 1916, which required skyscrapers to taper as they rose; and it is reasonable to suggest that the stepped shapes of radio cabinets and other household objects may have been inspired by skyscrapers. But when architects were grappling with the problem which the zoning laws created for them, it is entirely likely that they found their answer in Aztec temples, perhaps also in Babylonian ziggurats. Esther Born's book of 1938, *The New Architecture in Mexico*, makes a direct pictorial comparison between the pyramid of Cuicuilco near Tlacopam, DF – 'probably the oldest structure on the North American continent' – and a Corbusier building. In an earlier book, *Building to the Skies* (1934), Alfred Bossom illustrated as 'the Original American Skyscraper' the temple of Tikal, Guatemala, 230ft high. On the page opposite he illustrated 'The Thirty-Five Storey Building of Today. The architect for this thirty-five storey building was the Author. Note how the decorations are based on primitive American motives similar to those which inspired the Guatemalians to use such forms nearly 2,000 years ago'.

In these cases, and in that of the 'Mayan Theatre', Los Angeles, by Morgan, Walls and Clements, one would have thought that the debt to Pre-Columbian art was utterly explicit; yet it was still possible for Cervin Robinson and Rosemarie Haag Bletter in their otherwise admirable book *Skyscraper Style* (1975) to comment perversely on the book in which I published all these facts: 'If architects in New York ever had in mind Pre-Columbian architecture, it came as an afterthought.'

In their own book, they give, *en passant*, several more examples of Pre-Columbian borrowings: the canted walls and ornament of Frank Lloyd Wright's Hollyhock House, Hollywood (1920), which they freely admit 'seems to have been inspired by Mayan architecture'; the zig-zags on the Furniture Exchange Building, New York (Buch-

man & Kahn, 1926), which they suggest may have been based on the work of Adofo Best-Maugard, a Mexican artist who brought out a book on design in 1923 ('Such designs would have had the appeal of being both primitive and modern'); and the 'Mayan forms' which, without demur, they allow Forest F. Lisle to number among the sources of the Art Deco style of the Chicago Century of Progress fair, 1933. (They also grudgingly concede that there may be direct reference to Pre-Columbian design in the ornament of Edward Sibbert's Kress Building, 1935, and, possibly, the decorative detailing of Starrett & Van Vleck's Bloomingdale store, 1930.)

The difficulty for the art historian is not to prove that there was an American-Indian influence; it is to explain why. Better travel may be one answer. With an improvement in air services, it was easier to get to Mexico and South America. Mexico, too, was an arena of revolutions and new social experiments: what happened there was news, whether it was *coups d'état*, executions, educational schemes, new architecture by Juan O'Gorman, Antonio Munez Garcia, José Villagran Garcia and Carlos Greenham, or wall-paintings by Diego Rivera, José Clemente Orozco and David Alfaro Siqueiros. Sun and the snuff of social avant-gardism in the air drew out to Mexico writers such as Aldous Huxley and D. H. Lawrence, who added to the propaganda in their novels and travel books. Brazil was brought to sensational notice by the disappearance of Colonel Fawcett in 1925 and the expedition of Peter Fleming (Ian's brother) to find him in 1933, which led to another travel book, *Brazilian Adventure*. But above all, perhaps, the importance of Mexico and South America for North American architects and designers in the 1920s and 1930s was this: that here, relatively near at hand, were cultures which offered a truly *American* alternative to the jazzy European novelties of the Paris 1925 Exposition. Alfred Bossom wrote, in his 1924 book *An Architectural Pilgrimage in Old Mexico*:

> Mexico! Not to visit Mexico is not to know the Western Hemisphere. Not to have viewed the monuments of its romantic past is not to sense the inner meaning of American tradition, nor to fully grasp the development of the American people. . . . To the people of the United States, Mexico is logically a far greater source of influence than has yet been realised. . . . The American architect and the American artist may find much there to kindle their imaginations and inspire their efforts, and the layman also can discover much indeed by making Mexico an inspirational and artistic Mecca.

The Central and South American influence is seen in the decorative arts as well as architecture: in silver by the great French craftsman, Jean Puiforcat, who visited Mexico, the silver-mines country, for inspiration; in cactus designs on a wallpaper or in Keith Henderson's illustrations to W. H. Hudson's *Green Mansions*; or the Amazon and bat figures on clocks by F. Preiss. Hollywood 'westerns' also popular-

ized the North American Indian as a design motif, both in the United States and in England, where there was a 1935 revival of Coleridge-Taylor's *Hiawatha* and an Englishman from Hastings was able to convince the nation, in a series of highly popular but fraudulent books, that he was an Indian called Grey Owl.

Negro art, especially Dogon sculpture, had influenced Cubism. The 'blackamoors' admired by Alexandre Benois were already part of Art Deco exoticism. Now – rather as the cinema was familiarizing people with the American Indian – the phonograph, Victrola and gramophone throbbed with the beat of black music: jazz, which some apply to the Art Deco style as a whole, calling it 'Jazz Modern'.

Theoretically, the new recognition for black art and black music should have helped to give blacks a new status. But in fact most of them had little more status than as a decorative accessory, a touch of exoticism such as Edith Sitwell gave to a poem by the phrase 'the allegro negro cocktail shaker', or the American poet Vachel Lindsay added to his poem 'The Daniel Jazz':

An attempt has been made to suggest African tribal art on the cover of this book of poems by Vachel Lindsay (1915) – but it has come out more like a German coat of arms

> *Daniel was the chief hired man of the land.*
> *He stirred up the jazz in the palace band.*
> *He whitewashed the cellar. He shovelled in the coal.*
> *And Daniel kept a-praying :– 'Lord save my soul.'*

It was a derogatory, demeaning portrait of the black man, comparable with the sullen 'White man make bad medicine' image of the Red Indian. The negro as exotic trimming is implicit in Lindsay's poem 'The Congo : a Study of the Negro Race':

> *Fat black bucks in a wine-barrel room,*
> *Barrel-house kings, with feet unstable,*
> *Sagged and reeled and pounded on the table,*
> *Pounded on the table,*
> *Beat an empty barrel with the handle of a broom,*
> *Hard as they were able,*
> *Boom, boom* BOOM. . . .
>
> THEN I SAW THE CONGO, CREEPING THROUGH THE BLACK,
> CUTTING THROUGH THE FOREST WITH A GOLDEN TRACK,
> *Then along that riverbank*
> *A thousand miles*
> *Tattooed cannibals danced in files;*
> *Then I heard the boom of the blood-lust song*
> *And a thigh-bone beating on a tin-pan gong.*
> *And* 'BLOOD' *screamed the whistles and the fifes of the warriors,*
> 'BLOOD' *screamed the skull-faced, lean witch-doctors,*
> *'Whirl ye the deadly voo-doo rattle. . .*
> *Boomlay, boomlay, boomlay,* BOOM.'

In the 1971 exhibition of Art Deco organized by David Ryan and myself at the Minneapolis Institute of Arts, there was a painting by the French artist 'Harry' of a black man dancing with a white girl.

The veteran art critic of the *New York Times*, John Canaday (who well remembers the Speakeasy twenties and thirties) wrote of this picture (18 July 1971):

> The dancers by 'Harry' . . . remind me that 'nigger' became a popular word taken out of the American cotton fields and put into the Paris and London night clubs, where a black gigolo could offer the ladies a bit of miscegenation as alternative excitement to the more routine distractions of lesbianism. The presence of blacks as exotic ornaments in an expensive white society was regarded as evidence of a liberated racial attitude, but since the acceptance of a black lay in his remaining vehemently and picturesquely a graduate of the cotton field and the minstrel show, he was actually being subjected to a twice-degrading form of upside-down Uncle Tomism.

This was the period when Lady Louis Mountbatten was alleged to have had an affair with the black society pianist and singer Hutch, and Nancy Cunard's black lover, Henry Crowder from Georgia, was satirized as Mrs Beste-Chetwynde's 'Chokey' in Evelyn Waugh's *Decline*

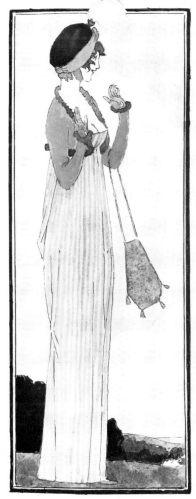
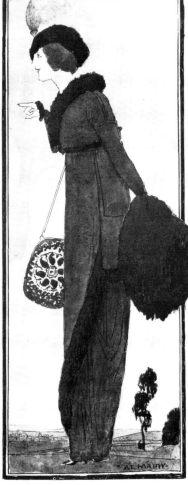

The English Regency revived: '1813–1913' by Marty, French, 1913

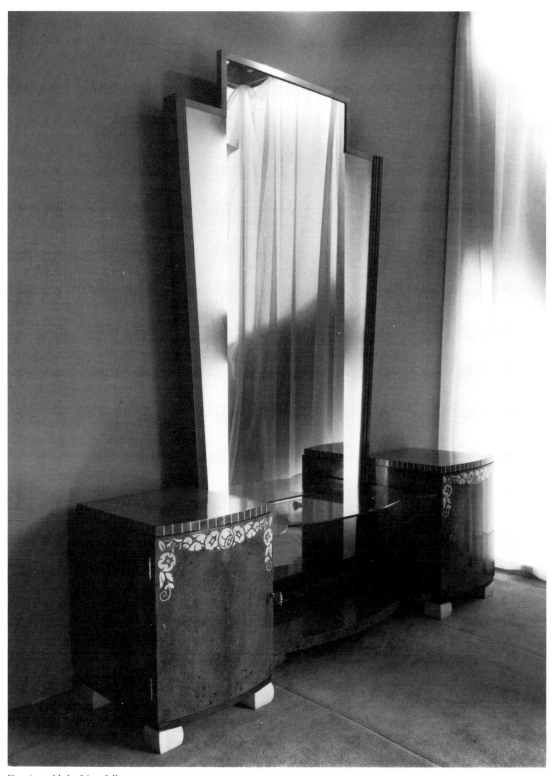

Dressing table by Léon, Jallot *c.* 1925

and Fall. Nancy Cunard published (in 1934) the important book *Negro: an Anthology*, with chapters on black literature, art, music and dance by several contributors. She also campaigned to raise money for the 1933 retrial of the Scottsboro Boys, unjustly convicted of raping two white women. These were the non-condescending beginnings of a movement which culminated in the Black Power campaign of the 1960s and 1970s.

Art Deco, then, was a promiscuously eclectic style, drawing on the art of many cultures and countries – and indeed periods (the English Regency, with its neo-classic lines and cult of dandyism, was an inspiration to Paul Poiret, Georges Barbier and other designers of the early Deco period). The 1925 *Exposition Internationale des Arts Décoratifs* in Paris drew the different strands together, and helped to bring about some kind of fusion. It was in intention an exhibition at which the different nations would show off their wares; but the French were playing at home, and while some people were impressed with individual pavilions of other countries, especially the Finnish one by Eliel Saarinen, it was the French triumph which remained in their minds.

French craftsmen remained supreme throughout the 1920s: in furniture, Emile-Jacques Ruhlmann, Suë et Mare, André Groult, Pierre Chareau, Maurice Dufrêne, Djo Bourgeois, Pierre Legrain and Jean Dunand with his brilliant lacquer effects; in silver, Jean Puiforcat, Orfèvrerie Christofle and Tétard Frères; in metalwork, Jean Dunand, Claudius Linossier and C. Fauré, whose enamelled vases are among the best examples of applied Cubism; in ceramics, René Buthaud, Emile Lenoble, Jean Mayodon and Andre Metthey; in glass, G. Argy-Rousseau, Antoine Daum, François-Emile Decorchemont, Maurice Marinot and of course René Lalique; in book-bindings, Rose Adler, Paul

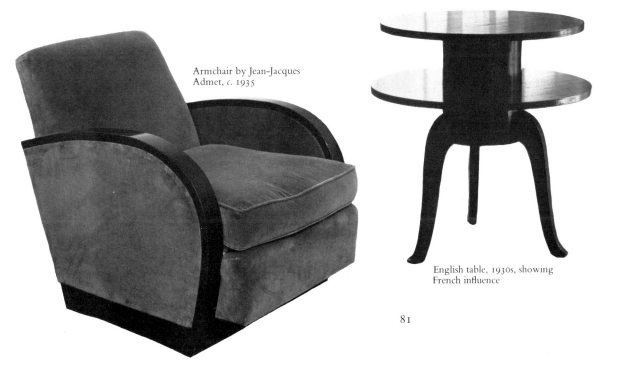

Armchair by Jean-Jacques Admet, *c.* 1935

English table, 1930s, showing French influence

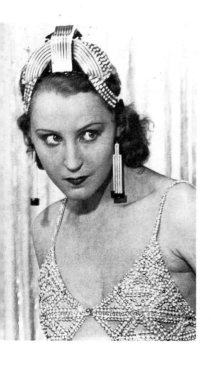

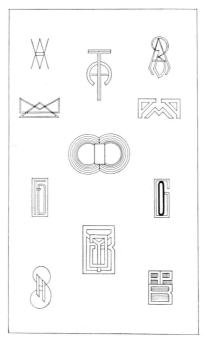

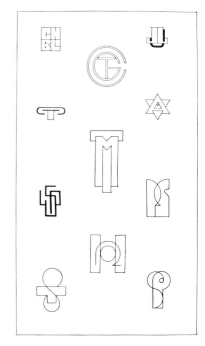

Brigitte Helm wearing a
parure by Raymond Templier
in the film *L'Argent*, 1928

French silversmiths' marks,
1914–25 and 1925–37, in the
form of intertwined initials

OPPOSITE

Jean Harlow, wearing a Deco
bracelet bearing her initials in
diamonds

Bonet and René Kieffer; in posters, Cassandre, Gesmar and Jean
Dupas; in textiles, Bénédictus; in jewelry, Sandoz, Boucheron, Car-
tier, Gerorges Fouquet and Raymond Templier; in illustration, a host
of brilliant executants, including Barbier, 'Benito', Georges de Feure
(who had grduated from Mucha-like Art Nouveau), 'Harry' and Jean-
Emile Laboureur.

There were artists in other countries who made their mark: Eileen
Gray with her marvellous lacquered screens in England; Clarice Cliff,
also in England, with her gaudy ceramics; the Swedish Orrefors com-
pany with its engraved glass; Kem Weber with his distinctive silver
in the United States; and the Americans Rockwell Kent and John Vas-
sos in book illustration. But, with the exception of Eileen Gray, who
was already designing important furniture in the early 1920s, most
of the non-French artists came to prominence and made their finest
contributions in the 1930s. By then, there had been time not only to
assimilate the Paris influence, but to break away from it.

Those who remember the twenties and thirties well are agreed that
there was a telling difference between the two decades. The Crash
of 1929 was not just a formal caesura between them, but a cause of
dramatic changes which were translated into the decorative arts as well
as into other aspects of life. Wyndham Lewis, who became a Fascist
(he wrote an early eulogy of Hitler in 1930) approved of the 1930s.
The 'real', he felt, was recovering its strength, and putting an end to
the 'weed-world' of the hated 'post-war'. In 1937 he wrote:

OPPOSITE
Une princesse, painting by
Raphael Delorme

Geometric candlesticks and
small plate in the 'Bizarre'
pattern, by Clarice Cliff, 1929

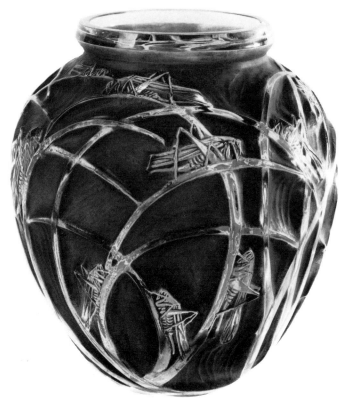

'Grasshopper' vase by Lalique

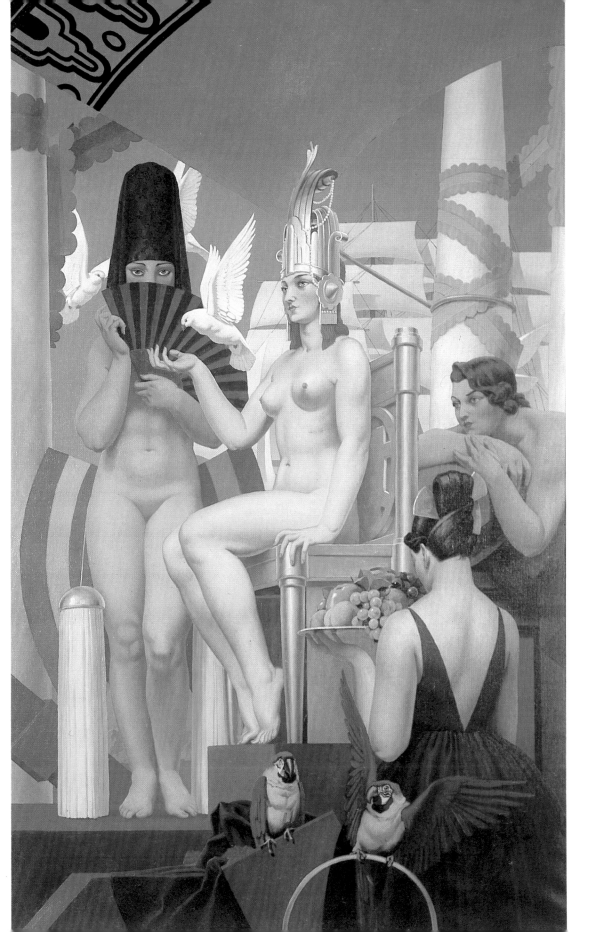

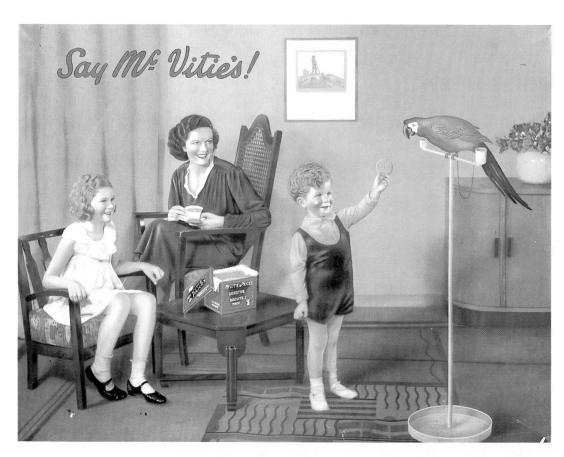

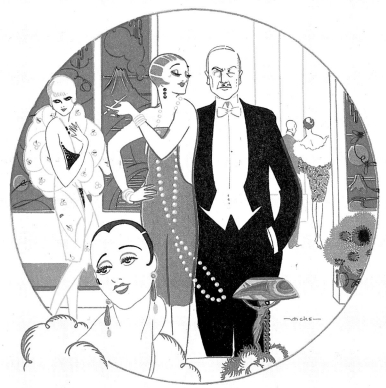

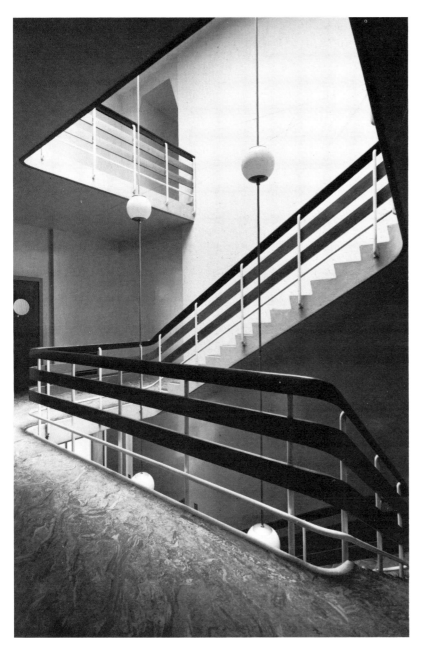

Changing lighting of the 1920s and 30s, photographed by Herbert Felton

OPPOSITE

Metal advertisement for McVitie's, *c.* 1935. Although Art Deco taste has reached this family in the rug, sideboard and permanent waves, they still use mock-Stuart furniture

From a brochure for the May Fair Hotel, London, 1927

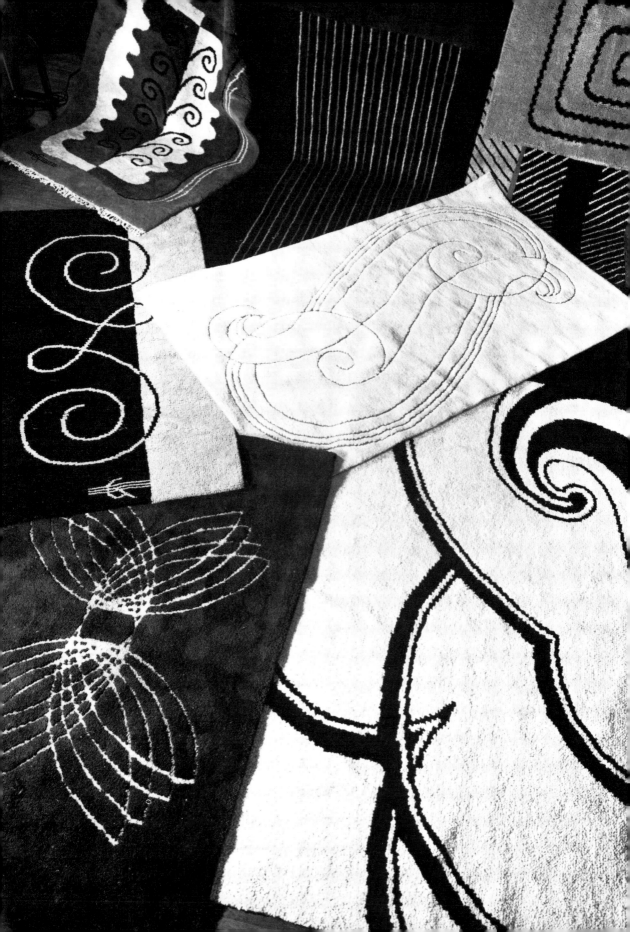

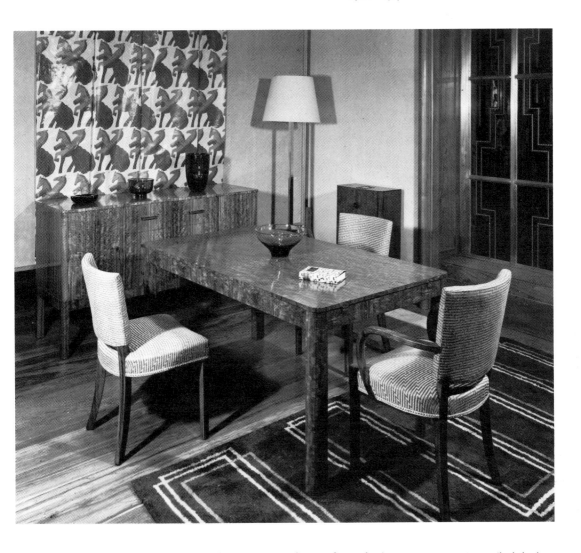

Decorative textiles helped to relieve the austerity of 1930s apartments

What would you say distinguished the Nineteen-Thirties from the 'post-war'? For it is a very different time indeed. . . . What we are seeing is this. The world was getting, frankly, extremely silly. It always will be silly. But it was getting into a really suffocating jam – no movement in any direction. A masquerade, a marking-time. Nothing real anywhere. It went on imitating itself with an almost religious absence of originality: and some of us foresaw an explosion. There must obviously arrive a point at which a breath of sense would break into it suddenly, and blow it all over. It's only a house of cards. Today we are in the process of being blown over flat.

And he observed: 'No one in 1937 can help being other than political. We are in politics up to our necks.'

From a quite different perspective, Sir Osbert Lancaster also observed 'some profound and to me depressing changes' in the Oxford which followed his time as an undergraduate:

Kosky fashions for 1929: the cloche hat was in vogue

Sun-ray motif on *New Era* catalogue, 1930s

OPPOSITE

Thomas C. Dugdale, *Arrival of the Jarrow Marchers*, 1936

Aesthetics were out and politics were in, and sensibility was replaced by social awareness. Figures such as Crossman, 'broad of Church and broad of mind, broad before and broad behind', who as undergraduates had been widely regarded as jokes, as young dons now loomed large with prophetic menace. In Blackwell's [the Oxford bookshop] the rainbow hues of the Duckworth collected Firbank were soon overwhelmed by the yellow flood of the Left Book Club, and the recorded strains of 'Happy Days are here again' floating across the summer quad were drowned by the melancholy cadences of 'Hyfrydwyl' chanted live by Welsh miners trekking southward down the High. Martinis and champagne had given way to sherry and beer; serious-minded, aggressive pipes had ousted the gold-tipped Balkan Sobranies of yesteryear; Sulka shirts and Charvet ties were now outmoded by thick dark flannel and hairy tweed. And along the corridors of the Union and in the more influential J.C.R.s [Junior Common Rooms] Party members proselytized with a discreet zeal that had formerly been the monopoly of Campion Hall, and everywhere the poets hymned the dictatorship of a proletariat of whom they only knew by hearsay.

Some committed 1920s spirits could not absorb the shock of the new intrusion of politics; hunger marches; the rise of Fascism; rumours of war. The impact of the 1930s on the 1920s was perfectly caught in an oil painting by Thomas C. Dugdale, now in the Geffrye Museum, London. It showed a couple in evening dress negligently craning from a window at a line of Jarrow marchers below: a 'Let them eat cake' scene.

The decorative arts became altogether more purposeful to match the new mood of society. The decorative motifs of the 1920s – the fountain, spilling its waters prodigally, unrecantably; the carefree deer, gazelles and antelopes (which perhaps owed something to the Diaghilev ballet by Poulenc, *Les Biches*, described by Harold Acton as 'the quintessence of the nineteen-twenties'); the fawns and fauns; the borzois and salukis which were as much a fashion accessory to the society woman as her Deco handbag or diamond clip – gave place to the more hard-edge, dynamic motifs of the 1930s, such as the zig-zag or electric flash (adopted by the Nazis among the sinister insignia of SS uniform but representative also of electric power and radio waves); stylized hair streaming in a neo-classical gale; and above all the sun-ray, which appeared on almost anything from gramophone needle boxes to suburban garden gates. This last motif no doubt had its origin in the sun-bathing, sun-worshipping craze which began in the early 1920s (Erté claims to have been one of the first enthusiastic sun-bathers, and in Hollywood a sun-tan lotion was marketed called 'Erté's Skin'); but the motif came to have a wider, more political symbolism. It was the symbol of New Dawns (whether fascist or communist), and also evokes worthy 1930s hikers, the gambolling nordic nudes at Hitler Youth camps, and the Nazi Strength through Joy (*Kraft durch Freude*) movement. Fashion and personal appearance also changed dramatically from the 1920s to the 1930s. The astute Patrick Balfour (later

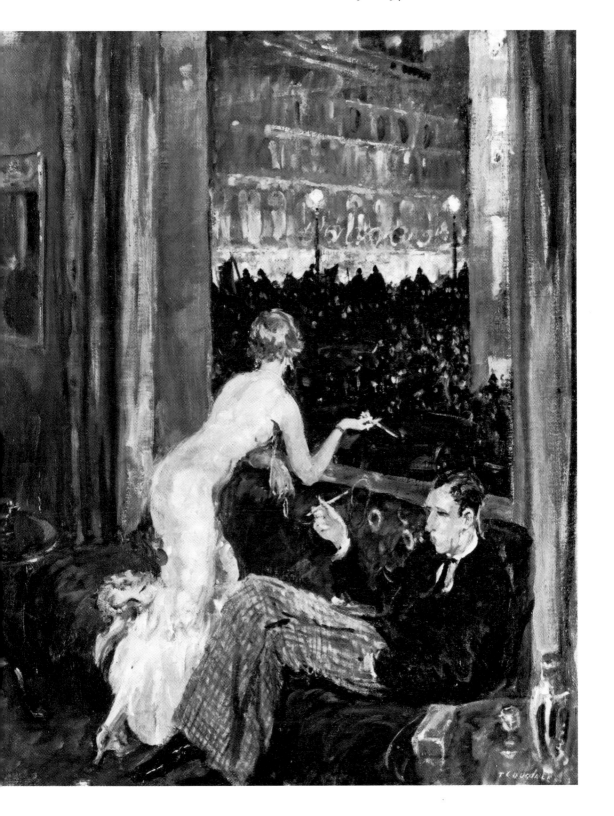

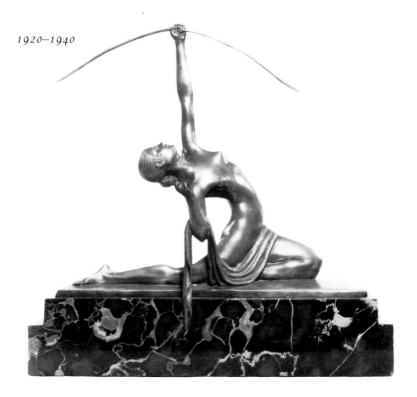

OPPOSITE

Arthur Gordon Smith,
The History of Radio, batik
mural (detail, showing Jessica
Dragonette singing in a Worth
gown). Commissioned by Mrs
Nadea Dragonette Loftus and
completed in 1934.
144 × 216 in.

Gilt bronze figure of a female
archer on marble base, by
M. A. Bouraine, 1920s

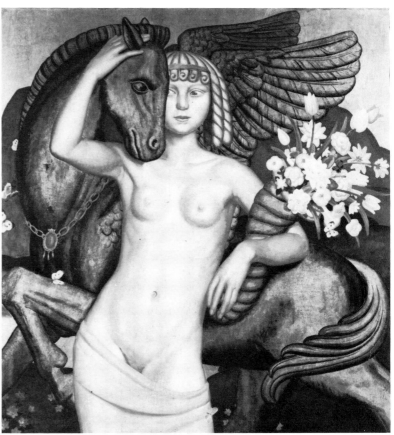

Plaster head. Hollywood
influence, ?English, 1930s

Ernest Procter, ARA, *Flora and
the Flying Horse*, oil on board
with gold and silver, 1927.
37¼ × 35½ in.

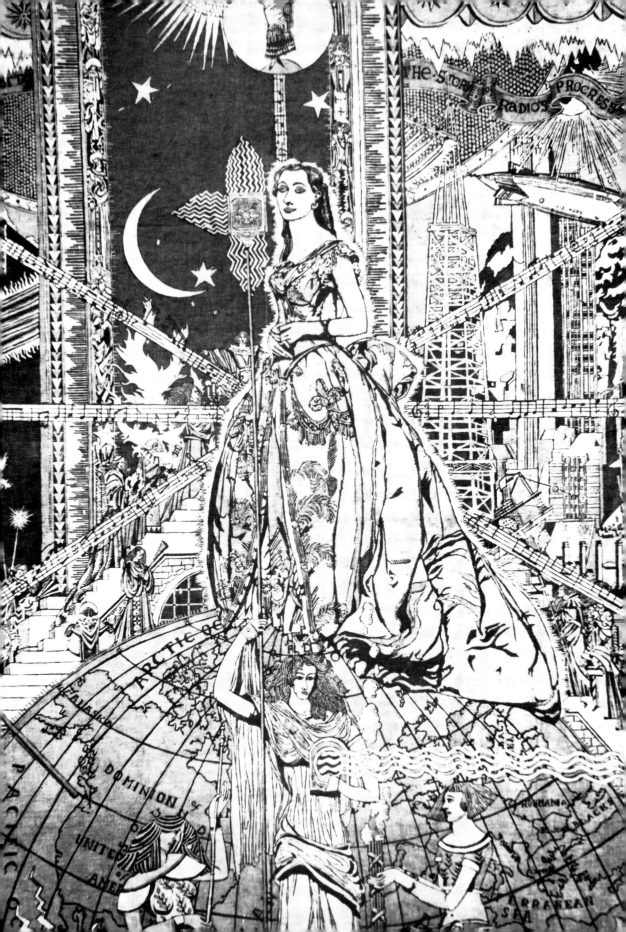

THE STORY OF RADIO'S PROGRESS

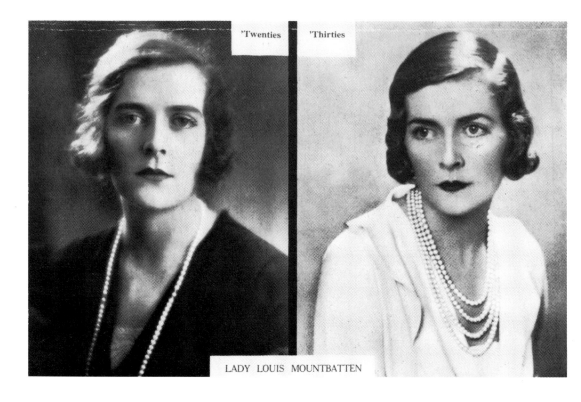

'Twenties 'Thirties

LADY LOUIS MOUNTBATTEN

In his book *Society Racket* (1933) Patrick Balfour (later Lord Kinross) contrasted the 'vague' look of the 1920s woman with the crisply defined 1930s look

Lord Kinross) observed in his book *Society Racket* as early as 1933 how Lady Louis Mountbatten, Lady Dalkeith and Lady Haddington had abandoned the 'misty', slightly *distrait* look of the twenties for the more focused and composed thirties look.

The change in women's appearance was achieved partly by more positive make-up: hard, cupid-bow lips, the lipstick often applied quite contrary to the real line of the lips; thin pencilled eyebrows in place of the plucked-out natural ones. But most of all it was achieved by hairstyle: by the new 'permanent wave' – a term which in itself expresses something of the new hard-and-fastness which was ousting twenties' nebulousness. When J. Bari-Woollss edited a new version of Gilbert A. Foan's *The Art and Craft of Hairdressing* in 1936, he noted of his predecessor (who had brought out the first edition in 1931):

> The present Editor often heard him bemoan the fact that at the time when he had settled down to compile what amounted to his masterpiece the art and craft of hairdressing itself was undergoing a revolutionary change. Almost as soon as the pages of the first edition went to press the trade as a whole was inundated with new inventions in machinery, in principle, and in technique. For example, the Wireless Permanent-waving Machine invaded Great Britain. Difficulties which had previously made the principle of wireless permanent waving a failure were suddenly overcome. The art of shampooing took on a new aspect with the discovery of soapless shampoos.

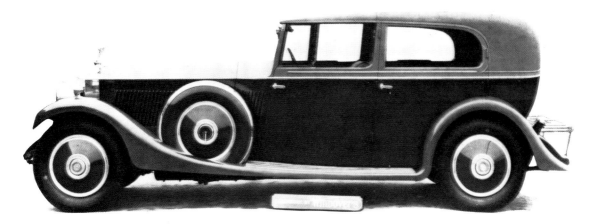

In *Society Racket*, Patrick Balfour also noted how the derivative fake-Georgian Mayfair drawing-room of the 'post-war' had been transformed into the clean-lined interior of 1933. (Osbert Lancaster made the same kind of observation, more satirically, in *Homes Sweet Homes*, 1938). To some extent, Europe might have moved naturally towards these cleaner lines, sharper angles, and muted colours. The need for economy in a time of recession would suggest such a direction. And a social conscience was developing, which could be seen in the architecture of Gropius and the Bauhaus and of firms such as Tekton in England, designed to offer airy, comfortable and well-designed apartments to ordinary people – something far more attractive and less patronizing than the almost penitential 'workers' dwellings' raised by Victorian and Edwardian philanthropists. The interior decorator Syrie Maugham, who was the daughter of just such a philanthropist, Dr Barnado, as well as the wife of Somerset Maugham, popularized 'off white' as the colour scheme for her rich clients, who might feel less guilty, less like 'bloated capitalists' or 'idle rich', in this unostentatious, oatmealy setting.

Patrick Balfour suggested that this car, designed by Lord Portarlington, 'may indicate a reversion to an aesthetic sense on the part of the Upper Classes'

Chair designed by Gerald Summers for Makers of Simple Furniture Ltd, 1934

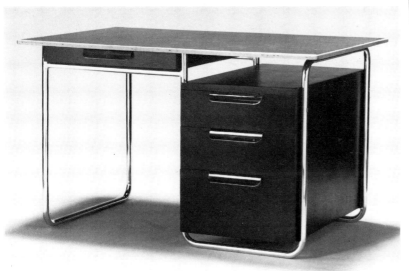

Desk designed by Wells Coates, P. E. L. Ltd, 1934

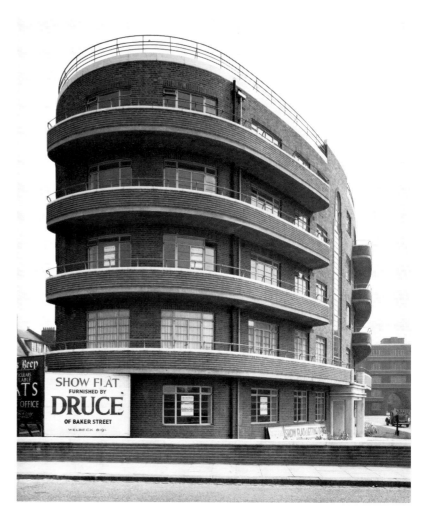

Typical curved appartment block of the 1930s.

But Europe was not the main source of the new clean lines and of what would be called 'streamlining'. The cultural centre was shifting to dynamic America, the powerhouse of the new machine age. World War I had cut off America from Europe. Even before the United States came into the war, the sinking of the *Lusitania*, a luxury British liner whose passengers included American citizens, in May 1915, had illustrated the dangers of wartime travel. So there was little cross-pollination, and by the 1920s American design lagged far behind that of Europe. Writing in *The Arts* magazine in April 1928, C. Adolph Glassgold recorded that both public schools and advanced art schools had been continuing, during the 1920s, to teach Art Nouveau. When invited to exhibit at the Paris Exposition of 1925, the United States, with becoming modesty, officially declined, on the ground that American craftsmen produced only 'reproductions, imitations and counterfeits of ancient styles'.

This might have resulted in American immunity to the dominant decorative style of the 1920s. But Cheney Brothers, an enterprising textile firm which in 1924 had introduced a line of 'Ferronière prints' based on Edgar Brandt's ironwork patterns (their Madison Avenue showrooms, 1925, were decorated with Brandt grilles), lobbied the Secretary of Commerce, who was then Herbert Hoover, to send American representatives with a 'watching brief'. Hoover appointed three commissioners who invited more than a hundred manufacturers and artists to attend as delegates. These prepared an official report; and American journalists sent to Paris wrote less official ones.

Not all the delegates were impressed by the new jazzy Paris style. 'The most serious and sustained exhibition of bad taste the world has ever seen,' commented one of them, Richardson Wright. But to the critic Helen Appleton Read the Paris pavilions were 'a cubist dream city or the projection of a possible city in Mars'. And W. H. Scheifley and A. E. du Gord, two faculty members of Indiana University, noted approvingly the death-throes of Art Nouveau: the French designers had abandoned 'the entwining algae, gigantic vermicelli and contorted medusas' of that style for 'the inorganic figures of geometry and geology – bodies bounded by plane surfaces'.

The Art Deco influence was soon apparent in those nurseries of budding styles, the New York department stores. Adam Gimbel, the director of Saks Fifth Avenue, who attended the Exposition, immediately introduced the 'new modernistic *décor*' in his store's show windows and interiors. Lord & Taylor and Franklin Simon were quick to follow his example. In 1927 Macy's staged an Art-in-Trade Exposition of Deco foreign and domestic furnishings. A sample of the 1925 furniture ensembles, ceramics, glassware, metalwork and textiles toured the Metropolitan Museum of Art and eight other museums early in 1926; and at the same time the Met established a permanent gallery for its modern decorative objects, most of them acquired at the Exposition.

Besides the Paris influence after 1925, a further injection of European ideas came from German, Austrian and Central European designers who emigrated to the United States, and from American designers who went to Europe for inspiration. Kem Weber from Berlin designed furniture and commercial interiors in Los Angeles. Paul Frankl, best known for his 'skyscraper' bookcases, came from Vienna; so did Joseph Urban, whose early work in the United States was designing theatre interiors. Winold Reiss, *ensemblier* of large public interiors, was from Karlsruhe, Germany. William Lescaze, who in partnership with George Howe designed the 'wraparound' style Philadelphia Saving Fund Society Building in 1932, came from Switzerland. Peter Müller-Munk, who arrived from Berlin in 1926, worked as a silversmith at Tiffany's before moving on to mass-production work for department stores. Raymond Loewy was born a Frenchman, and prepared for engineering school in Paris before coming to New

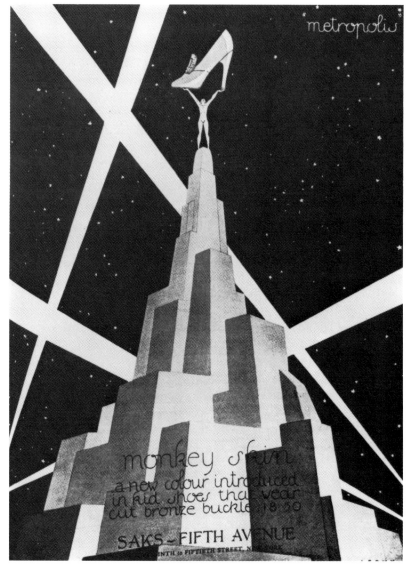

Raymond Loewy,
advertisement for Saks Fifth
Avenue in *Vogue*, 1927

The advance of automation:
the 'Plus' adding machine by
Bell Punch Company, London,
c. 1930

York in 1919, where he worked as a fashion illustrator for *Vogue* and
Harper's until a commission to modernize a Gestetner duplicator, in
1929, converted him, overnight, into an industrial designer. Laszlo
Moholy-Nagy, a Hungarian who had taught in the Bauhaus for five
years, came to the United States in 1937. Norman Bel Geddes, the
apostle of streamlining, met the German expressionist architect Eric
Mendelsohn as early as 1924, when Mendelsohn gave him a drawing
of his Einstein Tower and a copy of his *Structures and Sketches*. Geddes
introduced a catalogue of Mendelsohn's work at the Art Center's Con-
tempora Exposition of Art and Industry in 1929. In a radio talk during
the Exposition, Frank Lloyd Wright called Mendelsohn's work a
'powerful realisation of the picturesqueness of our special machine bru-
talities'.

American designers who visited Europe also imported new ideas. After Gilbert Rohde went to Europe in 1926 to study modern interiors, he began making tubular tables and became head designer for the Herman Miller furniture company. Walter Dorwin Teague, who revolutionized Kodak camera design, had also travelled to Europe in 1926 – 'to burn my mental bridges behind me'. After inspecting the work of Le Corbusier, Gropius, Mallet-Stevens and the 'modernistic' decorators of Paris, he came home 'a whole-hearted disciple of "modern" design'. Henry Dreyfuss, designer of the standard Bell telephone receiver, had visited Europe during a spell of unemployment in 1927.

So America was not quarantined from European example; but among these designers, including the immigrants, were some who thought that America, this great, newly rich nation, should be making her own contribution to design. She had, after all, already contributed the skyscraper. After the Paris Exposition, Frankl angrily declared that if America could have exhibited a skyscraper, 'it would have been a more vital contribution in the field of modern art than all the things done in Europe added together'. Frankl's own skyscraper bookcases, with their irregularly shaped shelves, were a naïve tribute to the American architects; and the skyscraper motif recurs in Hugh Ferris's futuristic book *The Metropolis of Tomorrow* (1929); a Raymond Loewy advertisement for Saks Fifth Avenue in *Vogue* (1927); a Loewy radio cabinet in wood for Westinghouse (1930); Harold Van Doren's public scale for the Toledo Scale Company (1932) and the plastic radio cabinet he designed with John Gordon Rideout for Air-King Products Company (1933).

The inter-war period was the great age of the American skyscraper. The architects broke away from neo-classicism and from the Gothic tendencies which had been so evident in the Woolworth skyscraper of 1913. The art historian Fiske Kimball wrote of the Barclay-Vesey Building (Ralph Walker, 1923–6), one of many built by telephone companies throughout America in the twenties, that 'Trivial reminiscences of the Gothic have fallen away'; and a photograph of it was used as frontispiece to the English-language editions of Le Corbusier's *Towards a New Architecture* (first published in 1923). Many skyscraper architects were strongly influenced by the design which the Finn Eliel Saarinen had submitted for a competition held in 1922 for a new Chicago Tribune Building. Certainly this was the take-off point for the magnificent Chanin Building, New York (Sloan & Robertson, 1927–9), which Cervin Robinson has called 'the first real skyscraper to be started in the twenties', though the bronze grilles at the entrances and in the lobby by René Chambellan (1893–1955) added a dynamic Deco element. In Gotham – the natural habitat of King Kong – were the Chrysler Building (William Van Alen, 1928–30), like a silvery rocket ready for lift-off; the RCA Victor Tower (Cross & Cross, 1930–1) and the sumptuous Waldorf-Astoria Hotel (Schultze &

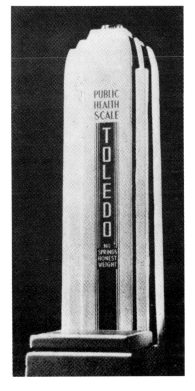

Harold Van Doren, public scale for the Toledo Scale Company, 1932

chanin
building

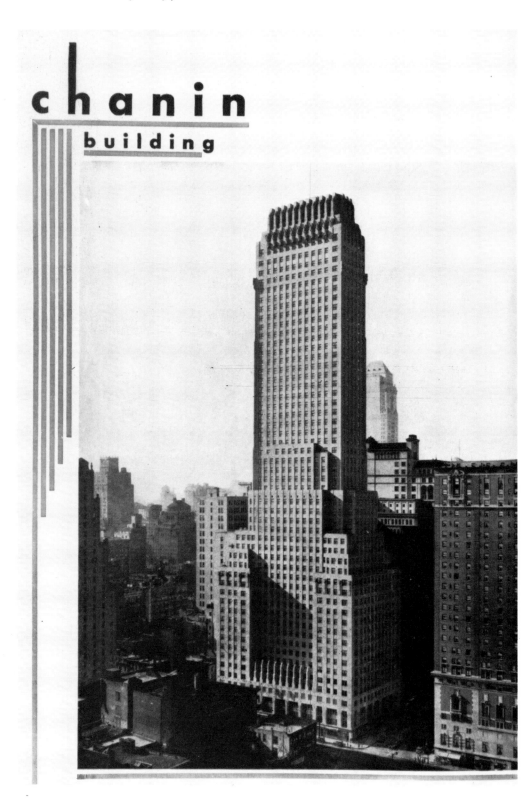

Weaver, 1930–1). Skyscrapers became municipal status symbols, and most American cities had at least one. Los Angeles had, among others, the black and gold Richfield Building (Morgan, Walls and Clements, 1928–9 – tragically demolished in 1968); the Bullock's Wilshire store (John and Donald Parkinson, 1928); and the Los Angeles City Hall (John C. Austin, John Parkinson and Albert C. Martin, 1926–8). Minneapolis had the Foshay Tower, built by a tycoon who was later jailed for frauds on the posts. Cincinnati had the Bell Long Lines Building (Harry Hake, 1929); the Carew Tower and the Netherland Hotel (1930–1) and the Times-Star Building (Samuel Hannaford and Sons, 1931).

In the later thirties, architects tended to emphasize the horizontal in skyscrapers rather than the natural verticals. This was in deference

Chrysler Building, New York, 1928–30. Architect, William Van Alen

ODEON Cavalcade

The New **ODEON** Masterpiece

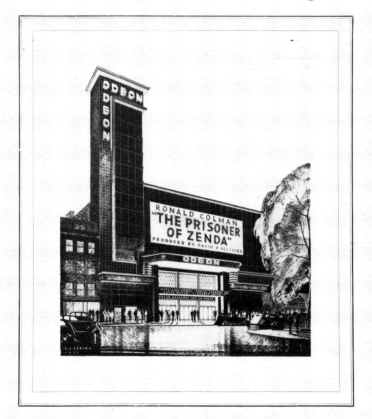

RONALD COLMAN
"THE PRISONER OF ZENDA"
PRODUCED BY DAVID O.SELZNICK

ODEON

Exterior of **ODEON** Theatre, Leicester Square, London

Joint Architects: Harry W. Weedon, F.R.I.B.A.
The late Andrew Mather, F.R.I.B.A.

OPPOSITE

A page from the original brochure for the Chanin Building, New York (1929). The architects were Sloan & Robertson; building was by the Chanin Construction Company, Inc.

OPPOSITE

Tennis girl by Frederick Preiss

An Icall plastic hairdressing by Messrs I. Calvete: frontispiece to *The Art and Craft of Hairdressing* edited by Gilbert A. Foan and J. Bari-Woollss (New Era Publishing Co., London, 1937)

Plaster wall heads of the 1930s

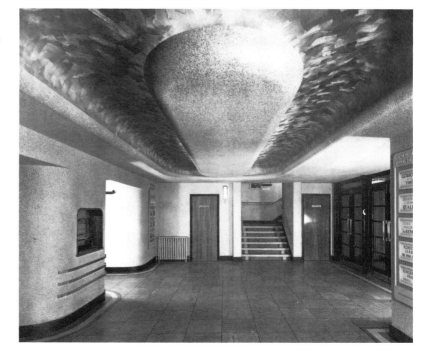

The County Cinema, Fleet, Hampshire, England

Oliver Bernard's prismatic entrance to the Strand Palace Hotel, London, 1929; (dismantled 1969: now in storage in the Victoria & Albert Museum)

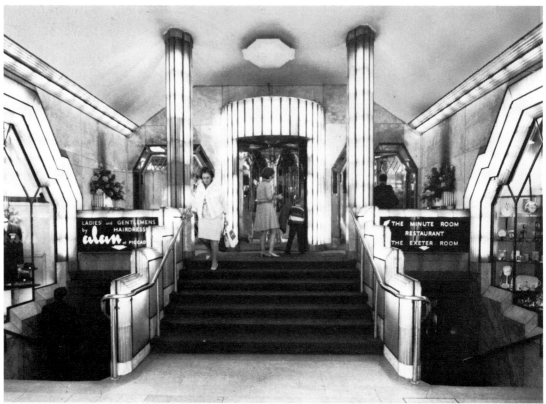

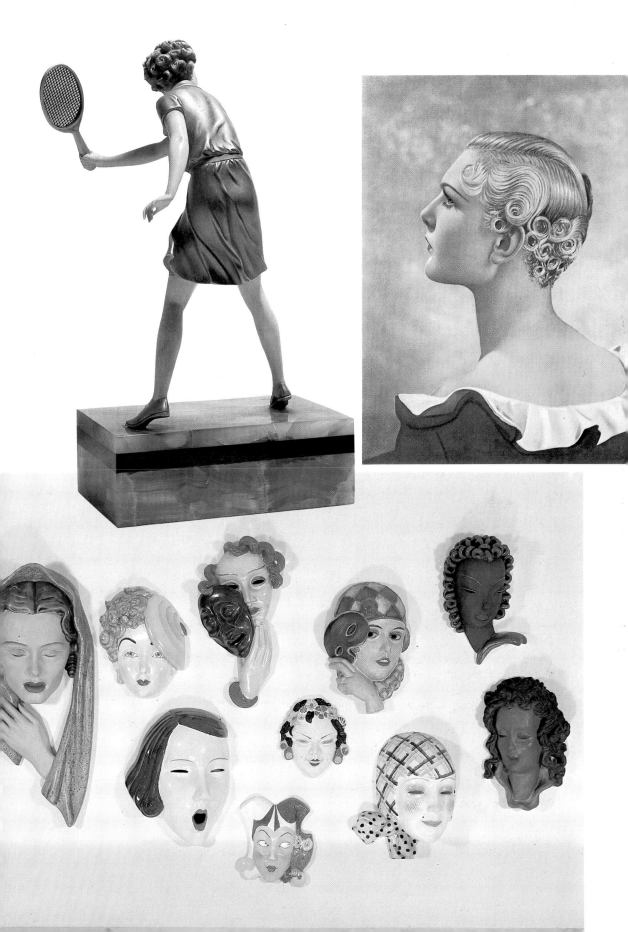

WEAGER

8584

SERVICE FOR EVERYBODY

to the concept of 'streamlining', which was America's other major contribution to inter-war design. During the Depression, as Jeffrey Meikle has pointed out, artists might take refuge in the past ('Historical novels filled the best-seller lists. Muralists decorated public buildings with frontier scenes.') But when ordinary people fantasized an alternative to their current misery, they looked to a future of material comfort and convenience.

Automobile ownership was rising. In 1910 there was one car for every 184 persons in the USA; by 1930, one for every five. One spin-off from the motor industry, inexpensive sheet metal from the continuous rolling mill, transformed the home appliance industry. And cars and other transport machines became models for things which did not move. The 1935 Super-Six Coldspot refrigerator, designed by Raymond Loewy, was described in an advertisement as 'Stunning in its Streamlined Beauty!', and in the 1938 model Loewy's office achieved 'an automotive effect' by treating the front as a V-shaped radiator with a peak running down the centre. Loewy also designed a streamlined pencil sharpener (1934). Robert Heller designed a streamlined 'Airstream' fan for A. C. Gilbert Co. (1938). Henry Dreyfuss's design of the Hoover 150, an upright vacuum cleaner (1936), was based on the 'Streamliner' trains first seen on the Union Pacific railroads during the second year of the Chicago Century of Progress Exhibition of 1933–4.

The leading propagandist for streamlining was Norman Bel Geddes, who has been described as 'the P. T. Barnum of industrial design'. His book *Horizons* (1932) began the national preoccupation with streamlined forms. Soon whole businesses could be devoted to the work of refashioning objects of everyday use in the new streamlined image, such as that of Lurelle Guild, who transformed an ugly tangle of metalwork into a gleaming machine-age sculpture in a redesign of the May Oil Burner Corporation pump and controls (1934). *Fortune* magazine in February 1934 showed Lurelle Guild's 'waiting room', full of untidy appliances awaiting treatment. As the 1930s progressed, few appliances were immune from streamlining. A streamlined meat-slicer, the Hobart Streamliner, was designed by Egmont Arens (*c*.1935). There was even a streamlined manure spreader (Oliver Plow Company, 1939) which, as Jeffrey Meikle drily observes, was 'presumably the ultimate in efficient elimination of waste'.

The design purists had plenty of fun at the expense of streamlining. John McAndrew, head of the department of architecture and industrial design at the Metropolitan Museum of Art, New York, scoffed that 'streamlined paper cups, if dropped, would fall with less wind-resistance', but were 'no better than the old ones for the purpose for which they were intended, namely, drinking.' But that was not the point. Streamlining was a form of symbolic packaging, a visual metaphor of aspiration and progress. It suggested a people who were not content

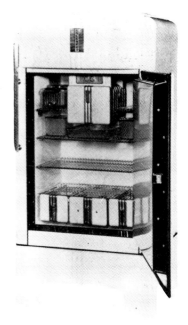

Raymond Loewy, Sears Coldspot refrigerator, 1935, with 'automotive styling' similar to that on a car bonnet

OPPOSITE

'Service for Everybody' colour print, United States, signed Weager and dated 1933

Coach made by
Burtenshaw's of Reigate,
Surrey,
England, 1930s

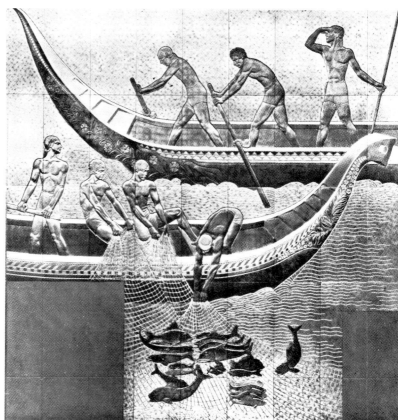

Gold lacquer panel
designed by Jean Dunand for
the main foyer
of the French liner
Normandie

to remain static in the doldrums, but were determined to ride forward, as fast as possible, into a shining future. Perhaps society, too, could be engineered into something smooth and frictionless.

Even in transport, streamlining did not always work. Much was made of the Streamliner trains; but trains were too long for streamlined locomotives ('great bulbous-headed caterpillars,' as one hostile magazine described them) to reduce wind resistance. The Greyhound bus designed by Loewy (*c.*1939) had rounded corners, but its 'streamlining' was almost wholly decorative – like that of the charabancs made not long before by Burtenshaw's of Reigate, Surrey, England. However, the trains, coaches and automobiles such as the Chrysler Airflow of 1934, literally mobilized the idea of streamlining, carried the streamlined gospel across the United States. Not only was it seen as an appropriate machine style for a machine age, an age of science, industry and business; it was also seen as a distinctively American style. In 1934, when the Rockefeller-funded National Alliance of Art and Industry moved its annual show of industrial design into the RCA Building,

Miss Grace Fell (daughter of H. Granville Fell, Editor of *The Connoisseur*) in fashion of 1937

the preliminary publicity announced its purpose: 'TO CELEBRATE THE EMERGENCE OF AN AMERICAN STYLE'.

The American blueprint for the future was put on display to the world at the New York World's Fair in the spring of 1939, which was so captivating in its mechanistic grandeur that one could almost forget the irony of projecting the world of the future when the world – it was now clear – was about to be engulfed by war. Bel Geddes was allowed to play God in the design of his Futurama, the mock-up of a city of 1960, in which streamlined automobiles moved along multi-level highways between towering skyscrapers. The exhibition itself was streamlined; the arrangement of buildings and escalators impelled people to follow the line of least resistance, like water, or like rats in a maze. The regimentation smacked unpleasantly of totalitarian government. In retrospect, there might even seem to be a sinister premonition of Auschwitz and Belsen in Du Pont's demonstration of insecticides: houseflies were introduced 'into a glass-walled death chamber' and exterminated with an atomized spray. And the last days of streamlining were also presaged and symbolized by one of the exhibits – the world's largest steam locomotive, Loewy's bullet-nosed Pennsylvania S-1, 'driving furiously nowhere on a treadmill'.

1940-1960

World War II | Austerity | 'Contemporary'

esus wept; Voltaire smiled. In that pithy antithesis Victor Hugo summarized the difference between the two main philosophies which dominated the western world from the eighteenth century onwards. Behind Christianity was the agony of Christ: the idea of the redemption of the world through suffering. Behind the Age of Reason which challenged Christianity and led to both the French and American Revolutions, was the satire of Voltaire, the sardonically smiling *philosophe*, his face set in the rictus portrayed in the busts of Houdon. The redemption of the world, as it were, through laughter. Voltaire's smile was as immovable as that of Gwylpaine, hero of Hugo's own *L'Homme Qui Rit*, whose grin was irreversibly carved into his features by the Compranchio Indians. Christians such as William Blake tried to write off the Voltairean satire as empty mockery; but humour, which landed Defoe in the pillory and prevented Sydney Smith becoming a bishop, is not necessarily frivolous. It may be a savage reaction to the *comédie humaine*, a mask for grief. Hugo's Gwylpaine says: 'The more unhappy I am, the more radiant my smile becomes.'

Gwylpaine's words could serve as a parable for the English popular arts in World War II. The tougher the going, the more defiantly chirpy the jokes. The joking began at the top. Nobody was more capable than Winston Churchill of conveying, in inspirational language, the grandeur and epic quality of the struggle in which Britain was engaged; but he, too, knew the virtues of comic relief: 'Corporal Hitler and his Nasties' . . . 'Some chicken; some neck' . . . 'The fishes are waiting'. He comforted the nation with jokes, and he was consoled by them himself: in the blackest hours of the war, he could usually be cheered up by a gramophone record of 'Run Rabbit, Run', a jaunty musical fable with an evident message for Hitler ('Here comes the farmer with his gun, gun, gun').

British postcard,
World War II

Once again the British showed perhaps the most engaging aspect of their collective character: genuine enjoyment at being satirized. Noël Coward could perpetrate the mawkish patriotism of 'London Pride', written in the spring of 1941. But he also sent up the British Home Guard (which thirty years later would be satirized all over again in the British television series 'Dad's Army') in a song which to some seemed almost defeatist:

> *Could you please oblige us with a Bren gun? –*
> *Or failing that a hand-grenade would do.*
> *We've got some ammunition*
> *In a rather damp condition,*
> *And Major Huss has an arquebus*
> *That was used at Waterloo.*
> *With the Vicar's stirrup pump, a pitch-fork and a spade,*
> *It's rather hard to guard an aerodrome, –*
> *So if you can't oblige us with a Bren gun,*
> *The Home Guard might as well go home.*

If you look on junk stalls today for relics of World War II, you will find ten humorous ones to every one which is upliftingly patriotic: Hitler peering from an ashtray in the form of a miniature chamber-pot

The Champion comic, 25 July 1942

Poster for the Ealing Studios film *The Goose Steps Out* (1942), starring Will Hay

OPPOSITE

Anna Neagle in 1942.
Inscribed: 'To Hilda, to
remind you of our work
together on the Amy Johnson
film'

COAT ML 2812

English women's dress of the
early 1940s, from a cloth
samples book

('Flip your ashes on Old Nasty – the Violation of Po-land'); Hitler being spanked by a Tommy on the cover of the songsheet 'Adolf' (words and music by Annette Mills, recorded by Arthur Askey); lapel badges of grinning tin-hatted soldiers; boys' comics about pranks in the RAF; a poster of Will Hay riding a jackbooted goose with a swastika band round its neck in the Ealing Studios film 'The Goose Steps Out' (1942); or a souvenir cartoon issued at the liberation of Antwerp in 1944, showing small boys making off with the business parts of a tank. On the wireless, Tommy Hanley of the radio comedy show *ITMA* (It's That Man Again) made light of the menace of German espionage, in the person of Herr Fünf; and the effect of black propaganda broadcasts from Germany by William Joyce was largely negated by guying him as 'Lord Haw-Haw', as in the song 'I'm Haw-Haw the Humbug of Hamburg'. The deadly flying bombs were known as 'doodlebugs', and a comical 'Squanderbug' paraded about the streets to exhort citizens not to be wasteful.

'Jesus wept; Voltaire smiled.' Late converts are supposed to be the most fervent. Perhaps this was the reason that Americans emphasized the seriousness of war rather than disguise it with defiant humour. Or perhaps the aspect of the American character which derived from Fundamentalist religion was more potent than the aspect which came from the Age of Reason via Jefferson and Benjamin Franklin or from the French Revolution via Lafayette. There was emotional jingoism in illuminated 'God Bless America' boxes bearing the Stars and Stripes

Illuminated 'God Bless
America' box, World War II

THE KID IN UPPER 4

It is 3:42 a.m. on a troop train.

Men wrapped in blankets are breathing heavily.

Two in every lower berth. One in every upper.

This is no ordinary trip. It may be their last in the U.S.A. till the end of the war. Tomorrow they will be on the high seas.

One is wide awake . . . listening . . . staring into the blackness.

It is the kid in Upper 4.

☆ ☆ ☆

Tonight, he knows, he is leaving behind a lot of little things—and big ones.

The taste of hamburgers and pop . . . the feel of driving a roadster over a six-lane highway . . . a dog named Shucks, or Spot, or Barnacle Bill.

The pretty girl who writes so often . . . that gray-haired man, so proud and awkward at the station . . . the mother who knit the socks he'll wear soon.

Tonight he's thinking them over.

There's a lump in his throat. And maybe —a tear fills his eye. *It doesn't matter, Kid.* Nobody will see . . . it's too dark.

☆ ☆ ☆

A couple of thousand miles away, where he's going, they don't know him very well.

But people all over the world are waiting, praying for him to come.

And he will come, this kid in Upper 4. With new hope, peace and freedom for a tired, bleeding world.

☆ ☆ ☆

Next time you are on the train, *remember the kid in Upper 4.*

If you have to stand enroute—it is so he may have a seat.

If there is no berth for you—it is so that he may sleep.

If you have to wait for a seat in the diner —it is so he . . . and thousands like him . . . may have a meal they won't forget in the days to come.

For to treat him as our most honored guest is the least we can do to pay a mighty debt of gratitude.

FOR VICTORY
BUY UNITED STATES WAR BONDS AND STAMPS

THE NEW HAVEN R.R.

★ SERVING THE GREAT INDUSTRIAL STATES OF MASSACHUSETTS, RHODE ISLAND AND CONNECTICUT ★

motif, and in posters (hardly to be distinguished from those of World War I) to induce people to buy US savings bonds and stamps. There was grim realism in the Manuals for Civilian Defense: the City of Wilber was in all seriousness given instructions on 'Fighting the Incendiary Bomb'. ('The Magnesium or Elektron bomb is the type most likely to be used by Axis forces for bombing American cities.') And there was shameless sentimentality in 'The Kid in Upper 4', an advertisement for the New Haven Railroad (1942), written by Nelson C. Metcalf, jr. and designed by Ed Georgi. Advertising's role had suddenly changed from hard sell to apologia: it had to explain shortages, and why services were not working as usual. 'The Kid in Upper 4' won the top award for outstanding copy in 1942 and is considered a classic in Madison Avenue folklore. But there was little attempt at humour. Irving Berlin managed it in 'This is the Army, Mr Brown'. Magazines such as *Flip* and *Wink* combined it with pin-ups, but that was simply a continuation of pre-war magazines like *Movie Humor*; and pin-ups could be regarded as a necessary item of forces supply, like boots, emergency rations and contraceptives. Their purpose was to ginger up morale and keep the minds of sex-starved troops on healthy objects. The pin-up industry was a serious business. There are seldom giggles in a strip-show: the men present are usually as intent and hushed as in a chapel.

OPPOSITE

Advertisement for the New Haven Railroad, 1942. Written by Nelson C. Metcalf Jr and designed by Ed Georgi

Nifty magazine, November 1942

Cover of *Movie Humor*, American pin-up magazine of February 1940

The most popular pin-up was Betty Grable, whose famous legs were insured for a million dollars. In 1944 she starred in a film called *Pin-Up Girl*. Early in 1941 the Petty Girl, named after her creator George Petty, began to appear in the foldout pages of *Esquire*. The Varga girl drawn by Alberto Vargas had made her debut a few months earlier. In December 1940 the first Varga Girl calendar was issued. An article of 1945 in *Paper and Print* on 'The "pin-up" craze among GI's' recorded that:

> Crews of the USAF often plaster the centre sections of Flying Fortresses with drawings and photographs clipped from the pages of *Esquire, Men Only, Look*, and similar publications. One navigator had most of the film stars, including Gypsy Rose Lee, accompanying him on day trips to Berlin, and, in his enthusiasm, had pasted his pin-ups on both the inside and the outside of his Fortress. On each flight down the 'Kraut Run', the Navigator's skipper swore that their particular plane was singled out for special attention by the German fighter pilots who 'wondered what all the queer pictures were about'.

Pin-ups became big business, and remained so after the war. An article by Fay Vickers in *Photo World* of August 1946, 'The Great American Pin-Up', said: 'This form of art has found its way from the fox-hole to the home. Psychologists say there is no harm in it. . . .'

In its heroic and triumphal appeal, its grimness and general portentousness, American taste of the war years has more in common with that of Nazi Germany than that of England. That statement, which might sound offensive, must of course be qualified: the Hitlerian trappings – swastika banners and tapestries, boxes carved with Nazi emblems, fleets of black Mercedes cars, presentation pistols and daggers with blood-brotherhood legends worked into the metal – suggested a Wagnerian exaltation and paranoia usually absent in America. But in Germany, too, there was no temptation to make jokes. Jokes were left to the anti-Nazi propagandists who dropped their caricature broadsheets over Germany. Jokes were punishable by death.

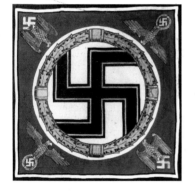

Nazi banner

Hitler's 7.65 mm Menz Lilliput pistol, heavily gold-plated and with mother-of-pearl handle. One side is engraved 'To the revered Führer from party member Kehl, Munich, whose homeland is the city of weapons, Suhl'. The other side reads: 'For Reds' and reactionaries' reward, and for our Führer's own defence'

OPPOSITE

Advertisement for Mercedes-Benz in *Signal* (Nazi propoganda magazine, France, August 1943)

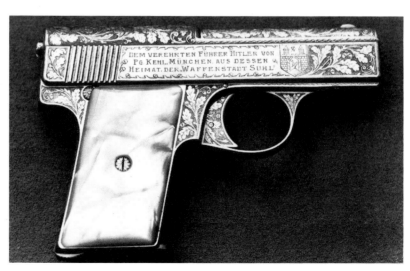

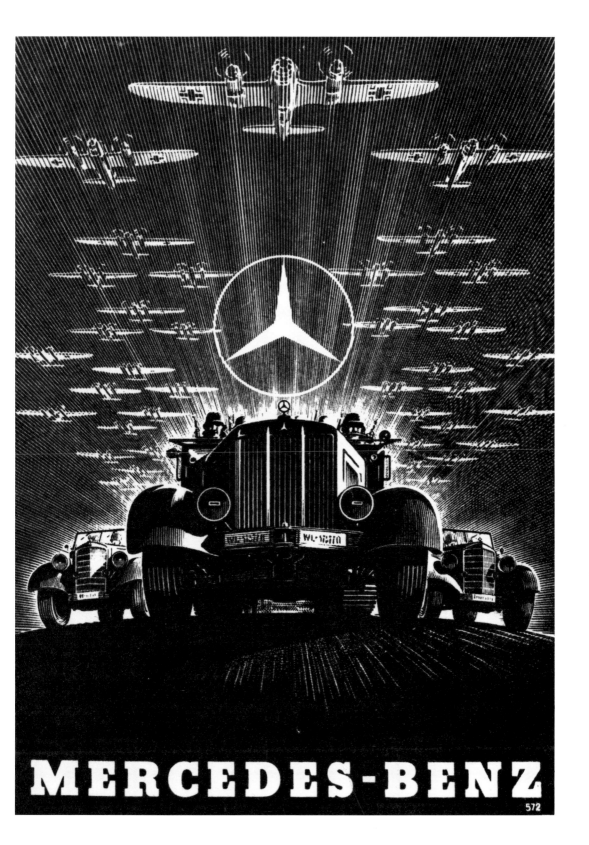

Whether in or out of favour, in wartime boyfriends and husbands became household icons in picture-frames

Distinctive even in the most distinguished company, the Jaguar enjoys universal approval. Each of the three saloon models, on 1½, 2½ and 3½ litre chassis, is a full 5-seater car of high performance, with luxurious appointments and many modern refinements. Air-conditioning, with de-froster and de-mister, is standard on the 2½ and 3½ litre and on the 1½ litre Special Equipment model. New Girling two-leading shoe brakes are employed on the 2½ and 3½ litre models. Jaguar Cars Ltd., Coventry.

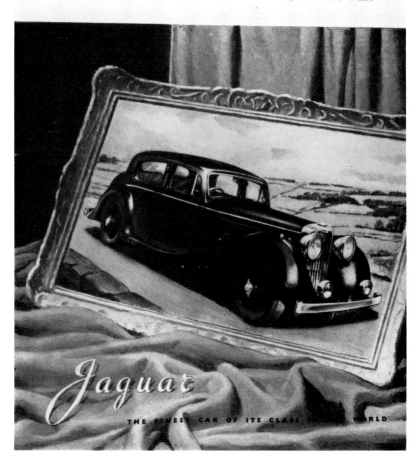

Jaguar

THE FINEST CAR OF ITS CLASS IN THE WORLD

Use of picture frame in advertisement for Jaguar cars

The war introduced some quirks of design which persisted well into the 1950s. One was the habit of showing people and things (especially in advertisements) in picture-frames. In the war, separated couples remembered each other and communicated with each other through photographs. The photographs – all-important household icons – were framed, and people grew accustomed to the beloved framed image. The picture-frame became a cliché of design, introduced gratuitously into advertisements for Yardley perfume, Jaguar cars and wool. The implicit suggestion was: 'If it's in a frame, it deserves your attention.'

Another wartime convention with widespread post-war currency was the amorphous patterning used by camouflage artists to disguise aircraft, Nissen huts and factories. Many well-known artists, 'doing their bit' for the war effort, had been involved in camouflage, including Oliver Messel, James Gardner, Basil Spence, the couturier Victor Stiebel, the magician Jasper Maskelyne and the wood-engraver Blair Hughes-Stanton. The last-named was in a group led by Lieutenant-Colonel Geoffrey Barkas, who was responsible for the camouflage of the Middle East forces from January 1941 to the end of the campaign. Barkas issued his men with a waggish instructional poem on the merits of camouflage, which included these lines:

> *You see these Greeny-Browny Blobs?*
> *Well, that's a special kind of Paint*
> *That makes things look like What they Ain't.*
> *No fooling, it's the latest thing –*
> *It's called Disruptured Patterning.*

'Disruptured Patterning' was the pompous official name for what the artists themselves more light-heartedly called 'wigglies'. These amoeba-like forms invaded design in the immediate post-war period – in the table-tops of the French designer Jean Royère (1946), the cross-section of a glass vase by Alvar Aalto (1947), a Jacqueline Groag design for Hill Brown (1948) and a plywood table designed by Carl-Axel Acking for A. B. Svenska Mobelfabrikerna (1949). Like the picture frame, the 'wiggly' became a hackneyed motif in graphic design, as in the headline cartouche of an article in the American magazine *Liberty*. 'Wigglies' were further popularized by the big exhibition of Hans Arp's works at the Valentin Gallery, New York, in 1949.

During the war, America had emerged as the most powerful nation in the world. Like Europe, she had made terrible sacrifices in terms of young lives; but she was not exhausted by war like Europe, indeed she profited by war. Eric Goldman wrote in *The Crucial Decade* (1956):

The America of V-J [Victory in Japan] Day, 1945 was prosperous, more prosperous than the country had been in all its three centuries of zest for good living. The boom rolled out in great fat waves, into every corner of the nation and up and down the social ladder. Factory hands, brushing the V-J confetti out of their hair, laid plans for a suburban cottage. Farmers' children were driving to college classes in glossy convertibles. California border police, checking the baggage of Okies returning east, came across wads of hundred-dollar bills.

Use of Arp motif or camouflage 'wiggly' ('disrupted patterning') in *Liberty* magazine

The birth-rate soared: the prams were full of 1960s student dissidents. Prices kept climbing. Kids of the Cape Cod resorts who had formerly dived for pennies 'now refused to budge except for nickels'. Mass unemployment ended: by the end of the 1940s it was down to around three million, roughly five per cent of the work force. President Truman, a 'little man' himself, was helping the little men to move into trim suburbs with a sympathetic mortgage policy. Obesity began to be a problem: in 1945 the average American consumed about 3,500 calories a day, as compared with Europeans, most of whom lived on fewer than 1,500 a day, many on an average of 1,000. The GI Bill of Rights helped millions of young men and women to obtain the most important badge of status in American life, a college education. Official moves were at last made to tackle discrimination against Indians, black and other minorities. Truman, horrified when a Winnebago Indian was refused burial on racist grounds in the Sioux City Memorial Park, invited the man's widow to bury him in Arlington National Cemetery; and in 1948 he issued an executive order establishing equality for all persons in the armed forces. (The equivalent move in the educational system would follow in 1954.)

There were big problems abroad: the rise of Communism, the Cold War, the loss of the nuclear monopoly, the revolution in China. In the late 1940s, Godfrey Hodgson has written, there was 'an almost operatic sense of tragic coincidence, a crescendo of foreboding' – with the Berlin blockade and the death of Jan Masaryck (1948), the fall of Shanghai (May 1949), the establishment of Mao as head of a Chinese People's Republic (September 1949) and, in 1950, the conviction of Alger Hiss for perjury and, two days later, the arrest in London of the Russian spy Klaus Fuchs. But at home there was confidence and optimism, a belief that abundance and 'revolutionary capitalism' could eliminate social barriers, creating 'a nation of the Middle Class'. In *Capitalism, Socialism and Democracy* (1942) Joseph Schumpeter predicted that the creation of new resources might 'annihilate the whole case for socialism'. In 1951 *Fortune* magazine, in a special issue on 'The American Way of Life' declared that 'American capitalism is popular capitalism'. J. K. Galbraith agreed in *American Capitalism* (1952): 'It works,' he wrote, 'and in the years since World War II, quite brilliantly.' And in the book which gave a catchphrase to the whole phenomenon, *The Affluent Society*, he wrote: 'Production has eliminated the more acute tensions associated with inequality.'

The Americans spoke of 'reconversion' – shifting the economy back from war to peace. In Britain, more drastic terms were used for what seemed to be needed: 'reconstruction' and 'regeneration'. There too, under the Labour Government which had turfed out Churchill, to the old warrior's amazement and chagrin, great social programmes were *en marche*, with the Butler Education Act of 1944 and the establishment of a National Health Service and a social security system.

But here, as in the rest of Europe, conditions were vastly different from those in America. Cities lay in ruins. Rationing was still severely in force, and there were chronic shortages of coal, bread and other necessities of life. Tuberculosis was on the increase for the first time in a century. 'What is Europe now?' Churchill asked on 14 May 1947. 'It is a rubble-heap, a charnel house, a breeding-ground of pestilence and hate.' The comparison of their condition with that of the Americans based in Britain caused some excusable envy among the English, summarized in the jibe: 'They're over-dressed, over-sexed, and over here.'

In Britain, where even necessities were in short supply, luxury goods were not to be had. It was a case of stretching resources, tightening belts, making ends meet. 'Britain Can Make It' was the title of a 1946 exhibition in London (in parody of the 'Britain Can Take It' slogan of war) – but could she? At Christmas time, handyman grandfathers were in demand to knock together forts, carts and other toys unobtainable in the shops. Women made cheap jewelry from barbola paste, deploying the decorative techniques of the pastrycook. Plaster was used for mantleshelf ornaments and trinkets such as a bottle-top of a busty starlet. Patterns were printed for do-it-yourself 'Quickly-made Lingerie' and other clothes. A powder compact was more likely to be of wood and plastic, with a perky 1940s motif to compensate for the materials, than of silver and enamel, or gold. If you had an old pre-war car to drive around in, you were lucky; if you could find and afford the petrol to go in it, you were luckier.

1940s bottle stopper

1940s powder compact in wood and plastic. Diameter 4 in.

The cheapest kind of 1940s jewelry: brooches of barbola paste

How different from the post-war United States, with its surge forward in the production of consumer goods. By 1947 America was providing one half of the world's manufactures – 57 per cent of its steel, 43 per cent of its electricity, 62 per cent of its oil; and it owned three-quarters of the world's automobiles. And automobile designers were trying to come up with something representative of the forties, this new optimistic age, not just harking back to the elegance of the pre-war models.

One example, the 1948 Tasco, was the idea of several organizers of The Sports Car Club of America, and its name, TASCO, derived from the initials of the club. Designed by Gordon Buehrig, who also designed the Cord 810, the Auburn 851 Speedster, and the Duesenberg Beverly, the hand-crafted aluminium body was built by the Derham Body Company of Rosemont, Pennsylvania. It had the first magnesium wheels ever made, produced by the Dow Chemical Company, and the first fibreglass fenders, built by the late Howard Anthony, founder of the Heath Company, makers of do-it-yourself kits. The instrument panel was designed like an aeroplane cockpit – perhaps a deliberate invocation of World War II glamour and technical experience. To maintain the smooth line of the body, the doors were opened by a push–button mechanism. The windows were operated by vacuum lift. It was never marketed.

The 1948 Tasco, designed by Gordon Buehrig

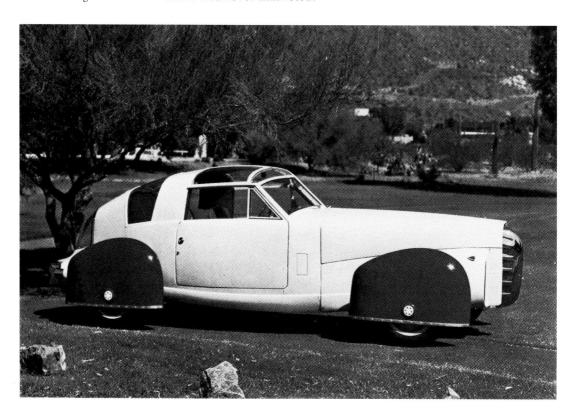

Another prime example of American post-war luxury is the gold, diamond and amethyst *parure* (colour illustration, page 138) made by Cartier in 1949 for Mrs Joseph Schillinger, wife of an avant-garde designer. Like the Tasco car, the Cartier *parure* could not belong to any other decade. It has a baroque quality quite alien to the icy restraint of Art Deco Cartier jewelry. Its inspiration is mid-Victorian – another example of a return to the exuberant self-confidence of that period. It may be objected that the very rich are always with us, and that there are always Cartiers, or their equivalent, to feed them with luxurious gew-gaws. But the exuberance is seen also in popular relics of the forties, such as wurlitzers and other juke boxes (colour illustration, page 137). In America the late 1940s were the time of mink coats, nylon stockings, dishwashers, alarm clocks, canned beer and deep freezers; and the pace of materialism would gain momentum through the fifties to a point of nauseous surfeit.

The Truman administration tried to redress the balance between American plenty and European want by the Marshall Plan – an appropriation of 17 billion dollars to be spent in the four years beginning 1948 on bolstering the economies of all the European countries outside the Iron Curtain and Turkey. Like most political moves, this was not prompted by pure altruism. Economic collapse in Europe would both deprive America of European markets it needed, and cause the kind of chaos and despair which would help the spread of Communism. But the Europeans were grateful for the help, even if their standard of living still remained many leagues below that of America.

But whatever might be their differences in material wealth in the post-war period, the English and Americans had one thing in common: people were glad to be home again, free of the miserable foreign embroilments of war. Artists were re-captivated by the folk traditions and folk art of their own lands. France, which had tended to dictate design, fashion and taste on both sides of the Atlantic before the war, was enervated: survival took precedence over sophistication. So artists returned to the bold, gaudy decoration of fairground carousels, the painted narrow-boats of the English canals and 'Showboat' paddle steamers of the Mississippi, gypsy caravans, Wild West wagons, Punch and Judy kiosks, circus and music-hall posters, Barnum and Bailey and Bertram Mills. The revived folk style affected everything, from book design to wallpaper to glass engraving to furniture. Tom Stoppard's later joke about 'Chipperfield commodes' almost became a reality.

The folk art of the narrow boats was directly celebrated in an Ealing Studio film of 1945, *Painted Boats*; and in designing a poster for the film, John Piper introduced another kind of British folk art, for the florid cartouche around the lettering was from a rubbing he had made of a slate tomb in Leicestershire or Nottinghamshire. The American paddle steamers also had great decorative allure, appearing on the

Back cover of *Waterways of the World* by W. J. Bassett-Lowke and Laurence Dunn (1946)

jacket of *The River Road* (1946), 'A story of the Mississippi River' by Frances Parkinson Keyes, and on the cover of *Waterways of the World*, a Puffin picture book (also 1946) by W. J. Bassett-Lowke and Laurence Dunn.

The circus and fairground were even more popular as sources of decorative motifs. In the late 1940s and early 1950s there was a positive mania for roundabout horses, swingboats, chairoplanes, lion tamers, sword swallowers, dodgems, striped tents, red-nosed clowns, performing monkeys and elephants. As an index of popular interest, over thirty books with the word 'Circus' in the titles are recorded by the *English Catalogue of Books* for the years 1942–59 – and that discounts a large additional number of books about circuses. Fairground and circus settings also occurred in several films, including Walt Disney's *Dumbo* (1941), for which the original sketches were made at the Cole Brothers' Circus; Columbia's *Tars and Spars* (1946) with the theme song 'Love is a Merry-go-round'; the Boulting Brothers' *Brighton Rock* (1947); Paramount's *Variety Girl* (1947); Max Ophuls' *La Ronde* (1950); Hitchcock's *Strangers on a Train* (1951); and Zoltan Fabri's *Merry-go-round* (1955).

The demotic arts of the fairground and circus were in accord with the left-wing tendency of post-war politics in Britain. Contributing with Barbara Jones to *The Architectural Review* (February 1945) under the title 'Roundabouts; Demountable Baroque', Eric Brown argued that the fairground had retained its exuberance because it was a working-class institution, free from interference by the genteel, good-taste bourgeoisie. He added:

'Circus bagatelle' game by Chad Valley Ltd

Fairground carousel horses were a popular motif of the late 1940s and the 1950s, as on this wallpaper

The essential quality of unashamed heartiness remains, and the flabby hand of the gentlemanly designer has not yet been loosed in the field of fairground design. May that same quality which gives us the writing on the coster's barrow, on the cut-price store labels, and on the windows of the cheap 'Dining Rooms', continue in the decorating of the fair machines and may the slick American industrial designer be restricted to static streamlining and the architectural re-styler to his pale blue and gilt church furnishings.

Gypsies, both in America and Europe, were – perhaps over-romantically – regarded as the purest custodians of folk tradition. The petty conventions of bourgeois civilization did not impinge on them as they rolled on through history in their harlequin-timbered caravans, making their own roadside camps, under the rule of their own vagabond laws and their own king. True, the British gypsies had 'done their bit' in the war; E. A. Williams, the young heir to his tribe's kingship, had at first been refused for the army but after a personal interview with Ernest Bevin had covered 370 miles a month on his bicycle, persuading his people to join up. But after the war gypsies were still seen as licensed mavericks. Refugees from persecution in Nazi Europe imported schmaltzy gypsy lore into America, including the Walt Disney studios. In England, the great F. E. Smith, the first Lord Birkenhead, had liked to claim gypsy blood, and his daughter, Lady Eleanor Smith, who became a passionate champion of gypsies and circus folk, wrote the plot of the 1946 film *Caravan*, starring Stewart Granger and Jean Kent. In April 1949 the Lansbury-Britannic Players presented 'The Gipsy Princess' at the Fortune Theatre, with Miss Una Paulet (now Mrs J. K. des Fontaines) performing the gypsy dance in the title role.

Advertisement for underwater telephone cables, incorporating mermaid telephonist

Lady's hand-mirror, part of a complete dressing-table set made in silver by Leslie Durbin, MVO. The motifs were modelled in wax, cast in gold and then applied

Apart from the resurgence of folk art, there was another powerful influence at work on immediate post-war design. In *Austerity/Binge: The Decorative Arts of the Forties and Fifties* (1975), I minted the phrase 'The Oyster Principle' to characterize this phenomenon. An oyster converts a piece of grit into a pearl. A whole series of recurrent motifs in post-war design resulted, I suggested, from the desire to de-fang and make friendly (or 'amicize') the threatening symbols of war. The Oyster Principle accounts for the extraordinary frequency of the mermaid motif in the late 1940s – it was a lyrical symbol that the seas were rid of torpedoes and submarines. I illustrated several examples of mermaid decoration in *Austerity/Binge* (there are a few here as well), for only by presenting such a profusion can one convince the sceptic that the profusion existed. Again the theme was taken up by the movie-makers: in the British film *Miranda* (1948) a doctor (Griffith Jones) on holiday from his wife snags an amorous mermaid (Glynis Johns) while fishing. And the mermaid swam into mainstream art in the *Sirènes* and *Nymphes des Eaux* of Paul Delvaux. A retrospective exhibition of his work at the Palais des Beaux-Arts, Brussels, from December 1944 to January 1945 may have helped spread the theme. He painted *Le Village des Sirènes* in 1942; *Composition, femmes devant le mer* (showing mermaids gambolling in the waves in front of gas-ometers and cranes while two very human girls, hand in hand, stroll along the beach) in 1943; and *Les grandes sirènes* in 1947.

There was another, more obvious, reason for the popularity of sea imagery from 1945. The seaside, with all its folk-art treats (letter-rock, candy floss, 'What the Butler Saw' machines on the pier, Punch and Judy, Kiss-Me-Kwick hats), was part of life again. The barbed wire and mines were cleared from the beaches. Christopher Marsden wrote in *The English at the Seaside* (1947):

> The English can resume, where they will, their odd littoral enjoyments. Once again they will be able to fill their hair with salt and their shoes with stones; they will be free once more to migrate to small and rainy towns in trains that are only crowded at the very time they travel; to leave their comfortable homes to eat unlovely meals in lodgings presided over by cross women of fanatical parsimoniousness. . . . The more reasonable sensuous pleasures of the seaside will also be open to them: the wriggling of bare toes in sand; the working of depressions for buttocks; the popping of blistered seaweed. They will be able to inhale again in the sunshine that curious aroma, always slightly fecal, which belongs to the rearward part of beaches – composed of flies and old newspapers and unintentionally dried fish.

The winged horse motif is another example of the Oyster Principle in operation. He represented the new safety of the air. The horsemen of the Apocalypse were superseded by the lyrical Pegasus of classical legend. Winged horses flew into the Korda film *The Thief of Bagdad* (1940), science fiction comics and John Buckland-Wright's wood-

PEGASUS
LONDON AND MONTREAL
activity
TRADE MARK
All sizes
5/9
each
MEN'S COMFORTABLE UNDERWEAR
Snugs (as illus.) and Middies
(half way to knee)
Singlets and Vests (short sleeves)
Write for FREE illustrated folder and
name of your nearest stockist to
PEGASUS, 18 Golden Square, London, W.1.
PAT. APPLD. FOR

Advertisemen from
The Daily Mirror,
8 February 1952:
Pegasus even got into the
underpants ads

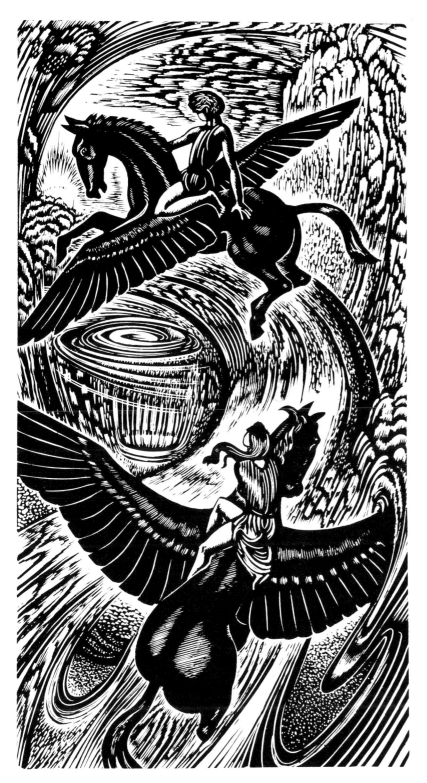

John Buckland-Wright, wood-
engraving for the Golden
Cockerel Press edition of
Keats's *Endymion* (1943–7)

Balloon cover, *Daily Mail Annual for Boys and Girls*, 1956

Barrage balloon: from *The British Boys' and Girls' Wartime Playbook* No. 1

engravings for the Golden Cockerel Press edition of Keats's 'Endymion' (1943–7), and even became the trade-mark of a brand of men's underpants – suggestive, perhaps, of classical proportions and painless uplift.

Coloured party balloons and hot-air balloons also symbolized the new freedom of the skies – in this case from barrage balloons and parachutes. The balloon was a kind of parachute in masquerade, replacing something plain and menacing which dropped from the skies to the earth, by something bright and fanciful which rose from the earth to the skies. Advertisers were particularly fond of this motif: in 1948 'Savko' fancy papers were shown streaming from a striped balloon, and in the same year Philips showed radio valves floating into the air like balloons. In 1947, the year of the New Look, Elsa Schiaparelli held a Balloon Ball, with invitation cards shaped like the Montgolfier Brothers' balloon of the eighteenth century and a hot-air balloon moored in the middle of a garden like 'an immense grey elephant bathed in a rainbow'. In the Ealing film *Kind Hearts and Coronets* (1948) Lady Agatha d'Ascoyne (one of the many roles in the film played by Alec Guinness) distributes leaflets from a balloon after her release from Holloway Gaol for suffragette activities, and is shot down by Louis Mazzini (Dennis Price) with a bow and arrow. Two more films, both of 1956, helped the balloon to ascend still higher in popularity, Michael Todd's *Around the World in Eighty Days* and Albert Lamorisse's winsome *Red Balloon*. In the same year Mary Quant designed

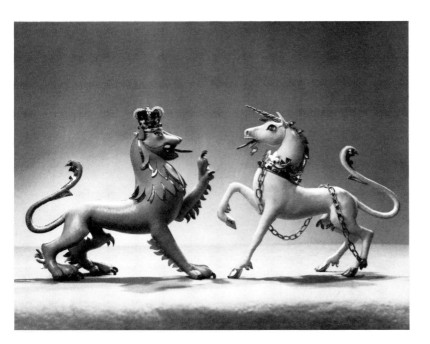

Heraldic lion and unicorn in golden-tan and white peccary decorated with gold kid, crimson tongues, teeth and claws, made by Peggy Tearle for the Festival of Britain, 1951

her 'balloon dress'. And again in 1956 Eric F. Goldman in *The Crucial Decade*, the classic account of American life during the ten years after the Hiroshima bomb, used the balloon as a metaphor for the state of America in the late 1940s – buoyant yet precarious: 'The post-war America emerging in the spring of 1947, so zestfully careering, so replete with evidence that the careering would take you fast and far, so formidably threatened, was like nothing so much as some great gaily colored balloon bounding along just above craggy wastes.'

Heraldry, the folk art of the aristocracy, was also disproportionately popular with forties and fifties designers – another working-out of the Oyster Principle. It 'amicized' the badges and symbols of war. In England, the Coronation of 1953 gave extra excuse for it: a book on heraldic symbols called *The Queen's Beasts*, with an introduction by Garter King of Arms and illustrations by Edward Bawden, was issued. Two years earlier heraldry had also seemed in place at the Festival of Britain, for which Peggy Tearle designed a heraldic lion and unicorn in golden-tan and white peccary decorated with white kid and crimson tongues, teeth and claws. Heraldic motifs also figured in the embossed leather wall-coverings and carved wooden doors of the 'Hollywood Spanish' style, still in vogue on the West coast of America. Leslie Durbin MVO, co-designer of the Sword of Stalingrad which Evelyn Waugh satirized in his war trilogy, designed heraldic silver peppers and salts for the high table of Girton College, Cambridge. Brave, if far from orthodox, heraldry decorated women's dress fabrics and the endpapers of a children's annual.

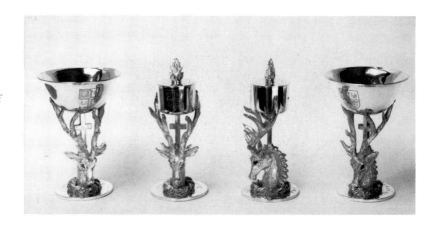

Heraldic silver peppers and salts for the High Table, Girton College, Cambridge, by Leslie Durbin, MVO. The decorative motif is the crest of Beryl Power, modelled and cast in the round

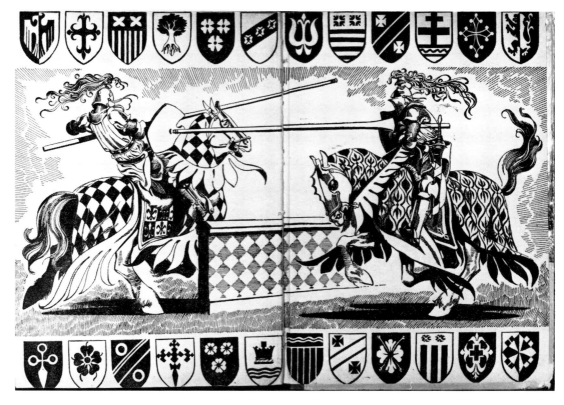

Heraldic endpapers from a 1940s film annual

Besides the folk art revival and the Oyster Principle, a third powerful tendency can be discerned in the 1940s – sheer escapism. In the painful memories of the immediate past and the privations of the present, there was much that people wanted to escape from. The escapist tendency showed itself in five main ways: the absorption of surrealist ideas into decorative art; the great popularity of ballet, that most escapist of arts; an obsession with ghosts, Gothick fantasy, and ruins; nostalgia for the comfort and security of the Victorian and Edwardian periods; and a fascination with South America and Mexico, one theatre of the world that remained relatively untouched by the war.

Sometimes these escapist manifestations were combined, as when Salvador Dali designed the ballet *Labyrinth* (1941) to music by Schubert, choreographed by Leonide Massine, presented by the Ballets Russes de Monte Carlo in the Metropolitan Opera House, New York. (Dali had also designed the spectacular and beautiful 'hollow swan' backdrop to the Wagner ballet *Bacchanale*, by the same company and also at the Met, in 1939.) In the 1940s Dali caused a sensation in New York by his window decorations for Bloomingdale's. Because he was such a supreme self-publicist, it was his kind of Surrealism, rather than that of Magritte or any other surrealist master, that most influenced designers. They pasticined him directly in advertisements, with melting watches and grotesque shapes supported by crutches. But a design such as C. F. Tunnicliffe's jacket for *Profitable Wonders* (1949) shows his influence in a more assimilated way, with the peeling back or excavating of a shape which reveals one vista, but itself represents something else. This jacket also incorporates the surrealist 'disembodied hands' motif of which I illustrated no fewer than eleven examples in *Austerity/Binge*, including Bruce Angrave's drawings for John Keir Cross's sinister stories *The Other Passenger* (1944). In reviewing *Austerity/Binge* in *The Listener*, Ronald Blythe, author of *Akenfield*, wrote of the disembodied hands: 'Their elegant surrealistic pleading probably had its artistic impetus in the paintings of Chirico, Paul Nash and John Armstrong, but, looking at them afresh, they seem touched by saluting hands, parting hands, drowning hands and hands stretching out of Belsen.'

Disembodied hands motif: jacket by C. F. Tunnicliffe for E. L. Grant Watson's *Profitable Wonders* (Country Life, 1949)

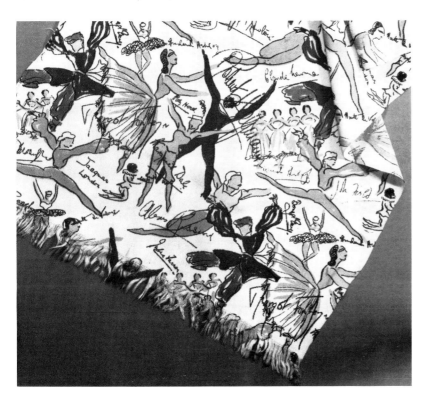

Jacqmar headscarf with ballet motifs, 1940s

In *Ballet Since 1939*, a booklet published for the British Council in 1946, Arnold Haskell explained the ballet renaissance of the 1940s: 'With the outbreak of war the demand for ballet steadily grew, partly no doubt from escapism, since ballet is the last stronghold of theatrical illusion' The ballet was able to recruit some outstanding artists to design settings. As well as Dali in New York, there were the three British-inspired ballets which Robert Helpmann produced and danced in: *Comus* (1942), *Hamlet* (1942) and *Miracle in the Gorbals* (1944). Comus, a modified masque, was designed by Oliver Messel. *Miracle in the Gorbals* had a magnificent marine dropscene painted by Edward Burra. Burra was a fringe Surrealist, and Leslie Hurry, who designed the lowering, vengeful scenery for *Hamlet*, could also be considered a Surrealist. Hurry also designed a nightmarish poster of coffins, skeletons and bats for the Ealing ghost-story film *Dead of Night* (1945). In the same year the ballet *The Haunted Ballroom* was revived at Sadler's Wells. In 1944 Ealing had made another ghost film, *Halfway House*, about a group of travellers staying at an inn that had been bombed a year earlier. This suggests that the forties' preoccupation with ghosts may have had something to do with the numbers of people so recently killed. But with ruins and follies ghosts were also part of the old England, and part of the stock-in-trade of the new romantic movement in painting led by John Piper and Graham Sutherland.

The expansiveness and assurance of middle-class life in the Victorian period had great appeal in a time of shortages and bomb-sites. Noël Coward's *Pacific 1860*, produced in 1946, significantly contained the song 'This is a Changing World' ('sung exquisitely by Sylvia Cecil in the second act,' the Master recalled). The 1860s were also evoked in the Ealing film *Champagne Charlie* (1944), in which Tommy Trinder and Stanley Holloway re-enacted the rivalries of the music-hall singers George Leybourne and the Great Vance. Other Ealing films which showed nostalgia for the time before the old England and its values had been disrupted by two world wars were *Pink String and Sealing Wax* (1945), a Victorian melodrama; *The Loves of Joanna Godden* (1947), an Edwardian drama set on Romney Marsh; and the classic comedy *Kind Hearts and Coronets* (1949), also set in the Edwardian period. The lavishness of Victorian and Edwardian women's costume was an attractive memory at a time when Harold Wilson, then Britain's President of the Board of Trade, was inveighing against the waste of material caused by the 'New Look' and protests were being heard about the 'hipettes' sold at 25s 6d a pair to pad out dresses. An American magazine gave the pattern for a 'Crinoline Lady' in crochet, and more crinoline ladies in coloured tinsel cut-outs against black backgrounds decorated many bedroom walls. A similar luxuriance in women's dress was to be found in all the extravaganzas of the 1940s set in South America, which was popularized above all by Carmen Miranda, the 'Brazilian Bombshell', perhaps the most outrageously overdressed

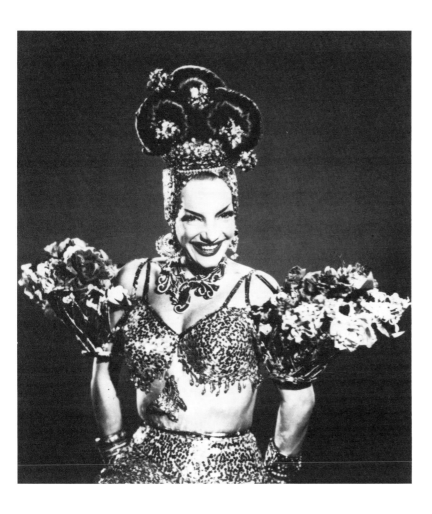

The most 'over the top' star of all time: Carmen Miranda, the 'Brazilian Bombshell'

woman in human history. (An entire museum in Rio today is devoted to her headdresses and platform shoes.) In his enjoyable book *Dime-Store Days* (New York, 1981) Lester Glassner, who was born in 1939 and spent his childhood in up-state New York, attributes to Miranda's influence the 1940s American fashion for artificial fruit: 'Carmen Miranda often got dressed up like a dancing strawberry-banana split, and when she did, there was just no stopping her. Her enormous influence on the artificial-fruit industry made the kitchens and dining rooms of my childhood resemble orchards of wax, plaster and paper ornamentation.' He ascribes to her influence also the 'fruit and flower configurations' in machine-moulded ceramic – pomegranate jam-jars, lily vases, and a bunch of bananas cookie jar. She also inspired tutti-frutti jewlry – Glassner illustrates a necklace of celluloid cherries hanging from a celluloid chain and banana earrings in glazed earthenware. He even detects her 'comic tempestuousness' in Joe Carioca, the parrot star of Walt Disney's *Saludos Amigos* and *The Three Caballeros*, movies to which Glassner was taken on birthday treats in 1943 and 1945. ('The tropic Technicolored heat of these animated features and the fiery, pounding samba rhythms of their musical scores were completely

133

unlike anything I had ever seen or heard before.') The Carmen Miranda fashion fused easily with the 'Hollywood Spanish' tradition, in which ladies' dress was still a kind of Victorian crinoline, with black lace mantilla thrown in.

I was born just over a year later than Lester Glassner, and his nostalgic book brings home to me how much jollier it was to grow up in 1940s America than in 1940s England. In England the fire-engines were painted grey as camouflage against bombs. Many theatres and cinemas were closed because of the danger of a direct hit on a large audience. (Though the racy Windmill Theatre boasted 'We never closed our doors.') Edwardian Nestlé's 'chocolate machines' (automatic vendors) on the London Underground platforms where men and women slept huddled in Henry Moore shapes, were allowed to stay pillar-box red, but they were empty. Most towns of any size had Woolworths stores, but they had little to offer either. In contrast, the movies and the dime-stores were to Glassner 'two opulent domains that always satisfied his childish desires for "more"'.

> The very existence of the dime store [he writes] spelled heaven-sent relief from the psychic hardships of childhood in the 1940s. The loss of one's equilibrium from the stony indifference of wartime reality was instantly assuaged upon entering any of those gaudy Xanadus. They were peaceful havens of fantasy and mischief, enchanted Coney Islands where toys, candy and cosmetics were packaged and sold in the glittering trappings of the Hollywood Style.

The 1950s arrived in America in the 1940s. Little Lester Glassner was already being taught to take his confident place in the consumer society. Whereas for most people in Britain, the forties were a time of yearning for luxury, and the fifties were a time for achieving it. The two decades were divided by a dramatic caesura – the Festival of Britain, 1951. Its pretext was a commemoration of the Great (Crystal Palace) Exhibition of 1851, again a harking back to the mid-Victorian period. But it *was* only a pretext: in fact, when the organizers had completed their ambitious plans for the Festival, they suddenly realised that they had completely forgotten about 1851, and James Gardner very quickly had to scribble a design for a Crystal Palace model, an embarrassed afterthought. The Festival turned into a defiant assertion of national regeneration after war and dragging austerity, a fanfare of optimism, a showpiece for British design, and, as its supremo, Sir Gerald Barry, called it, 'a tonic to the nation'. Young architects and designers, trained before the war and then frustrated by the war, were raring to show off their talents; and they were given the chance. Few of the main organizers were over 35, including Hugh Casson (now President of the Royal Academy), the overall supervisor of architecture, and Ralph Tubbs, who designed the Festival's most sensational building, the Dome of Discovery – at that time, the biggest dome the world had ever seen. (The Dome was counterbalanced by the slim, silvery 'Skylon', ingeniously mimicked in the Festival souvenirs produced by Biro, the ball-point pen firm.)

As a temporary entertainment and a 'tonic', the Festival was a success; but how permanent were its effects? The young organizers saw it as a chance to introduce people to their new vision of the future. But did they manage to impose it? Some of the visitors, and some of the organizers, thought the Festival's message had been successfully conveyed to the British. Barbara Jones, one of the Festival designers, thought 'it brightened up clothes, sheets, houses and thousands of things in daily use'. Jack Godfrey-Gilbert, a Festival architect, thought 'a new architectural language was born'. William Feaver saw Coventry Cathedral interior as the 'apotheosis' of Festival style. And Brian Aldiss, the science-fiction writer, regarded the Festival as 'a monument to the future'.

Others were more sceptical. They saw it as a temporary show that fizzled out like a pretty firework display. This is what Sir Misha Black, one of the leading Festival architects, said twenty-five years later:

> The Festival suddenly proved that modern architecture was in fact acceptable. . . . Suddenly . . . the get-rich-quick developers realised that this kind of architecture was common currency, that people accepted [it] without cavil. And it released a flood of the worst kind of bastardized modern architecture which the country had ever seen, and from which we have been suffering ever since. And I think that the harm which it did architecture was much greater than the good.

Christmas card design by Barbara Jones, 1950

Souvenir Biro ball-point pen in the form of the Skylon, 1951

The Skylon on the South
Bank, Festival of Britain, 1951
– the 'vertical feature' designed
by Powell & Moya

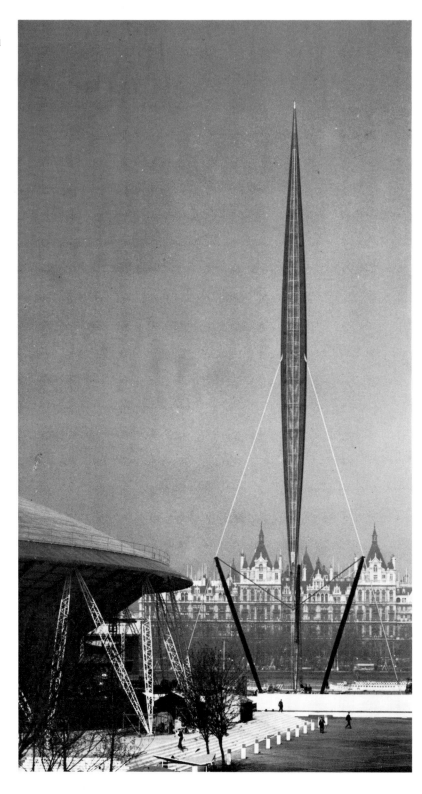

OPPOSITE

Wurlitzer 1100 juke box with
revolving light panels, *c.* 1946.
It originally had 24 selections
for 78 rpm records, but has
been converted to play 45s.
Height $57\frac{1}{2}$ in.

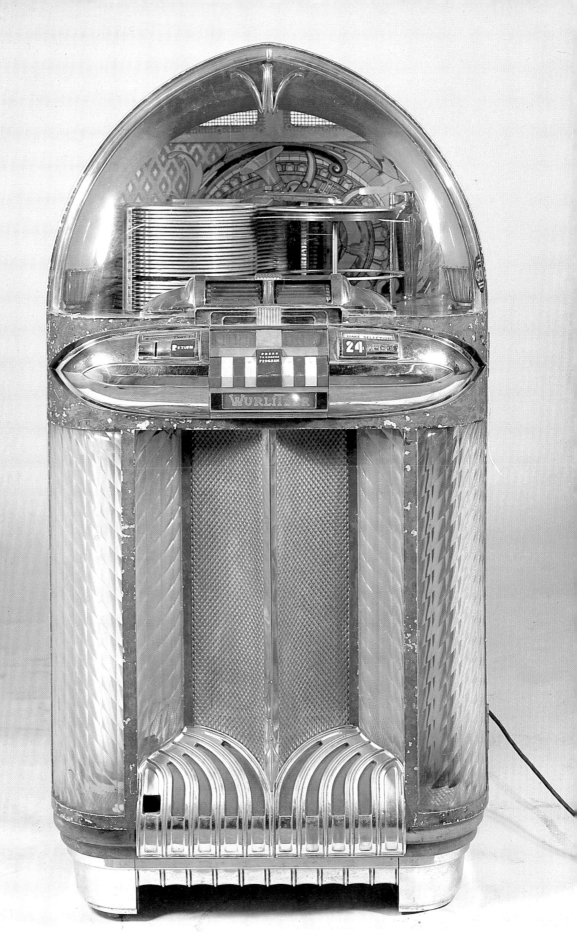

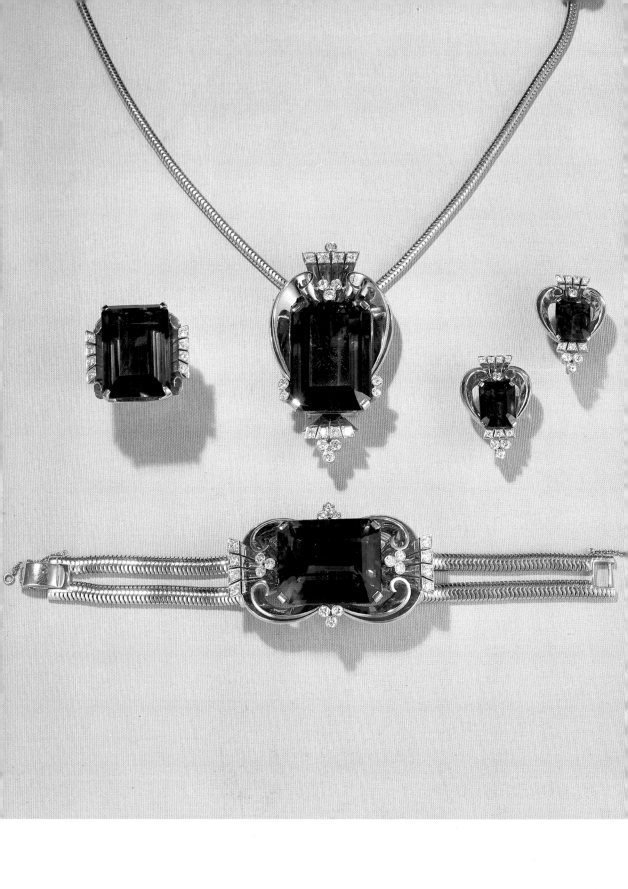

Strong words; but Black was probably right in suggesting that it was mainly the Festival tricks and gimmicks that the 1950s absorbed. The architects took up the bright, nursery colours of the Festival: to this day, blocks of flats are given patches of blue or yellow plastic in obedience to this fashion. And in furnishing, spindly-legged tables and chairs came in, also those legs with bobbles on the end, which have been labelled the 'cocktail cherry' style.

The Festival inaugurated the taste for whimsy as an antidote to drabness, austerity, and the lowering menace of nuclear weapons.

This frivolizing process had already begun in the United States in the 1940s, with the introduction by Parfums Weil of a new perfume called 'Gri-Gri', designed, according to the advertisements, 'to replace the atom bomb with a dash of the inconsequential'. The cartoonist Emett designed for the Festival the whimsical 'Far Tottering to Oyster

French 1950s lamp showing 'cocktail cherry' design

Rowland Emett with 'Neptune', one of the three locomotives he designed for Battersea; Festival of Britain, 1951

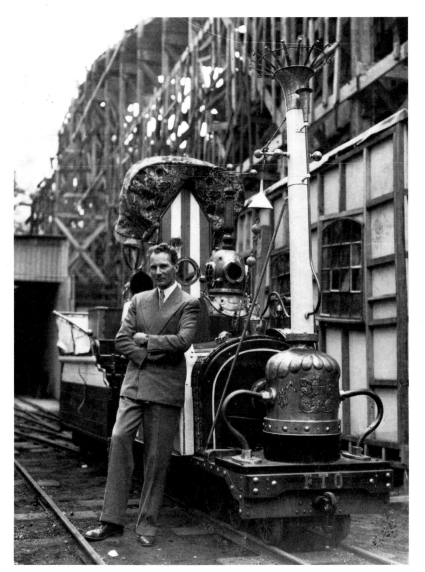

OPPOSITE

Forties baroque: gold, diamond and amethyst *parure* made by Cartier for Mrs Joseph Schillinger, 1949

Creek' railway. (Archaic transport – penny-farthing bicycles, decrepit wheelchairs, old crock motor cars – became part of the stock-in-trade of 1950s designers.) Edward Bawden's poster for the 1953 Ealing comedy *The Titfield Thunderbolt* shows another whimsical Victorian-style locomotive. (The plot involved the smuggling of an antique engine from the Science Museum to keep a branch line running.) The Festival contained an 'Eccentrics' Corner', including a smoke-grinding machine, an egg roundabout, a tea set made of fish bones, and a 'device for keeping the nose out of the tea'. Fanciful arts such as paper sculpture and flower arranging flourished. Barbara Jones's book *Follies and Grottoes* was published in 1953. The light-hearted trellis pattern became popular in clothes, handbags and interior decoration.

1950s handbag with trellis design

Joan Crawford flanked by trellises in the MGM film *Torch Song*. Her broad-tail cape-stole and full-skirted short dinner-dress of taffeta and jersey were designed by Helen Rose

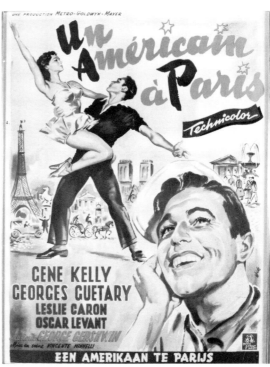

Now that Paris was open again to tourists, images of Gay Paree enhanced the whimsy: ladies walking poodles, Montmartre artists in berets, outdoor café scenes, Folies Bergères dancers. *Moulin Rouge* (1953), the film about Toulouse-Lautrec, gave new currency to the image of the Bohemian Paris artist flouting dreary convention. The artist's palette became a familiar motif in design, from cigarette lighters to ashtrays and vases.

The Paris café was a motif on this wallpaper, 'Place du Tertre', Interior Designers Collection of Walls Today, Inc.

French poster for the MGM film *An American in Paris*, starring Gene Kelly

Chrome and iridescent mauve enamel cigarette lighter of palette shape, English, 1950s

1950s English wall decoration, wire and plastic bobbles, in the form of a palette

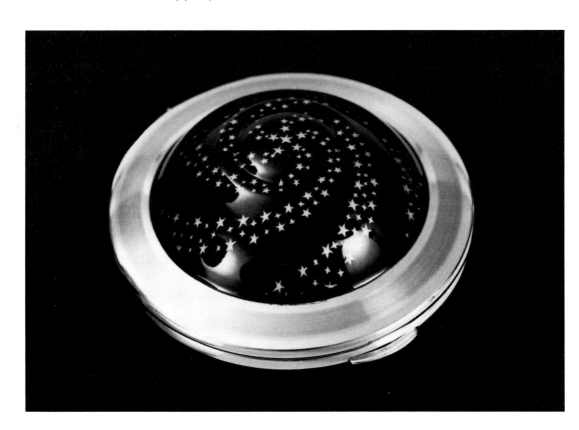

Science, as well as art, contributed new images. The 'cocktail cherry' chair legs were probably inspired by models of atomic and molecular structure. So was Edward Mills' giant abacus of plastic balls at the Festival of Britain and the Brussels Atomium. Shooting-star patterns followed the Russians' launching of the first artificial satellite ('Sputnik') in 1957 – which Mrs Clare Boothe Luce described as 'an outer-space raspberry to a decade of American pretensions'. (The cosmic humiliation was increased by the launching of Sputnik II with its live dog, and was not expunged by the abortive attempt to launch a rival satellite at Cape Canaveral, Florida, a month later – 'Stay-putnik' as British papers sarcastically dubbed it.) Alleged sightings of Flying Saucers introduced the UFO shape into several products, from radiators to Flying Saucer sweets (two discs of rice-paper, sealed at the edges and containing sherbert).

Another scientific development which had a strong effect on the decorative arts and even on architecture was the rapidly improving television set. In both America and Britain, the 1950s were the decade in which the television medium came to maturity and began to exercise a powerful influence on people's lives. In America, its power was first demonstrated in the 'trial by television' of Frank Costello in 1950, as part of the Kefauver Committee's investigation of organized crime in interstate commerce. It was the first 'TV spectacular'.

Richard Nixon's virtuoso performance with his dog when accused of corruption in 1952 was the next great proof of television power. Senator McCarthy, whose vicious campaign against alleged Communist infiltration had warped political and intellectual life of the early fifties, was crushed on television by Joseph Welch's 'Have you no sense of decency, sir, at long last?' in 1954. Children in the streets imitated the Senator's constant sneering interruption: 'Point of order, point of order, Mr Chairman.' Nixon again won kudos by television in 1959 when he taunted Kruschev amid the gleaming gadgets of a model kitchen in the United States National Exhibition in Moscow. Television replaced the fireplace as the focal point of the living room. The full extent of the television revolution was most clearly indicated by an observation of the Water Commissioner of Toledo, Ohio, in 1954. He could not understand why water consumption rose startlingly for three-minute periods. Then he hit on the answer: Toledo was flushing its lavatories during the commercials. In the same year the 'TV dinner', served on a special compartmented tray, was invented, so that programmes could continue, while the family munched silently, through mealtimes.

In England it was not trials or political posturings that established the power and popularity of television, but the Coronation of 1953. At least 25,000,000 people in Britain watched the ceremony on a television set, and they were joined by many more viewers in other European countries. Except for two short breaks, there were seven hours

'Flying Saucer' powder compact by Kigu, London, 1950s

143

By the mid-1950s the H-shaped television aerial had become a design motif, on this wallpaper ('Fifty East') from the Interior Designers Collection of Walls Today, Inc.

of continuous television. Many who had watched the great occasion on neighbours' sets now ordered their own. In 1958 several new transmitters brought BBC television to virtually the whole population of Great Britain and Northern Ireland. The Bill introducing commercial television became law in 1954.

Television obviously meant work for designers in designing television sets. Too often these masqueraded as fumed oak cocktail cabinets; though the 1950s Philco 'Predicta' set was a real attempt to allow the machine its own integrity, even if the superfluous detail of cocktail-cherry feet detracts from the otherwise ruthless simplicity of the design. But the 'television screen shape' also entered the general repertoire of designers as a symbol of modernity, the 'Contemporary' – on the sleeve of a Boston Pops record, the head of the mace Gerald Benney designed for Leicester University in 1957 and the windows of Chestergate House, Vauxhall Bridge Road, London (designed by Sir John Burnet, Tait and Partners in the late 1950s). The swirling gypsy dancer of the Gitanes cigarette packet, designed by M. Ponty, was shown performing on a television set in the Gitanes 'Grammont' brand, with a smoking pierrot viewer lying on the floor. Even the H-shaped television aerial mast (an abomination to architectural conservationists) took its place in 'Contemporary' imagery, as on the wallpaper called 'Fifty East' in the Interior Designers' Collection of Walls Today, Inc. of America.

On this 1950s cigarette pack for Gitanes, the trade-mark of the swirling gypsy (originally designed by M. Ponty in the early 1930s) appears on a television set

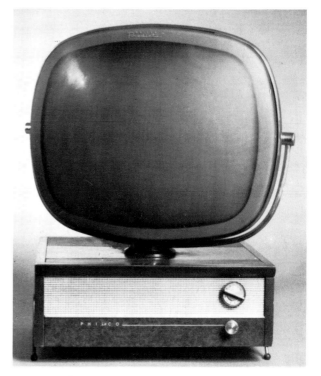

1950s 'Predicto', Philco television set, USA

In a valuable paper, 'Towards a Cartography of Taste 1935–1962' (published in *Popular Culture: Past and Present*, 1982), Dick Hebdige has written of 'the spectre of Americanization' in 1950s Britain. 'Increasingly, as the fifties wore on,' he writes, 'this negative consensus uniting cultural critics of all persuasions began to settle around a single term: Americanization. References to the pernicious influence of American popular culture began to appear whenever the "levelling down" process was discussed. . . . By the early 1950s, the very mention of the word "America" could summon up a cluster of negative associations.' Hebdige even suggests that the 'spy-masters' Burgess and Maclean who defected to Russia in 1951 were motivated 'by a profound contempt and loathing for America, for American cultural, economic and military imperialism, from the "Americanization" of the globe. . . .'

Certainly Burgess's and Maclean's friends knew that anti-Americanism was one of the few motives they could ascribe to them which had the ghost of a chance of winning any public sympathy in Britain. Burgess had been appointed Second Secretary in the British Embassy in Washington in August 1950. After Burgess's defection, his friend and fellow homosexual Harold Nicolson wrote (*Daily Express*, 14 June 1951): 'He hated Americans. Before he went to Washington Burgess often spoke of this, and I told him he would change his mind when he met the Americans.' Burgess confided in his friend John Hewit before he sailed: 'If I don't like America, I shall make a personal friend of Paul Robeson and get thrown out on two counts' – Robeson being both black and a Communist sympathizer. 'Burgess was as good as his word,' a book of 1955 recorded. 'In so far as a diplomat can be thrown out of a friendly country, he was thrown out of America.'

At the height of the McCarthy purges, pro-Communists such as Burgess and Maclean had of course special cause to be anti-American. There were two main reasons for the more general 'spectre of Americanization': jealousy and fear. Jealousy of American superiority in material riches – which was linked, in the British mind, with the feeling that America had borne less of the brunt of the war than Britain. (This jealousy came to a head when the great brazen American Embassy was built among the quiet mansions of Grosvenor Square in 1958.) Fear that American imports would undermine traditional English culture; and, more than that, a sneaking fear that America was, for the first time in history, taking the *initiative* in culture.

There was no doubt of America's material superiority. The contrast was most glaring in the automobile industry. For a start, a far smaller proportion of Britons owned a car: in 1948 there were just over 2 million private cars, in 1950 between 2.25 and 2.5 million, in 1955, 3.6 million. Second, the kinds of car they owned were different. In 1949 Harvey J. Earl, head of the General Motors styling department, transposed the Lockheed Lightning tailfin to the rear bumpers of the

Cadillac range, inaugurating the age of 'finned monsters'. To Dick Hebdige, the 1950 Cadillac was 'the embodiment in chrome of the American Dream ... untouched by the paternalistic mediations of European "good taste". . . . Here, in the 1950 Cadillac, it was quite evident that the "hallmarks of distinction" had been at last replaced by the fetish of stylistic variation.' The fetish was at its most extreme in the Cadillac Eldorado Brougham of 1957, which for $13,074 offered a dashboard with a tissue box, vanity case, lipstick, and four gold-finished drinking cups. In England, only the likes of Lady Docker, with her gold-plated Daimler, could match such marvels; the nearest the regular car industry came to finned monsterism was the charming 948cc Triumph Herald (1959) with its fledgling fins – a village Cadillac. The English critic Reyner Banham declared: 'Whilst the Russians had been developing "Sputnik" . . . the Americans had been debauching themselves with tailfins.' The words have exactly the patronizing tone of one of the great Lord Birkenhead's biographers, who said of Birkenhead and his Oxford contemporary, the cricketer C. B. Fry: 'While "F.E." made history, C. B. Fry made runs.' Banham made his name as a design guru in the fifties, and his condescension is typical of its time; but it is a green-eyed verdict – Banham would later become infatuated with America and its 'pop', trash culture, and would express those revised feelings in his book *Los Angeles: The Architecture of Four Ecologies* (1971).

In the mid-fifties, the American appetite for luxury, and for the status that luxuries conferred, seemed unslakable. Eric Goldman wrote:

> The America of 1955 was a country where Altman's in New York City had quite a run on mink-handled openers for beer cans and a woman's shop in Beverly Hills, California, sent out charge plates made of fourteen-carat gold; . . . where approximately one hundred million dollars a year – or just about four times the expenditures on public libraries – were paid out for comic books. . . .
>
> Middle-class Americans found money for whisky, flavored toothpaste, glass poles that were guaranteed to frustrate suburban woodpeckers; and radar-type fishing rods that sent out an electric wave to locate the fish and report back where it was. . . .
>
> Millions of American women (an estimated one in three) had the money to go to a beauty shop and have their hair tinted practically any color it was not – Golden Apricot, Sparkling Sherry, Fire Silver, or Champagne Beige. . . . The magazines said 'the influentials' were turning to skin-diving and the sales of web feet were up by more than a quarter of a million. . . .

The diary of Dori Schaffer, 'a child of the fifties who was unable to come to terms with her own generation' and who committed suicide in the early 1960s, shows the revulsion for materialism which could be felt by an intelligent teenage girl who at college (UCLA) was deep into Camus and Sartre. Dori was 20 when, on 14 January 1958, she recorded the first visit to her parents with her new husband:

I am appalled. I'm not sure who I married.

We drove along the winding curve of Los Roubles to the new house on a cul-de-sac in San Marino, a suburb of Pasadena.

Bill reacted like a peasant. He stared at Mom's house, her own design of cathedral glass and Palos Verde stone and gasped, 'You didn't tell me your folks are loaded.'

As we entered the circular parkway Bill couldn't stop talking about the house. Carefully he examined the white stippled concrete with its aggregate stones. He stopped and admired the wooden screen and the exotic tropical plants which surrounded the atrium of the entry.

Dori was an unusually well-off Jewish girl, but many young people had money to throw around in the late 1950s. The American movie *Lost, Lonely and Vicious*, released in 1958, showed teenagers racing about in fast, finned cars, and going down the primrose path of sexual precocity in coffee bars and Hollywood bedrooms. 'Juvenile delinquents' was a phrase current on both sides of the Atlantic (and, as usual, Noël Coward was on hand with an appropriate song). The very word 'teenager' came to have a naughty glamour, like 'flapper' in

The film industry was quick to exploit the interest in 'juvenile delinquents', as in this Howco International production, *Lost, Lonely and Vicious* (1958)

CONFIDENTIAL EXPOSE!

A WHITE HOT STORY OF BOYS AND GIRLS SEEKING SUCCESS IN HOLLYWOOD TODAY!

"LOST LONELY AND VICIOUS"

KEN CLAYTON · BARBARA WILSON
LILYAN CHAUVIN · RICHARD GILDEN
with
CAROLE NUGENT · SANDRA GILES

the twenties. It occurred in the hit song 'Why must I be a teenager in love?' (pronounced '*lerv*' by American singers, to the fury of English teachers in Britain). Between 1956 and 1961 no fewer than eight movies had titles beginning with 'Teenage' or 'Teenagers': *Teenage Rebel* (1956), *Teenage Wolfpack* (1956), *Teenage Bad Girl* (1957), *Teenage Caveman* (1958), *Teenage Monster* (alternatively titled *Meteor Monster*, 1958), *Teenagers from Outer Space* (1959), *Teenage Zombies* (1960) and *Teenage Millionaire* (1961). Teenage gangs and 'cosh boys' (the 1950s term for muggers) were constantly in the news.

As the decade progressed, influential voices in America were raised against the rampancy of materialism. Galbraith in *The Affluent Society* spoke of 'a senseless pursuit of goods while the people flounder.' John Steinbeck in a passionate and much-quoted letter to his friend Adlai Stevenson wrote:

> If I wanted to destroy a nation, I would give it too much and I would have it on its knees, miserable, greedy and sick. . .. [In rich America] a creeping, all-pervading nerve-gas of immorality starts in the nursery and does not stop before it reaches the highest offices. . .. I am troubled by the cynical immorality of my country. It cannot survive on this basis.

Jacket by Ray Scott Campbell for Ruth Chandler's *Too Many Promises*

Cover of Miriam Colwell's *Young*

1950s 'Bow 'n' Hank' set by Mosley, England

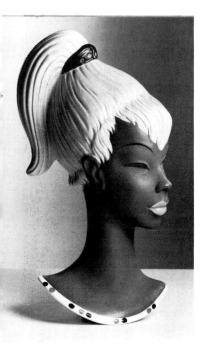

German terracotta head of girl with pony-tail hairstyle. Mid-late 1950s

Britain had by no means reached the American condition of surfeit, in spite of Harold Macmillan's assertion in 1957 that 'You never had it so good.' Even so, Richard Hoggart attacked materialism in his 1958 book *The Uses of Literacy* (the book that every sixth-former absolutely *had* to have read if he wanted to do well in examination general papers) with the same tone of moral outrage as Steinbeck and Galbraith. He held up to scorn the 'shiny barbarism' of the fifties, 'the ceaseless exploitation of a hollow brightness' and the 'spiritual dry-rot' of a 'Candy Floss World'. In a parody of 1950s romantic fiction, he envisaged a 'Kosy Holiday Kamp' with 'three dance halls, two sun-bathing parades and lots of milk bars.' Innocuous enough institutions, one might think; but to Hoggart they were arenas of juvenile corruption, of abandonment of thought in the vacuous pursuit of pleasure.

America was seen as the chief agent of this corruption, with its horror comics, bubble gum, automobile fever – above all the rock culture it was importing. The Establishment did its best to put up the barricades. Dick Hebdige claims that BBC personnel were aware of 'the "damaging", indeed potentially subversive, impact which American cultural artefacts (particularly popular music. . .) could have on public "morale".' He adds:

> Despite the relaxation in the tone and style of BBC broadcasting, allegedly affected by the advent of commercial television in 1954, rock 'n' roll was deliberately ignored and resisted by the BBC radio networks. British balladeers and cabaret-style singers were systematically favoured, and in 1956, the year when Elvis Presley's *Heartbreak Hotel* was released, not one rock 'n' roll song was featured in the annual review of popular songs.

But men further-sighted than the BBC mandarins realised that Presleyism was more than a passing phase, a barbaric novelty which could be negated by ignoring it. In his poem 'Elvis Presley' (1957), Thom Gunn wrote:

He turns revolt into a style, prolongs
The impulse to a habit of the time.

It was not only in popular music that America seemed to be taking the initiative and dominating. It was in the ascendant in 'high culture' too. In his brilliant book of 1959, *The Tradition of the New*, the American art critic Harold Rosenberg invented the word 'Coonskinism' to describe the American contribution to art. 'Coonskinism as a principle won ascendance in American painting for the first time during World War II,' he wrote. 'With no new styles coming from Europe – and for deeper reasons than transportation difficulties – American artists became willing to take a chance on unStyle or antiStyle.' Rosenberg was referring to the 'action painting' of Jackson Pollock and Willem de Kooning. (Rosenberg had invented the term 'action painting' and de Kooning designed the dust-jacket of *The Tradition of the New*.) This style, in Rosenberg's words, 'emphasized the creative bearing of such elements of creation as the mistake, the accident, the spontaneous, the incomplete, the absent.'

Jacket by Willem de Kooning
for Harold Rosenberg's
The Tradition of the New (1959)

American supremacy seemed to run across the cultural gamut. One contributor to a symposium on the arts edited by Robin Ironside in 1956 asked: 'What novels of any worth have been written in Britain since *Women in Love* and *A Passage to India*?' In America, Faulkner and Hemingway were still writing novels. Tennessee Williams and Arthur Miller (accoladed by marriage to the supreme 1950s sex-symbol, Marilyn Monroe) were writing plays. The greatest living poet, T. S. Eliot, though he might be hopelessly Anglophile, was also an American. And for most people, American films and film-stars were still the only ones that counted. Only perhaps in music, with Benjamin Britten, had England a claim to superior genius; though in terms of effect on civilization, Presley's rock and the film version of Bernstein's *West Side Story* (1961) far outweighed Britten's contribution.

But by the later fifties there were signs of a real challenge to the American cultural suzerainty, both in 'high design' and in the popular arts. Suddenly, everything was coming up Italian. Vespa and Lambretta motor-scooters were the supreme status symbols for teenagers. Loren and Lollobrigida were in their prime. The most extreme Paris fashions bore an Italian name, Schiaparelli. In coffee bars (even more iniquitous and ubiquitous than milk bars) teenagers guzzled 'froffy coffee' from espresso coffee machines (known as 'Expresso' in England). Songs like *Ciao, ciao bambina, Arriverderci, Roma* and *Che sera, sera* battled with Elvis on the pop charts. From Italy came stiletto heels and winkle-picker shoes. Schoolboys read the dirty bits of Moravia's *Woman of Rome* under the desk lid.

Already in the later 1940s, Italian designers such as Carlo Mollino, Paolo Buffa and Enrico Rava were designing furniture more original and 'futurist' (to use an Italian term) than any being made elsewhere

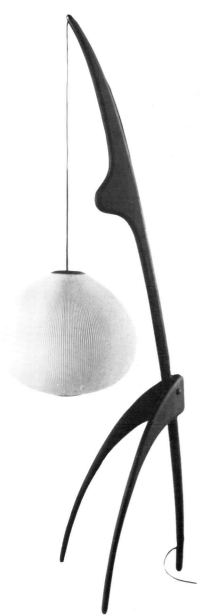

1950s lamp by Carlo Mollino, Italy

in the western world. With justice the Italians now look back on the 1950s as a period of magnificent design innovation: this has recently been celebrated in an impressive book, *Il Design Italiano degli Anni '50* (edited by Andrea Branzi and Michele De Lucchi, 1980). The 'Italian design phenomenon', these authors suggest, like neo-realism in the cinema, had an advantage over the other art disciplines: both had 'a lesser tradition behind them' – no titanic Michelangelo or Bernini or Dante to imitate or give them an inferiority complex. The result was innovation without too many restraints. Interior design became an obsession of urban Italian society of the 1950s, just as film clubs were its intellectual training grounds. New magazines, new shopping centres and new houses 'announced the irresistible springtime' of a new Italian architecture, industry and design.

As early as 1952, an editorial in the art and design magazine *Domus* was crowing:

> Italy has, with Piaggio's designers, characterized the scooter, and she has very well-designed motor-cycles like Motom 'Delfino' and the Rumi; a great industrial motor-cycle designer, Renzo Orlandi of Modena, and Viberti of Turin; the most attractive sewing machine in the world, the Visetta; Pavoni's espresso machine, Cassina's chairs and the Rima metal chairs and cabinets, the fantastic Pirelli floorings, Crippa's perfect packagings, and the 'Carro di Fuoco', the Liquigas coach designed by Campo and Graffi; she has the two-deck OM railcars by Zavanella, the VIS writing desks by Rosselli, Albini's folding units for the Rinascente, the products designed by Zanuso for Prodest-Gomma, the Solari clocks and watches by the studio BBPR, the furniture designed by De Carli, Mollino, Romano and Viganò, the Arteluce lamps, etc. . . . The beautiful, pure and simple 'Italian line' . . . has been finally recognized the world over.

In a half-devastated country which 'had 20 years to forget behind it', design stood for the hope that industrial production could be used to attain the cultural revolution that politicians and clerics had obstructed, could be a tool for framing a new society. Italian industrial designers would 'manage' culture. They would challenge the American business-oriented definition. Aestheticism would be pitted against materialism. The desires of the designer were to be elevated above those of the consumer. Not that Italian businessmen were oblivious of the exploitation potential of the 'Italian line', which could 'act as a bright substitute for . . . engineering weaknesses to beat competition'. But the business tradition of the Olivettis and the Brustios was itself enlightened.

The supposed political/metaphysical implications of the new Italian style were lost on the English and other Europeans who welcomed it into their homes so enthusiastically. What for the Italians was symbolic and a 'tool of cultural revolution' was to the English just 'Contemporary'. Just style, in fact. The style has been defined as 'radical erosion of the product', which is a fancy way of saying simplification for effect.

1950s desk by Olivetti, Italy

But it was more than that. It had a vitality, a novelty and an element of the shocking which were just what war-jaded, austerity-cramped nations felt the need of. To the Italian designers their creations might be 'the place of the mediation between contradictions' or anything else that gobbledygook jargon might suggest. To the customer, they were fun. Italian design was a sign-language, a stylistic code which all could decipher. Like Art Deco in its time, the high Italian design percolated downwards rapidly. 'Even the smallest joiner's shop,' Branzi and De Lucchi write, 'soon learned how to make bar counters that looked like Gio Ponti's own designs, the smallest electric work-shop soon learned to make lamps that looked like Viganò's. . . .' The style 'finally replaced Fascist tinsels and the provincial Ottocento'. It was the first mass use of any style in Italy since Art Nouveau Liberty (even Art Deco had not fully 'taken' there).

Italian 1950s design avoided the historical trap of imposing a reductive, punitive model habitat. The Bauhaus had reduced architecture to poverty level – severe clinical blocks little more attractive than gas chambers (which their owners quickly busied themselves in humanizing, tricking them out with ruched curtains and *kitsch* vases). Italian designers of the 1950s recognized what people really wanted. Without descending to meretricious ritziness (as American designers were prepared to do, to humour the customer), they were attuned to the spirit of the time: good design did not have to be sunk in historicism.

1950s Venetian glass vase by
Aldo Nason

OPPOSITE

The American Dream in
danger: jig-saw puzzle of
forest fire in California, late
1950s

Space-age toys of the 1950s.
Dan Dare was the hero of the
children's comic *Eagle*,
founded by the Revd Marcus
Morris in April 1950

The Venetian glassmakers are a good example of a surprising receptiveness to new ideas. One might have expected them to cold-shoulder the style which belonged to espresso machines and scooters. Some caution and conservatism would have been excusable in the heirs to a proud and ancient tradition. (The *recorded* history of Venetian glass begins in AD 982.) But on the contrary, the glassmakers of Murano, Venice, took up the style and expressed it with wonderful zest and freedom from inhibition. Aldo Nason, the son of a traditional Murano glassmaker, Emilio Nason, might easily have become an unremembered maker of tourist souvenirs. Instead, he took manic 1950s shapes (some like hollow tree stumps or the roots of prehistoric teeth) and filled them with audacious colour effects. His vases are like the jars in old-fashioned sweet shops, filled with dolly-mixtures, bullseyes and hundreds-and-thousands. And these sweets are not kept separate. Through a seething morass of mauve lozenges surges a river of brilliant lemon yellow. It is an offence against every tame interior decorator's rule-book on colour harmonies. It is a frontal assault on Good Taste. It did for glasswares what Elvis was doing for pop music, replacing an anodyne traditionalism by something with spirit, youth and vivacity. And femininity. That was perhaps the most distinctive and pervasive aspect of the Italian 1950s style. It was a homage to the female shape, whether in hourglass vases (a shape echoed in the guitar, the quintessential 1950s instrument), armchairs, wickerwork tailors' dummies or the design of the Vespa motor scooter ('Vespa' means 'wasp', and the name was given to the scooter because of its 'wasp waist'). We remember that the 1950s were the decade of the 'sweater girl', of Sabrina, renowned for her dumbness, blondeness and bust, of Marilyn Monroe, Jane Russell, and the special cantilevered brassiere which Howard Hughes designed for Jayne Mansfield – 'immoral uplift', as someone commented.

Of course the growing influence of the 'Italian line' did not prevent the designers of other countries from making distinctive contributions to 'Contemporary' style. Scandinavian glass was immensely popular, including the high-quality wares of Orrefors, who, like the Murano glassmakers, proved able to adapt to the times. Some of the most archetypally 'fifties' jewelry also came from Scandinavia: Jensen, who had been among the leading Art Deco jewellers, now designed bracelets, pendants and necklaces which could come from no other decade than the 1950s. An American family was far more likely to have Eames chairs than Mollino ones; English families could buy some of the advanced furniture designs being sold by Heal's. The old-established French silversmiths, Christofle, who had distinguished themselves in the 1920s and 1930s, showed that the spark of creativeness was not dead in Paris. Even Asprey's of New Bond Street, London, perhaps the most doggedly traditional of English firms, produced some flamboyantly 'Contemporary' candlestands in 1958. The Chelsea Pottery

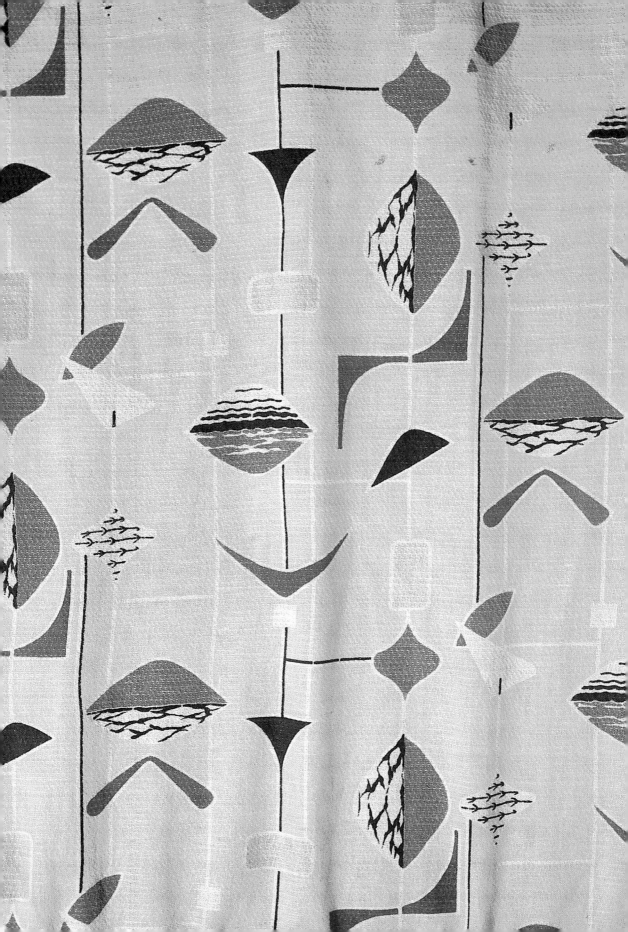

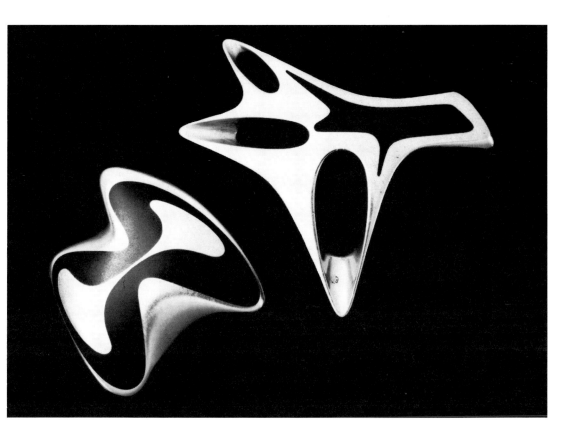

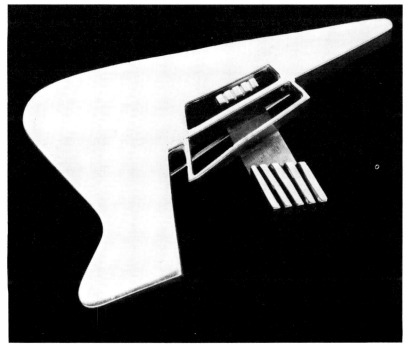

1950s brooches by Henry
Koppel in silver and green
enamel and silver and black
enamel

1950s silver and applied gold
'revolver' brooch by Margaret
de Patta, New York

OPPOSITE

Italian textile design, *c.* 1957

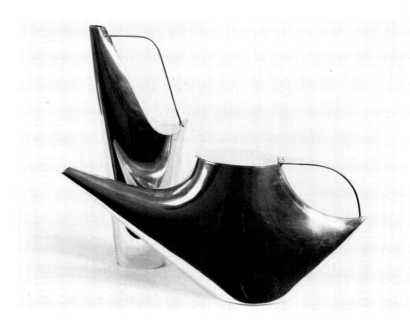

Coffee pot and teapot in silver by Christofle, France 1950s

A heavy Asprey seven-light candlestand designed by Jeus Andreason, the oval sconces rising from a base of twisting tubes. 33.6 cm wide, London 1956

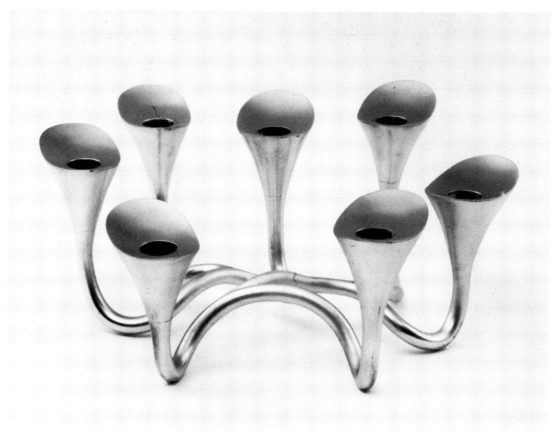

Film poster for *East of Eden* starring James Dean

was already making the delightful enamelled platters which they are making still. 'Picasso-type' faience (some signed by the old master himself) was a staple of tourist merchandise in France. American movies helped to perpetuate American country dress for teenagers (Monroe for girls, Elvis and James Dean for boys); but English boys at least devised their own national dress: the drape jackets and drainpipe trousers of the 'Teddy Boys' were fondly supposed to be a revival of gentlemen's dress of the reign of King Edward VII. This fashion could perhaps be seen as the first manifestation of two traits which were to become dominant in the 1960s: the assertion of a distinctively 'British' look; and the move towards a so-called 'classless society' by the yobs imitating the nobs.

But in the late 1950s, the 'Italian line', like Hogarth's serpentine 'Line of Beauty' in the 1750s, was still the line of least resistance. Writing in 1961, T. B. Fyvel in *The Insecure Offenders: Rebellious Youth in the Welfare State* recorded the switch from Teddy Boy style:

Step by step, through various deviations, the clothes and haircuts grew less eccentric and extreme, until at the end of the fifties they had become

unified in the rather attractive 'Italian style', which had become normal walking-out wear for the working-class boy; and by 1960 this had blended with 'conservative cool', or just very ordinary but well-cut clothes.

Len Deighton's *Ipcress File* (1962) contained this passage:

> I walked down Charlotte Street towards Soho. I bought two packets of Gauloises, sank a quick grappa with Mario and Franco at the Terrazza, bought a *Statesman*, some Normandy butter and garlic sausage. . . . In spite of my dawdling I was still in Lederer's Continental coffee house by 12.55. . . . Jay had seen me of course. He'd priced my coat and measured the pink-haired girl in the flick of an eyelid. I knew that he'd paid sixty guineas for each of his suits except the flannel one, which by some quirk of tailor's reasoning cost fifty-eight and a half. . .

Dick Hebdige, who quotes this passage, observes that Deighton's spy, Harry Palmer, is defecting not to Russia, still less to America, but to Italy ('Mario', 'Franco', 'frappa') and the Continent ('Gauloises', 'Normandy butter', 'garlic sausage'). And Hebdige, who wrote about 'the spectre of Americanization', now chronicles its laying:

> It is perhaps the final irony that when it did occur, the most startling and spectacular 'revolution' in British 'popular' taste in the early sixties involved the domestication not of the brash and 'vulgar' hinterland of American design but of the subtle 'cool' Continental style which had for so many decades impressed the British champions of the Modern Movement.

1960-1980

Swinging Sixties | Cynical Seventies | Pop/Psychedelia/Punk

Cover of *The Twist*,
USA, 1960

In January 1960 Paul Reilly succeeded Sir Gordon Russell as Director of the Council of Industrial Design in London. He contributed the *Design* magazine leader for the first issue of 1960, which was headed 'The Challenge of the Sixties'.

'We have just lived through 10 very formative years in the history of modern design,' he wrote. 'Thanks to the spadework of the 1950s, the 60s could be a decade of remarkable achievement, given certain conditions.' He hoped that those 'at the social centre of gravity' in Britain would give a lead, and that the world would begin to look to Britain, not to Scandinavia, Italy or the United States, for 'leadership in design'.

Reilly asked overseas propagandists to 'declare a close season for beef-eaters and halberdiers, and to concentrate for a while on our more up-to-date appearances, lest the world should come to look upon us as the Old Curiosity Shop of Europe'. As he pointed out, Italy had even more ancient traditions, but it was for her modern work that she was admired and copied.

In the 1960s, Reilly's hopes were to be realised – though not perhaps in the way he had envisaged. Britain shed its fusty, olde-worlde image, and 'Swinging London', with its Beatlemania and Rolling Stones, its Carnaby Street and mini-skirts and Chelsea boutiques, became a world influence in lifestyle and fashion.

The exact origins of the phrase 'Swinging London' are lost in the twists of modernity. Some trace them back to the catchphrases of the popular television comedian Norman Vaughan – 'Swinging! . . . Dodgy!' But John Anstey, Editor of the *Telegraph Sunday Magazine*, believes that Diana Vreeland, that supreme arbiter of fashion, first used the words 'swinging' and 'London' in the same breath, and that they were first printed together in his magazine (then the *Weekend Telegraph*) on 30 April 1965.

Earlier in 1965, Anstey was staying at the Crillon Hotel, Paris. Miss Vreeland was staying there too, and asked him to her suite for a drink. Looking across the city from the penthouse window, Anstey said how much he loved Paris. '*I* love London,' Miss Vreeland replied. 'It is the most swinging city in the world at the moment.' When Anstey arrived back in London, he commissioned an American journalist, John Crosby, who was London columnist of the *New York Herald Tribune*, to produce a feature on Swinging London with illustrations by the German photographer Horst Munzig.

Unfortunately, Munzig was only interested in the picturesquely archaic aspects of England – bowler hats, guardsmen's uniforms, the odd horse-drawn carriage. But Crosby quoted Vreeland's comment, and the magical phrase recurred in a caption: 'The life of the city is the people who live there, the rhythm that pulses through its crowded streets. Compulsively people gravitate to the capital from the provinces and abroad drawn by a kind of telepathy of talent, ideas and

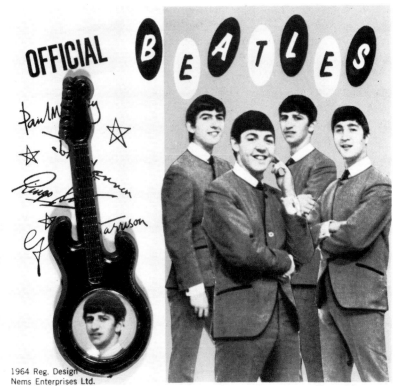

1964 Reg. Design
Nems Enterprises Ltd.

Clean-cut Beatlemania of the
early 60s
Plastic 'Ringo' lapel badge in
guitar-shaped frame

Wearing old military uniforms
was the fashion when Ricio
designed this 'Carnaby Street'
postcard

action, until the scene explodes – and London is a swinging city.'
Crosby described, though Munzig did not photograph, the institutions
of Swinging London: the nightclub Annabel's, Mary Quant's bouti-
que in Chelsea, the Beatles, and Carnaby Street, which 'pulses with
slender young men in black tight pants that fit on the hips like ski
pants, their tulip-like girl friends on their arms, peering into the gar-
ishly lit windows at the burgundy coloured suede jackets with the
slanted, pleated pockets – very hot stuff with the Mods right now.'

Three weeks later a reporter from *Time* magazine came to see John
Anstey. She had been sent to write a cover story about the wonderful
new Swinging London. The *Time* article gave Swinging London
international recognition. London was 'where it was at'.

Did this English renaissance happen through the 'leadership' Reilly
had demanded? Or did it happen through the welling-up of a new
popular culture from below and its *adoption* by the commercial
exploiters and the panjandrums of the art world? In pop music, cer-
tainly, the initial impulse seemed to come from below, with Elvis
'turning revolt into a style' and the Beatles rising to messianic status
from working-class Liverpool. But could the same be said, for exam-
ple, of Pop Art? Again the English led the way: Richard Hamilton
and Peter Blake had already pioneered in the fifties this definitive art
movement of the sixties, of which David Hockney and Allen Jones

Influence of Op Art: 'Saturn'
by Peter Perritt, part of the
1966 Constellation range
designed by him and Isobel
Colquhoun for Simpson &
Godlee Ltd

were also to be key figures, alongside Warhol, Lichtenstein, Olden-
burg, Jim Dine and the rest in America – and Bridget Riley was to
be the outstanding practitioner of Op Art, though that was pioneered
by Victor Vasarely. But while the Pop artists might find their inspi-
ration in the *schlock* and *kitsch* of magazine ads, comic strips and deter-
gent packets, they were sophisticated commentators, manipulating,
satirizing and parodying the images they found.

And what of design? Superficially England might seem to take the
lead in the sixties, but the philosophy which underlay 1960s design
still came from America. Nobody realised this more clearly than the
English founding father of Pop Art, Richard Hamilton, who asked
in a lecture at the Institute of Contemporary Art, London, in 1959
(summarized in *Design*, February 1960) what were to be the differences
between the 1950s and the 1960s. He suggested that the old high-falu-
tin' ideas about 'honesty' in design – truth to materials and function,
and 'the fulfilment of basic human needs' – would have to give way
to the American deference to market demands. He quoted an Ameri-
can manufacturer who had said to his young British assistant: 'What
you describe as good design is merely what we would call "high style".
But it would be no good designing a "high style" product for a honky-
tonk Mid-West market.' Hamilton concluded that the consumer
would have to come 'from the same drawing-board' as the product:
in other words, if you had to kowtow to popular demand, you had
better try to influence what that demand would be.

In the 1950s, the Americans had perfected the technique of 'design-
ing the consumer to the product', instilling in people a 'desire for pos-
session' and creating an 'image' into which people wanted to fit.
Arthur Drexler, the great automobile designer, had suggested that the
designer needed 'the training and inclinations of a psycho-analyst'.
Look magazine, introducing 'the FABULOUS FIFTIES look', the 'age of
everyday elegance', had suggested that 'Functionalism today is not
enough for Americans.' Designers must now offer 'Plush at popular
prices.'

If you were going to try to influence the consumer, you needed
to find out as much about him as you could. Market research was
the American pseudo-science which claimed to do this. In *Design*,
November 1960, commenting on Hamilton's lecture, Reyner Banham
wrote of 'a sort of sporting relationship between the consumer and
producer, of which market research is the outward symbol.' In the
same month it was announced that a new company, Business Research
Associates, had been founded to carry out market research for industry
in Britain. Based on Dr Ernest Dichter's organization in the United
States, it had two psychologists and a sociologist on its staff.

But Richard Hamilton, being an artist, could not accept that con-
sumer research could give *all* the answers. The researcher could not
supply the 'image'. That, Hamilton argued, could only be created by

the designer, the artist. So he denied that the impulse came from be-
low: 'The mass arts, or pop arts, are not popular arts in the old sense
of art arising from the masses. They stem from a professional group
with a highly developed cultural sensibility.'

An important ingredient in the new American philosophy which
outraged most of the old truth-to-material designers, was the cheerful
acceptance of 'obsolescence'. In 1950s America, production was no
problem: the difficulty was to consume at a rate which would keep
up with production. In increasingly affluent Britain the same con-
ditions began to obtain after years of austerity. 'Built-in obsolescence'
was the answer, with cardboard furniture, throwaway paper knickers,
and plates and flatware which could simply be junked at the end of
a flight.

According to a survey by the Chase Manhattan Bank in February
1969, the tonnage of reinforced paper and 'non-woven fabrics' in the
United States had grown from 10m.lb a year in 1960 to 40m.lb in
1968. (Non-woven fabrics were made of synthetic fibres – rayon or
nylon – bonded with heated glue). In March and April 1970 the Design
Centre, London, staged an exhibition of disposables called 'Here
Today'. The exhibits included tissues, towels and, somewhat gratui-
tously, lavatory paper – whose destiny had always been to be disposed
of. But there were also clothes by Goujon (Paper Togs) Ltd. It was
(wrongly) estimated in 1970 that 10 per cent of the 20m. United King-
dom people in the age-group 14–35 years would be converted to the
use of disposables in five years' time. Given a daily rate of one pair
of disposable panties per woman, 1.2m. pairs a day or 437m. pairs
a year would be a possible market. Add 218.5m. pairs for men, and
paper knickers alone would be worth £24.1m. The large paper com-
panies, such as Bowaters, licked their lips; but they should have been
warned by the experiment of 1966, when paper dresses had proved a
flop both in Britain and America. 'Maybe they just weren't marketed
right,' Andy Warhol suggests, pointing out that in one big store they
were sold in the 'notions' department – in other words, just as a 'fun'
novelty, not as serious clothing. And paper dresses were mainly re-
served for 'fun' occasions, such as the opening, in 1970, of the Frederick
Glaser Fashion Center on Chicago's North Side. The interior by Ron
Zocher was described as 'looking like a discarded set for *2001*'s Space
Hilton Hotel' – a spherical, bi-level saloon with walls covered in mir-
rors and heavy-duty vinyl. Floor surfaces and desks were covered in
seamless white melamine. Clients at the Center were garbed in
'brightly-colored, fireproof paper gowns and slippers' by the Kimber-
ley Clark Corporation.

The idea of obsolescence never really caught on in clothing. It had
more success in furniture. In 1968 *Design* reported that 'Jean-Louis
Avril, an architect, is concerned with the unexplored uses of card-
board, not only in furniture but in the possibly more important field

Upholstered dining chair from
the Maxima Collection
designed by Max Clendinning
for Race Furniture Ltd, 1966

of temporary, quickly erected structures, and undulating screens for commercial purposes. . . . His new chairs resemble those of African chieftains, and have high comfortable backs which cardboard chairs often lacked.' The most lasting application of impermanence was in containers for drinks. Long Life beer came in short-life cans. Soft drinks were sold in 'one-trip' glass bottles. In the mid-seventies there was briefly a scare in New York that Coca-Cola cans might mean the end of the immortal Coca-Cola bottle.

The throwaways caused a new environment problem: they stayed around. Refuse was becoming a luxury. Local councils, expected to perform the disappearing trick, charged more for the performance. The Keep Britain Tidy Group made an experiment at Chessington Zoo, Surrey: on alternate Sundays paper cups printed 'For God's Sake Put Me in the Litter Basket' were issued, and the number which ended up in the baskets was compared with the number of blank cups placed in them on the other Sundays. The pious message did not seem to have much effect. With renewed concern for the environment in the early 1970s, 'recycling' of waste was encouraged. Centres were set up in big cities for the reception of empty bottles and used tins. And as recessions set in, people again wanted furniture and household utensils which would last.

A more positive American contribution to design than obsolescence was ergonomics, or 'human engineering' – the science by which furniture and appliances used by humans were adapted to human dimensions and the range of human movements. In the age of technology, custom-building was seldom possible. With industrial mass-production, it made sense to get the answer right first time, keeping the trials and errors to the drawing-board. Shortly after the war, the American industrial designer Henry Dreyfuss was working with colleagues on the interior of a heavy tank for the army. As a result, they hit on the idea of 'anthropometric charts' showing the human body in different postures. The revised and expanded second edition of Dreyfuss's set of charts, *The Measure of Man: Human Factors in Design*, was issued in 1959.

Five years of medical investigation of comfort criteria for air travellers went into the executive-carrying JetStar aircraft, designed by the Dreyfuss Organization for the Lockheed Aircraft Corporation, USA, and in use by the early 1960s. X-ray photographs were used to develop an armchair which supported the body weight about the 'ischial tuberosities' (the bony points within the buttocks). Dreyfuss collaborated with Lockheed on the whole of the interior design. A mock-up of the JetStar interior was built in the designers' office so the team could learn at first hand how much leg room was needed and what other snags might arise.

English designers were also keen to learn about ergonomics. In 1960 the British Council held a course, 'Introduction to Ergonomics',

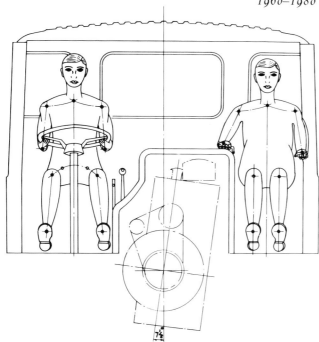

Ergonomics: Leyland's 'ergomatic cab' for long-distance lorries, 1965. The driver was given ample room to operate the controls. None was offset. The engine had to be pushed to the side and the bonnet top indented to give the required working space. The arm supports for the mate were built up to help hold him in a relaxed position

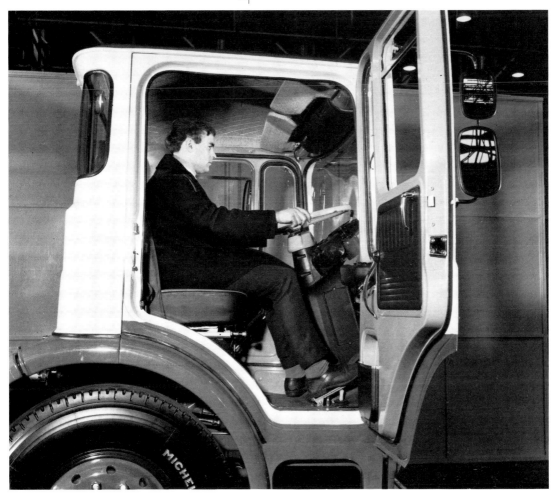

The transistor radio as
status symbol: a Hallmark
eighteenth-birthday card

Moulton mini-automatic
bicycle, 1966

attended by eleven overseas specialists, one of whom, S. Griew, spoke on 'The Human Being as a Receiver and Processor of Information'. The old guard tended to regard this as absurb gobbledygook, but the younger designers enthusiastically applied ergonomics to their commissions. The definition of a Good Bed was under discussion. Thousands of photographs of a man in pyjamas, lolling and rolling about in sleep, determined 'the ideal dimensions of a mattress'. Bed manufacturers were now to take into account the difficulties of cleaning under a low bed or of making a high one. They were also ordered to 'eliminate squeak'.

Ergonomics were also applied to flatware. When Gerald Benney designed silver for the Ionian Bank's new premises in Coleman Street in 1960, one complete set was made up in his workshop and was used by the directors; minor modifications were made before approval was given. Hi-fi equipment benefited from the new science. Even the anthropometrics of the lavatory came under careful scrutiny. 'Is the WC seat too private and delicate for logical theory?' asked J. Beresford Evans. Apparently not: *Design* magazine proudly noted that 'The conception of a lavatory basin as an integral part of a work top is not new but has recently been revived in the form of a "vanitory unit".'

The units were getting smaller. Many people were being moved out of old semi-detached villas into flatlets in high-rise blocks – 'little boxes made of ticky-tacky', as Tom Lehrer put it in one of his satirical songs. The philosophy of 'Small is Beautiful' was coming in, though that parrotable phrase had not yet been popularized by Robert Schumacher's book. As early as 1960, Eric P. Danger, an American specialist in industrial market research, suggested that the 'disaster' of the Edsel car (which had sold badly) could have been avoided by observing the way taste in cars had been going throughout the 1950s: 'it should have been obvious that the demand for bigger and better cars was reaching its peak, and that the future trend was likely to be towards the smaller, more compact car as has actually been the case.' The bubble car and mini cars, British innovations, were followed in Italy in 1970 by Fiat's Autobianchi A112, a compact four-seat family saloon. The huge increases in petrol prices in the 1970s added to the popularity of small, low-consumption cars. The 'finned monsters' which had proclaimed status in 1950s America were beginning to seem prehistoric.

In 1960, Max Braun's pocket-sized combined radio and record-player (only $9 \times 6 \times 2$in. when the two parts were coupled together for carrying) was exhibited at the Milan Triennale, alongside a portable, battery-operated television receiver with transistor circuitry and 8-in. picture tube by Sony. In 1961 the 'Rio' transistor radio won the Duke of Edinburgh's design award. Designed by Eric Marshall for Ultra, it was still in the characteristic 'wedge' shape of the 1950s, but in miniature.

Much of the miniaturization of the sixties and seventies was for fash-

Trojan bubble car, 1966.
Length, 8 ft 10 in.

Hope your 18th Birthday gets off to a great start...

Moulton mini automatic

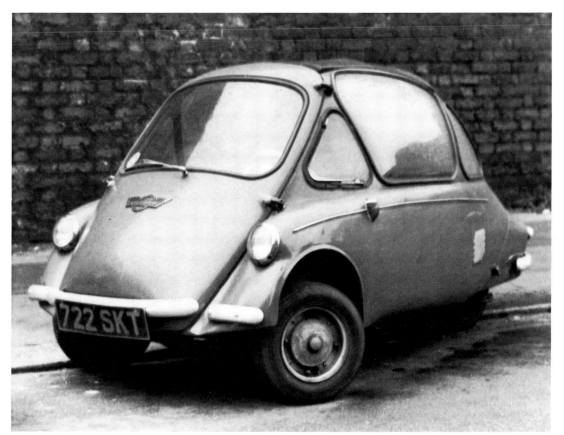

Cover of *Private Eye*,
1 November 1963, after
Harold Macmillan's
retirement. (It implies that he
had prevented R. A. Butler
from succeeding him)

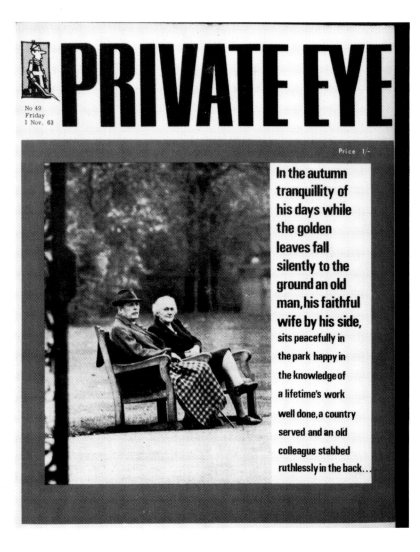

ion and stylistic effect, rather than for convenience. This was certainly true of the mini-skirt of the mid to late 1960s – one case where small really was beautiful. (Though the usual old miseries made sour jokes about 'pelmets'.) There was small pleasure in watching the postcard-sized picture on one of the really small television sets: they were just an amusing novelty for picnics. The new fashionable appeal of the miniature was exploited by Tiger Morse in August 1966 when she called her new boutique on upper Madison Avenue, New York, 'Teeny Weeny'. Political commentators spoke of 'mini-revolutions'. A pop group called itself the Small Faces. The heroine of the Rocky Horror show called herself Little Nell – hardly what Paul Reilly had had in mind when he worried about Britain becoming 'the Old Curiosity Shop of Europe'.

At the beginning of the sixties, there was a feeling of 'the world's great age begins anew'. What was happening in politics chimed in

with this mood. In the United States, the bumbling old figure of Eisen-hower, superannuated warrior, was replaced by the dynamic young President John F. Kennedy. Norman Mailer praised Kennedy in a magazine article titled 'Superman comes to the Supermarket'. He later explained:

> I knew that if he became President, it would be an existential event. . . . Regardless of overt politics, America's tortured psychotic search for security would finally be torn loose from the feverish ghosts of its old generals, its MacArthurs, and Eisenhowers . . . and we as a nation would finally be loose again in the historic seas of a national psyche which was willy-nilly and at last, again adventurous.

In England, Harold Macmillan, a relic of Edwardian England portrayed by the young satirists of *Beyond the Fringe* as teetering on the brink of senility, and his chosen successor, Lord Home (usually represented by the cartoonist Gerald Scarfe as a death's head on spider legs) were succeeded by the Labour leader Harold Wilson, a hard nugget from the north who spoke rousingly of 'the white heat of technological revolution'. The young men who came to notice in the 1950s were rebels, Angry Young Men, Outsiders – men like Brendan Behan, Colin Wilson, John Osborne. By contrast, the new man of the sixties was David Frost, a 'classless' figure in a dapper business suit: satirizing the Establishment, but still of it. In spy fiction, the wholesome, immaculately tailored James Bond, a Bulldog-Drummond-like figure, superseded the sleazy anti-heroes of Eric Ambler and Graham Greene. The male protagonist of the British television series *The Avengers*, in which Diana Rigg made her name, wore a bowler hat, carried a rolled umbrella and was called Steed, a name suggestive of both grooming and chivalry.

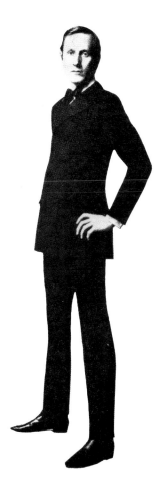

There was a new, crisp, clean image for young people. The Beatles' manager Brian Epstein showed sound commercial acumen when he got them out of their tacky 'skiffle' gear and into smart lapel-less suits, and made them brush their hair into gleaming black scarabs. The sort of transformation was taking place that Patrick Balfour (later Lord Kinross) had noticed in the 1930s when he illustrated how the vague, fluffy 1920s appearance of Lady Louis Mountbatten, Lady Dalkeith and Lady Haddington was changing into something more positive – a hardening of image. In 1960 Warhol admired at Max's Kansas City, New York, 'hard-looking, beautiful little girls with perfect make-up and fabulous clothes . . . you'd find out later they were 15 and already had a baby.' In a 'nostalgia' article about the 1960s in *TV Times* (Great Britain) of 19 June 1975, Jill Whiffing recalled: 'Like Mary Quant, I visited Vidal Sassoon and exchanged my curls for a ruthless geometric cut. It was the reverse of today. Then, everyone was desperate for straight shiny hair, and girls with curls either hid their heads in shame or ironed their hair under brown paper.'

Black mohair suit with silk facings: the 1967 Blades look by Rupert Lycett Green, from *Dress Optional* by Rodney Bennett-England, published by Peter Owen Ltd, London

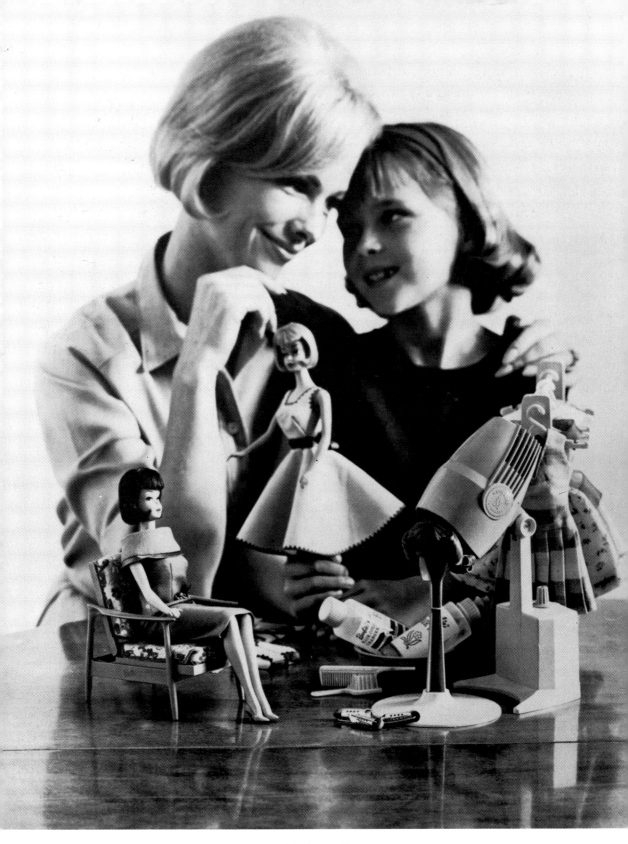

Barbie fashion dolls, by Mattel Inc. 1965

The Mods, in their streamlined outfits, were taking over from the slovenly rockers and beatniks of the late fifties. On 2 August 1964 the *Sunday Times* colour magazine, London, published a picture feature about the Mods under the headline 'Changing Faces'. One caption read: 'They have been called the anti-hoorays. "But you can tell us by the way we walk – feet out," said one Mod. "Rockers are hunched. We hope to stay smart for ever, not shoddy like our parents."'

There was to be an end to the age of shoddy, to the post-war period of 'making do'. And there was to be an end, too, to gulping up culture wholesale from America: Swinging London was confident enough now to wage a war of independence. Another of the *Sunday Times* captions read:

American styles are out, like Madras cotton jackets, and Seven and Sixes – that's the name we give to baby Mods who're still wearing these 7s 6d T-shirts from Woolworth's. Denzil says it's suits now, and basket shoes. You need £15 a week to be a leader – most Mods make between £8 and £10 a week and spend about £4 on clothes. 'It's pure dress now,' says a 'stylist', 'no gimmicks. Your handbag has to look expensive inside, it could never be plastic.'

American styles were also going out in America. In his memoir of the 1960s, Andy Warhol remembered the summer of 1963 as 'the last summer before the English invasion.' In the spring he had already met David Bailey and Mick Jagger, apostles of the new English dandyism: 'They each had a distinctive way of dressing: Bailey all in black, and Mick in light-coloured unlined suits with very tight hip trousers and striped T-shirts, just regular Carnaby Street sports clothes, nothing expensive, but it was the way he put things together that was so great. . . . And of course both Bailey and Mick were wearing boots by Annello and Davide, the dance shoemaker in London.' Warhol had already met Nicky Haslam, art director of *Vogue*, who had come to New York from London in 1962 when his friend David Bailey brought over his newest model, Jean Shrimpton, to work for *Vogue*. 'It was from Nicky [Warhol wrote] that we first started hearing about the mod fashion revolution in England that had started in '59 or '60. Nicky may actually have started the frilly men's shirt look because I remember him getting curtain lace at Bloomingdale's and tucking it up his sleeves and everybody would be asking him where he got the "great shirt" because they'd never seen anything like it.'

When Warhol met Jimi Hendrix (then still known as Jimmy James) in 1966, Hendrix had 'short hair and really beautiful clothes – black pants and white silk shirts': the 'pirate prince' look came in 1967 after Hendrix returned from a trip to England as 'the Jimi Hendrix Experience'. In 1966 he was 'just simple black and white elegant'. Warhol's London art dealer Robert Fraser was 'beautifully tailored in pin-stripe suits'. And the new lieutenant Warhol acquired in the same year, Fred Hughes, 'insisted on Savile Row suits. Everyone always stared at him

The groomed 1960s look: the author's sister in 1961, with Millicent Martin haircut

Jimi Hendrix coat-hanger by Saunders Enterprises. English, late 60s

because he was so perfectly tailored – like something out of another era. When he came by that first day, he was wearing a flared, double-vent dark blue suit, blue shirt, and light blue bow tie.'

In 1967 Jonathan Aitken published his book *The Young Meteors*, which was about successful people under 30 earning more than £3,000 a year. (That was a time when £1,000 a year was still a very high first-job salary for a university leaver.) The Meteors included the designer David Mlinaric and the art critic Mario Amaya, he who in 1968 would be shot with Andy Warhol. They gaze seriously into the lens, sleek and efficient-looking, like young bank managers. In the previous autumn, Warhol had met Peter Fonda at a Hollywood party: the future hirsute star of *Easy Rider* looked like 'a preppy mathematician'. The sixties and early seventies were the heyday of John Betjeman's 'Executive':

> *I am a young executive. No cuffs than mine are cleaner;*
> *I have a Slimline briefcase and I use the firm's Cortina.*
> *In every roadside hostelry from here to Burgess Hill*
> *The* maîtres d'hotel *all know me well and let me sign the bill.*

The late 1950s teenagers, in their jeans and tartan shirts, looked like country-and-western bumpkins: even their hairstyles had country names – 'pony-tail', 'farmer cut', 'DA' (duck's arse, not district attorney). The young blades of the early sixties – in three-piece or double-breasted suits whether working-class or upper-class (that was part of the new 'classlessness') looked like city slickers.

An orientation toward the city, toward metropolitan elegance and corruption and metro-culture, is typical of the 1960s. The 1950s infatuation with the countryside was over. The main interest in folk art was in the *kitsch*, Pop folk art of the urban areas. Andy Warhol, almost unfailing barometer of passing fashion, 'couldn't imagine living in a tiny, nothing little place in the Himalayan Mountains. I didn't ever want to live anyplace where you couldn't drive down the road and see drive-ins and giant ice-cream cones and walk-in hot dogs and motel signs flashing!'

When Warhol met Bob Dylan in the early 1960s, 'he was already slightly flashy . . . definitely not folksy anymore – I mean, he was wearing satin polka-dot shirts.' At the Newport Folk Festival and at Forest Hills 'the old-style people booed him for going electric.' The change in pop music from traditional guitar to electric guitar, and later to giant consoles of electronic mixing equipment and special effects, was part of a general de-folking of the arts. One of the most successful pop groups called itself the Bay City Rollers. When the Beatles sang of 'Strawberry Fields for ever' they were not yearning for arcadia: the reference was to a Salvation Army children's home in Darkest Liverpool.

As well as shifting interest from country to city, the 1960s moved

from feminine to masculine. (The two often go together: if baroque Louis XIV piled *gloire* on *gloire* in the Louvre, Paris, rococo Marie-Antoinette played at dairy-maid in a froth of Fragonard petticoats at Rambouillet.) Male film stars eclipsed the women: Paul Newman, Steve McQueen, Dustin Hoffman, Jack Nicholson, Robert Redford, Sean Connery, Jon Voight, Warren Beatty, Peter O'Toole. Rudolph Nureyev, who defected to the West in 1961, was more famous than any woman ballet dancer of the time. And the women who did make it as film stars were not in general the voluptuous or 'fluffy' 1950s type, the type of Jayne Mansfield, Marilyn Monroe or Diana Dors, but a new cutaway model, boyishly gamine like Mia Farrow or Lisa Minnelli; tough and back-chatting like Barbra Streisand or Glenda Jackson; or crusadingly Women's Libbing like Vanessa Redgrave or Jane Fonda. Nancy Sinatra sang: 'These boots were made to walk right over you.'

As Warhol noted, the old Hollywood was over. And by 1963, the date of which he was writing, the new Hollywood had not yet come into being: this was the interregnum of the French girls – Jeanne Moreau, Brigitte Bardot, Françoise Hardy, Sylvie Vartan, Catherine

Brigitte Bardot in Paris, preparing for a French television show in 1967

Deneuve and her sister Françoise Doréac who died in a car smash in 1967. That was the summer, he remembered, of the Liz-Taylor-in-Cleopatra look – 'long straight dark shiny hair with bangs and Egyptian-looking eye make-up.' Those black-outlined eyes added new definition to the female face. Warhol thought it was via the Cleopatra look that 'folk evolved into something slick and fashionable that would eventually become the geometric look.'

If the new woman was powerful and man-eating (Cleopatra was a good symbol of that), the new male film stars were not 'macho' like Clark Gable, Burt Lancaster, Kirk Douglas or John Wayne. They were sexual neophytes like Dustin Hoffman in *The Graduate* (1967); misfits like Hoffman again in *Midnight Cowboy* (1969); exploited failed hustlers like Voight in the same film; even impotent, like Beatty in the first half of *Bonnie and Clyde* (1967). They were not fierce, independent monoliths – they tended to hunt in pairs, move in caring, interdependent couples (though as yet without a whiff of homosexuality) – Newman and Redford in *Butch Cassidy and the Sundance Kid* (1969); Voight and Hoffman in *Midnight Cowboy*; Nicholson and Peter Fonda in *Easy Rider* (1969). At the end of the decade, a film was made called *The Odd Couple* (1968), about two men sharing a house – but still with no more innuendos than a Laurel and Hardy movie.

As in the Edwardian period, the new taste for masculinity was reflected in the arts, too. When Emile de Antonio first came to see Andy Warhol's works, Warhol showed him two canvasses:

> One of them was a Coke bottle with Abstract Expressionist hash marks halfway up the side. The second one was just a stark, outlined Coke bottle in black and white. I didn't say a thing to De. I didn't have to – he knew what I wanted to know. 'Well look, Andy,' he said after looking at them for a couple of minutes. 'One of these is a piece of shit, simply a little bit of everything. The other is remarkable. It's our society, it's who we are, it's absolutely beautiful and naked, and you ought to destroy the first one and show the other.'

Stark was in, fuzzy, fudged and tentative were out: this applied to popular design as well as to Pop Art, to consumer goods as well as to consumers. A new rigour entered design as well. In 1960 there were still traces of 1950s styling. The Chevrolet Corsair had hints of the old finned limousines, though chrome and flashings were reduced. Danish stacking chairs designed by Nanna & Jørgen Ditzel for Møbelfabriken A/S still had bobble feet. Wall-lamps were still being made in the 1950s poke-bonnet shape. The new Dutch (Holland-America Line) liner, the *Rotterdam*, had Italian-style armchairs and rocking-horses in the nursery in a pastiche of fairground carousel style.

But by contrast, fifties whimsy was cast aside in the tableware designed by Robert Welch for the new *Oriana*. That had a purposeful, businesslike look. Everything on the *Oriana* was rigorous and hard-edge except for a mad clock designed by John McGill with gold leaf

decoration in the characteristic Chinesey right-angled bracket shapes of the sixties. Design was becoming crisper, more sharp-angled, with a free use of steel tubes with square or rectangular cross-sections. Purer shapes came in – the vowels of design, as it were, rather than diphthongs. The poke-bonnet lamps were replaced by straight-sided cylindrical or 'chimney' pendant lamps, hanging from their long flexes like Miss Muffet spiders and giving what was called 'local [i.e. limited] illumination'. Thorn's 'Chelsea' range of cylindrical lighting fittings, designed by Richard Stevens and Peter Rodd, were definitively sixties: the fifties would have felt the need to make some whimsical adaptation of the plain geometric form. Spotlights came in during the late sixties, making illumination still more 'local', and rooms more like film sets.

The Eclisse lamp from Italy, 1967. It had a ball and socket device enabling the light to be wholly or partly obscured. Designed by Vico Magistretti, it came in six colours

Spotlight, part of Allom Heffer's F1 series, 1967. The lampholder housing is anodized satin silver and 'eggshell black'

In 1967 Rank Bush Murphy produced 19-in. screen television sets in coloured finish – red, orange, black, green and blue

Again, the chairs based on the semi-circle designed by Tobias Scarpa for Santa-bona in 1960 would have had no place in the fifties, but belong to a type that persisted throughout the sixties and became part of the design 'vocabulary' of Habitat. The gold-plated necklace model 'DennMark', designed by Robert Welch and made by Dennison New-mark Ltd in 1961, was made up of circles and rectangles with none of the wedges or paraboloids of fifties styling. The new 'masculinity' of design was more literally given expression in the most notorious British building of the 1960s, the phallic Post Office Tower, London, and in the more naturalistically phallic Milward Courier cordless electric shaver, designed by Kenneth Grage in 1963.

David Sykes' grp Globe Systems Hi-Fi unit, 1970. The speakers were lined with polyurethane foam to damp resonance. The spherical transcription unit had a synchronous turntable and a rotating, blow-moulded lid

'Comfort Explosion' – chair constructed from a solid block of foam, designed by Rupert Oliver, 1970

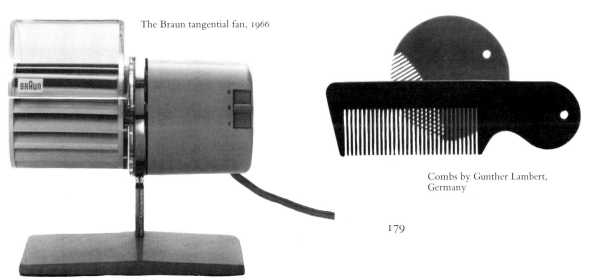

The Braun tangential fan, 1966

Combs by Gunther Lambert, Germany

179

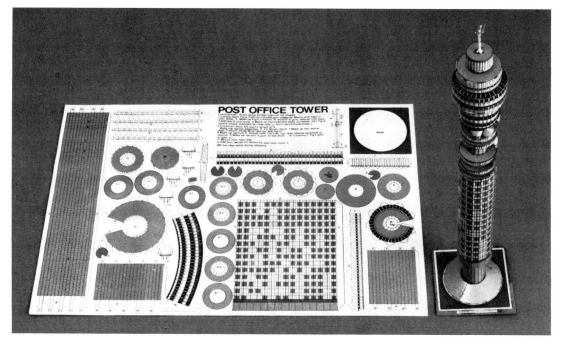

A large scale silver model of 'Concorde' with articulated nose-cone and lowered undercarriage, the fuselage and wings with brushed finish and engraved windows and doors. By Asprey & Co. Ltd, 1975, on smoked clear perspex stand. Length 48¾ in. Weight 316 oz.

Cardboard cut-out of the Post Office Tower, London, designed and made by William Belcher, 1970

The two countries which had lost the war – Germany and Japan – were both extremely influential in 1960s design. In Germany, the Max Braun organization was the leading exponent of the new purism. As *Design* magazine commented: 'To talk about Braun design is to talk about a sort of Platonic ideal – which is not easy unless you are ready to deny the validity of the ideal as a whole.' Some of the younger designers were prepared to deny it: to them, Braun products looked too much like Bauhaus Revisited. Braun's stated object was the omission of everything superfluous, especially 'built-in chic'. When asked if he felt everything should be rectangular, Dieter Rams, one of Braun's chief designers, showed a photograph of his desk fan, a pure cylinder on a simple stand. Pale grey was the colour he favoured for nearly all his products.

Japan, too, was becoming an international force, winning many design prizes. The Japanese were adding a reputation for innovation to their traditional one for plagiarism. They were advanced in technology: 1960 saw the sound radio designed by Takiko Hashiki for Hitachi, the beautiful portable tape recorder designed by Tadashi Saito for Sony, and the 50cc moped designed by Tatsuo Sugawara, Yasahiro Komori and Key Toyokawa for Suzuki. All three manufacturers would consolidate their positions through the 1960s. Sony design in radios, tape recorders and television sets was almost as pared-down and purist as Braun design; but in the later 1960s, the Easy Rider period, the Japanese firms made motor-cycles as Pop and extravagant as any in the west.

Of all the technological miracles of the 1960s, none caught the imagination more than the advances in space-travel which resulted in the landing of the first men on the moon in 1969. The Americans won the space-race and turned science fiction into science fact.

The moon landing led to explicit references to space travel in the decorative arts, such as the textile patterns 'Space Walk' by Sue Thatcher and 'Lunar Rocket' by Eddie Squires for Warner (1970); and to more oblique imagery such as the 'space frame linking the past with the future' at the 1970 Expo in Osaka, Japan (which included Okamoto's Tower of the Sun).

Lunar module space ship, 1970.
Toy by Mego Corporation,
Hong Kong

But throughout the 1960s, during the run-up period to the landing, the materials and the colours associated with space travel were top favourites with designers and architects. Of course it would be nonsense to claim that all choices of materials and colours were determined by a fascination with space travel. They were also determined by the feeling that design should be appropriate to the new technological age. And, naturally, many choices were made on exclusively practical grounds: for example, that fibreglass was flexible (an ergonomic advantage). But the symbolism of space stood for the whole of technology; and space travel put materials through some of the most gruelling tests that could be devised. By the kind of metonymy in which 'sceptre' stands for 'authority', 'spaceship' might stand for 'technology'.

The attributes and accoutrements of space travel were silver, transparent and invisible. The spaceships were silver; so were the suits in which at least science-fiction heroes made their space odysseys. Their helmets, and the windows from which they peered out at the Universe, were transparent. And space itself, through which they hurtled night and day at the mercy of man's technology, was invisible.

Silver was *the* colour of the 1960s. New buildings were covered with silvery metals (polished steel or aluminium), such as the Drugstore in King's Road, Chelsea, London – perhaps the most exciting single building of the decade in England – the Ted Lapidus shop in New Bond Street, London (polished steel), and the Christa Metek boutique, Vienna (polished aluminium), designed in 1968 by Hans Hollein, the 34-year-old Austrian architect who had already designed the much admired Retti Candle Shop, Vienna, in 1966, another silver-clad structure. Alcoa (the Aluminum Company of America) had as its headquarters in Pittsburgh, a thirty-storey building with curtain walls and plumbing in the metal. Invoking space imagery, their new inventions in 1961 included a 'music sphere' (sound-reproducing system) designed by Lester Beall, and a 'solar toy' (sculpture powered by a solar cell mounted in an aluminium reflector) designed by Charles Eames.

By the later sixties, the rooms in which people lived, as well as the offices and shops in which they worked, gleamed with silvery appliances and furniture. Silver spotlights gave 'local illumination'. Habitat was selling tubular steel furniture and Aram was reproducing Corbusier's tubular chairs. Naked metallic televisions replaced those which had skulked inside wooden cabinets. Record-players were now silvery 'decks' (a phrase used in spaceships) with separate speakers for the stereo reception which became popular in the early sixties. Most people could not afford anything very substantial in real silver, but in the late sixties wide silver rings, like small hollow cylinders, were worn by the young.

Warhol's first 'Factory', at 231 East 47th Street, New York, was lined with silver foil and was known as 'the Silver Factory'. Warhol

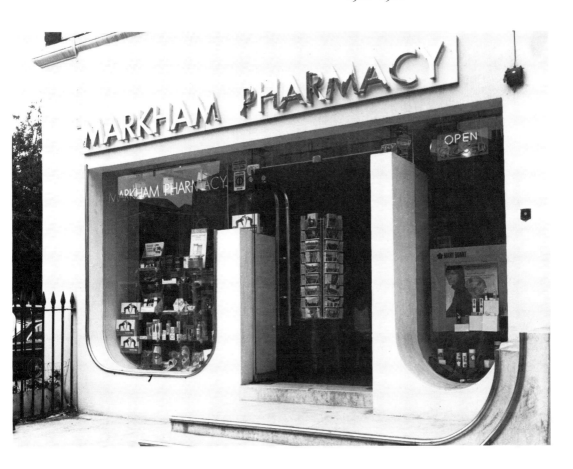

himself had silver hair; so did his friend the boutique owner Tiger Morse, who also wore silver jeans. Warhol went to a place called the Masque on Christopher Street, New York, where 'everybody dressed in tinfoil'. (It lasted only two weeks.) He did silver pictures of Elvis Presley and gave one to Bob Dylan, though he was mortified to hear that Dylan used it as a dart-board. He had silver helium-filled pillows floating at a Merce Cunningham dance concert, again at a Castelli Gallery launch and again at the Fergus Gallery on La Cienega, Los Angeles. His friends the Velvet Underground group wore aluminium outfits from Paraphernalia boutique and carried tinfoil whips. In the late 1960s, when he moved factory to Union Square, 'Everyone could sort of sense that the move downtown was more than just a change of place – for one thing, the Silver Period was definitely over, we were into white now.' It was at that time that the Procul Harum recorded their top-of-the-pops song 'A Whiter Shade of Pale'.

The transparent aspect of space technology was represented by acrylic sheet, a material which had been developed before World War II as an alternative to glass. (It had been used for cockpit canopies for aircraft.) Perspex and Plexiglas were trade-names under which acrylic

In line with the shining silver architecture of the nearby Chelsea Drugstore: the Markham Pharmacy, King's Road, London, redesigned in the late 1960s

was manufactured. Joe Colombo designed a desk light in it for O-Luce. David Colwell's reception desk at the Institute of Contemporary Arts, London, was in black and clear illuminated Perspex.

It was no great step from the transparent to the invisible. Automatic lift doors did not need handles. Digits were disappearing from clock and watch faces, and in the 1970s the watch face disappeared entirely in Sinclair's martially named Black Watch – a digital model with snap-off cover. The most surreal, sadistic and silly use of the invisible in design was in the 'invisible jewelry' of Gijs Bakker (1975), achieved by wearing tight gold wires around strategic points on the body to make marks.

With living space diminishing, collapsible furniture, pieces which served two purposes, and furniture which could be deflated like balloons or rubber dinghies was as desirable as miniaturization. Beds which let down from the wall were built into flats. Joe Colombo, whose motto was 'flexibility at all costs', introduced his infinitely extendable Addition seating system made up of slabs of foam, upholstered and pegged to steel junction pieces.

The phrase 'blow-up' belongs to the sixties in all its varied meanings. It was the title of the sensational Antonioni film of 1967 about a trendy photographer – and photographers such as David Bailey, Avedon, Lord Lichfield and Don McCullin were the heroes of the sixties, while their models, such as Shrimpton and Twiggy, became the new heroines. 'Blow-up' also referred to nuclear explosions. 'Blow-dry' was the new free-and-easy method of styling hair, after the 'home perms' ('Which Twin Has the Toni?') of the 1950s. And fellatio, which could not be mentioned in 1950s novels but figured in 1960s fiction, notably Jenny Fabian's and Johnny Byrne's *Groupie* (1969) – was called a 'blow job'.

In 1967 an exhibition of blow-up structures was held at the Musée de l'Art Moderne, Paris. It had photographs of inflatable hangars and exhibition halls and showed a temporary hospital which had been built by the Garret Corporation in Arizona, as well as Pop Art *objets de vertu* such as pump-up bottles and bananas. In England, Incadine had designed a couch for Christina Smith of Goods and Chattels 'as a follow-up to their large PVC pouffe'. Zanotta Poltrone of Milan made attractive chairs; so did Aubert, Jungmann & Stinco of A. J. S. Aerolande, Paris. The best-known make of inflatable furniture was Quasar Khanh. Transparent blow-ups were in fashion, but Quasar were also making opaque white versions. Quasar Khanh designed an inflatable house in transparent PVC. At Montfleury, Cannes, was the most inflated exercise of all – a sports centre whose huge winter swimming pool cover, supported by internal air pressure, was designed by Roger Taillibert and made by L. Stronger & Co. of Germany.

In this fold-up, double-up, blow-up world, Pop Art was able to affect design powerfully. Commerce had been drawing inspiration

from fine art for centuries – as in the copying of Raimondi engravings on Italian maiolica plates, the use of Millais's *Bubbles* as a Pears' soap poster, or the reproduction of Old Masters on chocolate box lids or jig-saw puzzles. But the 1960s were the first period when fine art drew its main inspiration from commerce.

Richard Hamilton's collage of 1956, 'Just What Is It That Makes Today's Homes So Different, So Appealing?' is generally regarded as the first Pop painting. But there was a world of difference between that, a satire on fifties materialism, and the American Pop Art pictures of the sixties, which were an embracing and a celebration of materialism. Roy Lichtenstein called Pop Art 'an involvement with what I think to be the most brazen and threatening characteristics of our culture, things we hate, but which are also powerful in their impingement on us.' This was still supercilious fifties culture-man talking: the hateful dross was to be transmuted into artistic gold. But the true Pop artists, of whom Warhol is the archetype, actually *liked* Coca Cola bottles and squeezed tooth-paste tubes – we have already seen how Warhol wanted always to be near 'drive-ins and giant ice-cream cones and walk-in hot dogs and motel signs flashing.' David Sylvester perceived as early as 1964 that 'Pop Art uses pop imagery as a source in the same sorts of ways as Renaissance and neo-classical art used antique sculpture.'

America, as we have seen, led the way in skyscrapers (architecture) and streamlining (design) but Pop was the first 'gallery' art form in which it led the world, the first in which it escaped from what Rosenberg, in *The Tradition of the New*, called 'Redcoatism', the borrowing of styles from Europe. Pop might have been named by an English critic, Lawrence Alloway, and pioneered by an English artist, Richard Hamilton, but America was where the raw material of inspiration lay. Michelangelo found his in the sculptures of ancient Italy. From about 1963 the Pop artists found theirs in the junk culture of modern America. 'Once you "got" Pop,' wrote Warhol, 'you could never see a sign the same way again.'

Warhol himself had begun as a commercial artist. Dealers who remembered his cover designs for magazines were reluctant to give him exhibitions. Jasper Johns and Robert Rauschenberg had designed windows for Tiffany's. Jim Dine had grass-roots Pop antecedents: he had been brought up in a hardware shop.

The true Pop artists revelled in the commercial products they depicted – or they depicted traditional subjects in a commercial way. Michael English, the most Pop of the English Pop artists, gave this description in *3D Eye* (1979) of how he was inspired to do his 'food paintings' of 1968–9 while sitting in a Wimpey bar:

> Glancing down toward my cup my eye was caught by something red. Look up! The tomato. It sat there, calm, red and very plastic – totally unreal. Down one side was a trickle of what looked like dried blood. Ket-

Roy Lichtenstein, *Modern Sculpture with Velvet Rope*, 1969. Brass, velvet rope. 83¼ × 26 × 15 and 59 × 26 × 15 in.

Pop Art furniture: Rupert Oliver's spanner seat and nut table at the 1971 International Engineering Exhibition. Moulded from high density polyurethane foam, it had a black spray-on polythene skin

V8 Can by Michael English

OPPOSITE

Pop Art in the bedroom: advertisement for a 'spreadmobile', American, 1976

chup? It couldn't be. Did people eat that? It was almost obscene; it was certainly obscene. But it was bloody good. It hit me right in the eyes. It buzzed in my brain and churned at my stomach. My fingers itched to get it down. I had to paint it.

In 1970 Motif Editions, London, issued a series of four posters by English called 'the Rubbish Prints'. The exhibition to launch the series marked the beginning of English's world-wide success. One was of a crumpled V8 juice can; the others showed a ketchup bottle, a Coke bottle top, and a squeezed tube of SR toothpaste. This is how English describes the genesis of the can print:

An empty juice can lay on its side in the gutter. Screwed up and dented, it had been kicked along the streets by kids coming home from school, or run over by a lorry. A muddy trickle of water from last night's rain ran along the gutter. The tin was clean and bright, though its images and colours were distorted by its new shape. It struck me that the tin, despite being so carefully conceived and lovingly designed, ended up in the gutter just the same. Its design and production were geared to this very end; it was a true product of society.

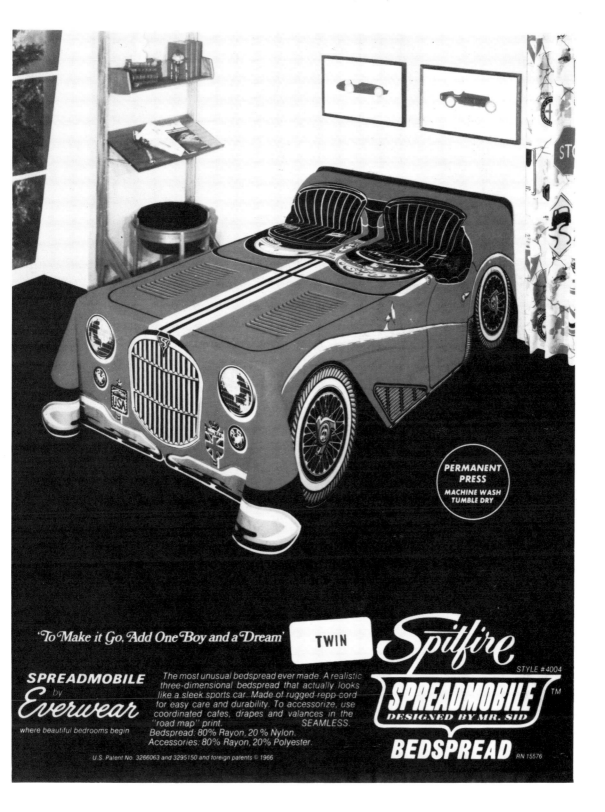

'To Make it Go, Add One Boy and a Dream' | TWIN | *Spitfire*

STYLE #4004

SPREADMOBILE
by
Everwear

where beautiful bedrooms begin

The most unusual bedspread ever made. A realistic three-dimensional bedspread that actually looks like a sleek sports car. Made of rugged repp cord for easy care and durability. To accessorize, use coordinated cafes, drapes and valances in the "road map" print. SEAMLESS.
Bedspread: 80% Rayon, 20% Nylon.
Accessories: 80% Rayon, 20% Polyester.

U.S. Patent No. 3266063 and 3295150 and foreign patents © 1966

SPREADMOBILE ™
DESIGNED BY MR. SID

BEDSPREAD RN 15576

PERMANENT PRESS
MACHINE WASH
TUMBLE DRY

Here, then, was a message for a mess-age. The rubbish that did not get into the architect-designed litter bins had its own intrinsic qualities. And it could be turned into architecture as well as into art: in 1976 the young architects Shiu-Kay Kan and Michael Poteliakhoff presented their scheme for 'garbage housing' – shelters made of catering cans spot-welded and filled with concrete for the end walls, riding on a beer-crate floor slab.

What Pop Art took from commerce it gave back in full measure, rather as a great orator, Gladstone or Lloyd George or Hitler, siphons emotion from a crowd and trains it back on them. In an article in *Design* of February 1968, Corin Hughes-Stanton analysed the impact of the Pop or 'Post Modern' design symbolized by Carnaby Street. He believed it was not, as many claimed, a passing fashion, In a brief three years, Carnaby Street had 'explored and exhausted every conceivable form of three-dimensional as well as graphic titillation'. It was a non-literate, non-verbal, non-theorist movement, which had 'pulled the rug from under Contemporary or Modern.' The creative period of Pop, he felt, was over. What would happen next? Hughes-Stanton thought the Carnaby Street *approach* to design would persist: and time has proved him right.

There was some direct application of Pop Art to products, as when Alan Aldridge (who designed the 'Lord Kitchener's Valet' shop in London and decorated books of Beatle lyrics) was commissioned by Philips to design the door of a refrigerator. (The design was very 'Lord Kitchener'-like and was called 'The General's Wardrobe'.) There was far more direct Pop Art in advertising, ranging from clodhopping attempts to imitate Warhol or Peter Blake to ads which were works of Pop Art in their own right, such as Robert Delphine's 'graphic poem' to the Citroën Dyane in 1968. But as Hughes-Stanton perceived, it was the revolution in *approach* that Pop Art brought with it that was to have the lasting influence on design, rather than the mannerisms of individual artists. What was that approach? It was to meet people's needs without moralizing about what they should be. It was 'non-static': there was no 'ideal' which, once attained, must be adhered to. It was freely experimental. It was humanistic and anti-puritannical. It might look like an 'aesthetic free-for-all', but (Hughes-Stanton concluded) it had 'a more realistic total coherence than the Modern Movement, for all its apparent visual unity, ever achieved'. He added: 'It means that we may no longer (to give a single example) have to choose between ergonomic but clinically dull cars, and pleasure-giving but dangerous cars.'

That was to be the long-term effect. In the meantime, for a brief period, Pop Art was as truly popular as pop music. When Andy Warhol and his entourage walked into the opening of his Philadelphia show in 1965, they were mobbed. 'The kids . . . started actually screaming. I couldn't believe it – one day you're in an art gallery in Toronto

Pop Art in furniture: boxing-glove chairs in leather, by De Sede (Switzerland), 1978

Glass table on cast concrete and chrome-cross base, by Saporiti, Milan; with four chrome Saporiti chairs, 1978

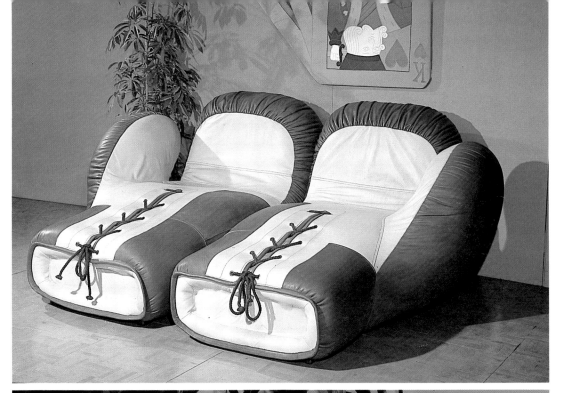

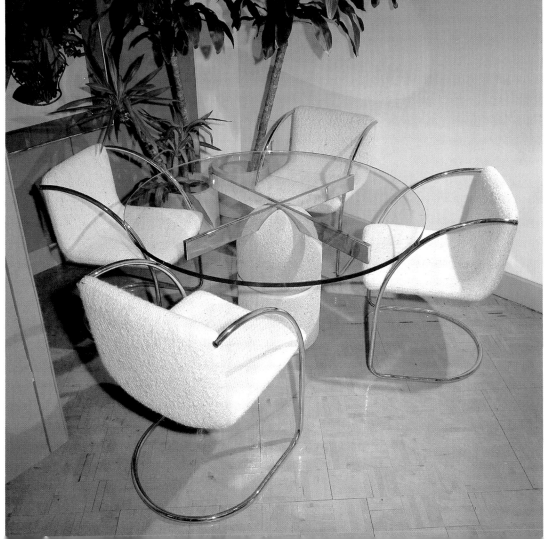

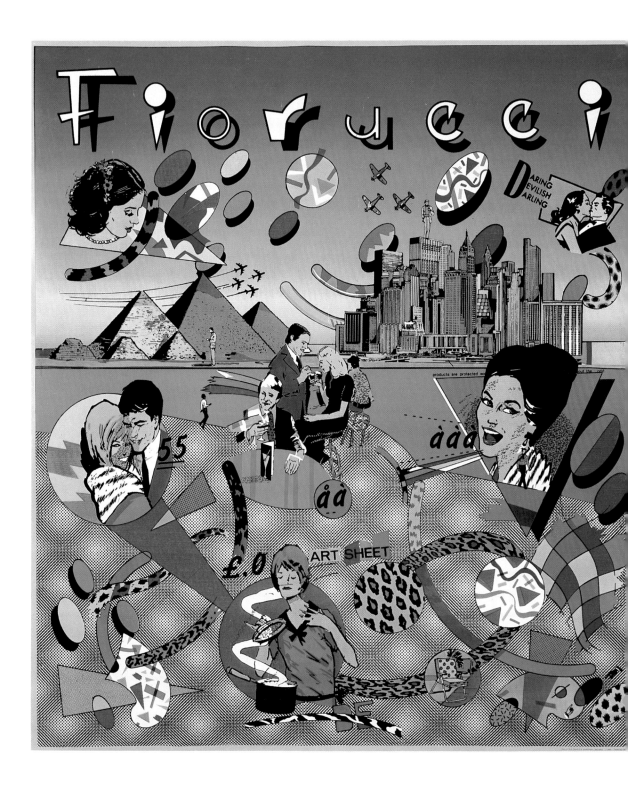

and not one person comes in all day to see you, and then suddenly there are people who get hysterical at the sight of you.' And, just as the kid-dominated pop world was being brought to art, so the old, connoisseur-dominated art world was being forced to come to terms with Pop. Warhol exulted:

> The old idea used to be that intellectuals didn't know what was going on in the other society – popular culture. Those scenes in early rock-and-roll movies were so dated now, where the old fogies would hear rock and roll for the first time and start tapping their feet and say, 'That's catchy. What did you say you called it? "Rock and . . . *roll*?"' When Thomas Hoving, the director of the Metropolitan, talked about an exhibit there that included three busts of ancient Egyptian princesses, he referred to them offhandedly as 'The Supremes'. Everybody was part of the same culture now.

One of the main effects of Pop Art in general, and of Warhol's art in particular, was to popularize the idea of 'multiples' – not only the repetition of a single image many times in a single work, but also the art forms, such as posters and prints, which 'democratized' the artist's original concept. In 1957 a British Museum scholar, Owen E. Holloway, had advanced the revolutionary idea that prints could be *more* important than originals. In his book *Graphic Art of Japan* (1957), he said that the art-lover 'will have been brought up on the superstition of an art valuable in proportion to the exclusiveness of its appeal and the absolute originality of its products. He will cherish a corresponding suspicion of anything that can be brought "down" to the level of the masses, and the diffusion of a whole edition all equally good is something he simply will not wish to contemplate.' He spoke of 'the cult of false originality' and of 'the fetish value ascribed . . . to "original" sketches of the artists themselves.' He added:

> We are a machine age, and it is therefore a wonder in itself that these original sketches should have been done archaically 'by hand'. We are above all a business community, and their superior rarity gives them a genteel pecuniary standing that a mere engraving could never possess. We have convinced ourselves (as an oriental observer remarks) 'that art is a thing too good for this world, labour too brutal an activity to be mentioned in the same breath with art. . . .' Thus a perverted idealism and an amazing insensibility exist side by side.

Here in the late 1950s – a time when the first Pop Art was being produced in Britain – was a spirited defence of multiples, when the name of Warhol was virtually unknown to the art world.

In August 1962, Warhol gave up the rubber-stamp method he had been using to repeat images, and took up silkscreening – the process by which photographs are blown up, transferred in glue on to silk, and then rolled across with ink so that the ink goes through the silk but not through the glue. His first experiments were with heads of Troy Donahue and Warren Beatty; then, when Marilyn Monroe died in that month, he made the first screens of her face.

Poster for Fiorucci, incorporating 50s nostalgia motifs, 1980

Rauschenberg wanted to learn about silkscreening. Henry Geldzahler suggested he should go and see Warhol. The art critic David Bourdon, who was present, recalled the occasion for Warhol:

> You got out the Marilyns, and then, because Rauschenberg hadn't ever been to see your things, you showed him some of your early works, including the wide painting of green Coke bottles repeated hundreds of times across the canvas. It wasn't even stretched, you didn't have the room to stretch the big ones and usually you kept them rolled up. You showed him the repeated Coke bottles and told him you were going to crop the picture to make the bottles go right to the edge of the frame.

Like other Pop Art, Warhol's multiples inspired some direct copies and some less direct ideas such as Paco Rabanne's dresses of multiple plastic squares linked together with multiple metal rings.

Posters became the leading popular art form of the 1960s and early 1970s, a vehicle for psychedelic extravaganzas or (in Paris, 1968) revolution. The interest in old posters, from Lautrec onwards, was shown by the success of Lord's Gallery, St John's Wood, London, which opened in 1962, by the publication of many books on the subject (including some with large poster-pages intended to be torn out and hung on the wall), and the widespread sale of big poster reproductions by firms such as Athena.

The exhibition Cybernetic Serendipity, organized by Jasia Reichardt at the Institute of Contemporary Arts, London, in 1968, showed some of the possibilities of a relationship between art and computers. The word cybernetics derives from the Greek *kubernetes*, steersman. The phrase *la cybernétique* had been used as early as 1834 for the science of government, but the use of 'cybernetics' for 'control and communication theory' dated from Robert Wiener's book *Cybernetics* of 1948. Could art and computers ever come to terms in anything more sophisticated than endearingly humanoid robots in a space movie? The 1968 ICA exhibition suggested ways in which they might. There was a possibility of computer-aided design. The 'graphic display terminal' was a 'powerful and compact information processor, tailored to communicate with the designer in the medium he best understands – visual images.' The main advantage claimed for the graphic display terminal was that it enabled the artist 'to explore an infinitely greater number of possible solutions during the course of a project'. There were some direct spin-offs of the exhibition in art, notably a limited set of lithographs issued by Motif Editions, of images made by computers. These included 'The Snail', an elegant composition by Kerry Strand of California Computer Products, and 'return to square', by the Computer Technique Group of Japan, in which an arithmetic series program transformed a small square into the profile of a woman and then back into a square. People began to talk about 'computer graphics' as though this was the way ahead for art. The Korean artist Nam June boldly asserted that 'the cathode ray will one day replace canvas'.

OPPOSITE
Detail from *Sixteen Jackies* by
Andy Warhol, 1965

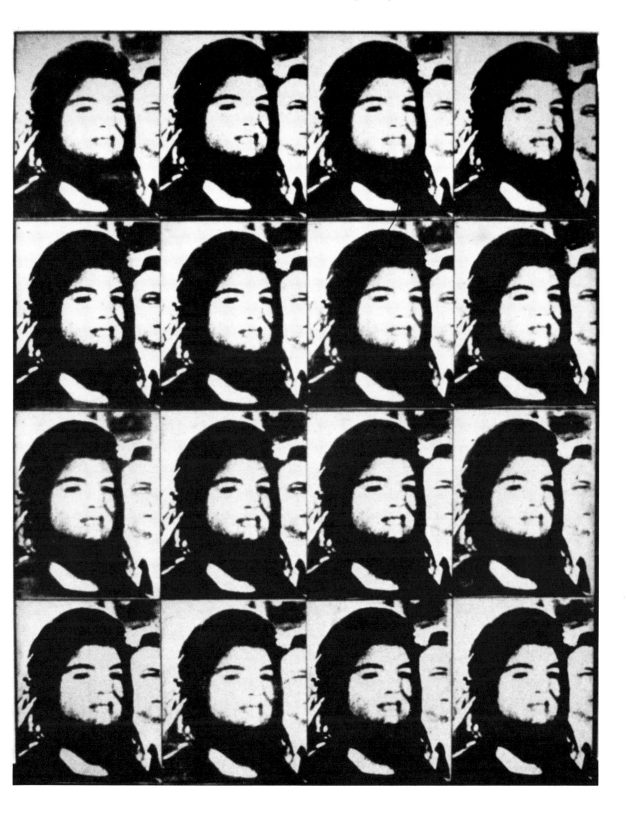

Whether that will happen, remains to be seen. For the present, the main effect of interest in computers, robots and cybernetics seems to have been a boost for the air-brush painters. For an era with an 'aerospace industry', the air brush, or 'aerograph', might in any case seem an appropriate medium. It was also a natural weapon for the Pop artist, as its early associations were commercial. It had been invented shortly before 1893 and was first used for touching out the wrinkles which plate-camera photography showed up all too well. At an early date it was also used for technical drawings of the insides of engines and pumps. Because of its 'mechanical' nature it had been favoured by some of the Bauhaus designers and graphic artists. Since it could convey the subtlest gradations of flesh-colour, and the sheen on a tightly-stretched bra, it was used by George Petty and Alberto Vargas for their magazine pin-ups (Petty and Varga girls).

In the 1960s, with graphics returning to posters and Pop Art developing, airbrush was in favour in commercial art. It portrayed people without blemish, products flawless and idealized. But above all it was the perfect medium for artists who wanted to represent the cybernetic society or science fiction. No other technique could reproduce with

Two early examples of computer graphics from *The Computer in Art* by Jasia Reichardt, published by Studio Vista in 1971

such verisimilitude the shimmer and highlights of a spaceship, or make the apparatus of a bionic arm seem so convincing. Terry Pastor painted gleaming spaceships spearing through the vacant interstellar spaces; David Hardy produced 'Skiing on Europa', a science-fiction illustration; the Japanese artist Hajime Soratama combined a Vargas-type pin-up and cybernetic hardware in his illustration of a robot girl holding a glass of lemon tea in one hand while removing her leotard with the other.

The artist best known for his mechanical and bionic subjects is Philip Castle, who adopted the airbrush technique from his college contemporary, Adrian George. He painted Elvis turning into a jukebox; Farrah Fawcett-Majors (then actually married to the actor who played the Six Million Dollar Man) with jutting silver breasts that might be the noses of jets or the headlamps of a fifties Pontiac – Castle's favourite automobile; the Queen and Prince Philip as Artoo Deetoo and See Threepio. All his pictures are executed in a miraculous technique, smooth as sliced blancmange, subtly gradated as litmus changing colour. His original inspiration was the two artists who signed with the initials VK and AF on the fifties Pontiac ads. VK, Castle later discovered, was Van Kaufman: Castle assumed that one artist painted the car, the other the glamorous background of Floridan beach or night-lit casino.

Airbrush was the natural medium for the so-called Superrealism of the 1970s. It was used by Michael English for his 'rubbish paintings' of 1970; by Alan Aldridge (in conjunction with Harry Willock) for illustrations to William Plomer's *The Butterfly Ball and the Grasshopper's Feast* (1973); and by Jean-Jacques Maquaire in a clever cover illus-

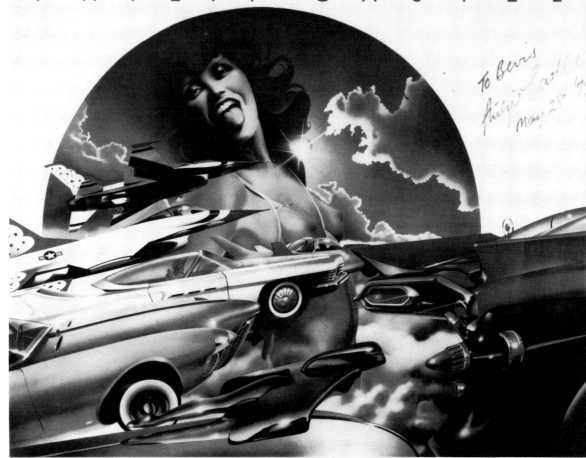

NEW AIRBRUSH PAINTINGS
PHILIP CASTLE

**21 FEBRUARY-24 MARCH 1978·THUMB GALLERY·20/21 D'ARBLAY STREET LONDON WI
TELEPHONE 01-439 4059 · OPEN WEEKDAYS 10AM-6PM SATURDAYS 11.30AM-5PM**

Poster for a Philip Castle
exhibition, 1978

tration to a Sony promotional booklet in 1978, which showed the figures '78-79' made up of hi-fi components.

Was it art? In *The Airbrush Book* (1980), Seng-gye Tombs Curtis and Christopher Hunt offered the same sort of apologia for airbrush technique as was once advanced in defence of the camera: 'There are as many expressive possibilities with the airbrush as with the hand-brush. There is as much technique to learn . . . and just as much skill in application; and should one so choose, one can develop a personal handwriting with the airbrush as much as the handbrush.' The authors even compared the airbrush with ancient Chinese brushwork: 'A suggestion in a manual of Chinese painting reads: "When manipulating the brush do not move the fingers but move the whole arm." Exactly the same could have been written for the airbrush.' But the best airbrush artists, including Philip Castle, did not need such specious justifications for their art. To them, the impersonality and the inhu-

manness of the medium, its coldness of finish, its 'slinky perfection', were merits, not disadvantages. As Man Ray, who had used airbrush brilliantly as early as 1917, said: 'It was thrilling to paint a picture hardly touching the surface – a purely cerebral act, so to speak.'

The airbrush belongs less with the 1960s than with the 1970s, the age of electronic calculators and home computers. The sixties had a character distinct from that of the seventies, as we shall see. But there was also a difference between the early and the later sixties: as though the pace of life were hotting up so much that not only did lifestyle change dramatically from decade to decade – now the decades themselves were becoming fissiparous. The difference between the early and the late sixties is perfectly typified by the contrast between the early, crisp black-and-white Dezo Hoffmann photographs showing the Beatles in their clean-cut, Epstein-prescribed monkey-suits, and the Peter Blake sleeve for *Sergeant Pepper's Lonelyhearts Club Band* with its polychrome hippyism and folk/pop/psychedelia treatment.

In the early 1960s, young people found they had financial and commercial power. They used it to go one better than their parents – but in the same direction. Smarter suits, faster cars, larger doses of comforting materialism. As the smart-suited Mod told the *Sunday Times* in August 1964, 'We hope to stay smart for ever, not shoddy like our parents.' But by the late sixties many young people wanted to express their new-found power by breaking away from materialism altogether. There were several appealing ways of doing this. (Some had already been preached and practised by the 'beat' generation of Jack Kerouac, Allen Ginsberg and William Burroughs.) One was to 'drop out' of society, giving up any regular job and living in a 'commune'. Another was to 'freak out' or 'expand your consciousness' by taking drugs, whether the fairly innocent cannabis or the more dangerous LSD extolled by Dr Timothy Leary. (There was a pleasing neatness, for young English people, in exchanging the ideology associated with one kind of LSD – pounds, shillings and pence – for that associated with the other – lysergic acid.) With the drug culture went a new taste for 'ethnic' clothing: kaftans, patchworks, beads and bangles replaced the sharp suits and smart little dresses. Conventional religion was ousted by eastern mysticism (more kaftans, beads, drugs and joss-sticks), astrology, and a dewy version of Christianity in which the 'Jesus People' emphasized the innocence and ethics of the superstar Christ, not the dogmas and sectarianism of his followers. The passive, meditative, cheek-turning aspect of Christianity took over from the aggressive, evangelical side seen in the 1950s in Billy Graham's crusades and Johnny Ray's passionate, stage-thumping 'I Believe'.

'Permissiveness' was another aspect of the new youth culture. The availability of the Pill meant that women could have what sexual relations they wanted without fear of getting pregnant (the 'getting into trouble' which carried a severe social stigma in the 1950s and could

The drug culture: cover of Clive Matson's *To the Mainline Heart*

TOO GREAT A RISK!

Birth control advertisement,
c. 1975

Permissiveness: 'I'll try
anything', handtinted photo by
Rabanne & Rabanne, issued by
'Nice 'n' Sleazy Provocative
Post Cards', New York

Permissiveness: 'Pressed Ham', postcard by Vic Smith, Dennie Lafrenière and Larry Thor Hunter for Cold Flash Graphics, Vancouver, BC, 1980. 'Mooning' from car windows was a temporary fashion

still provide the central drama of the film *The Knack*, 1965, starring Rita Tushingham and Michael Crawford, and of Margaret Drabble's novel *The Millstone*, 1966, filmed as *A Touch of Love*, 1969.) The other sexual taboos of the pre-1960 period were also being broken. The *Lady Chatterley's Lover* case (1960) and the *Last Exit to Brooklyn* case (won on appeal in 1968) virtually put an end to the censorship of literature. Nudity, first introduced timidly in films such as Zeffirelli's *Romeo and Juliet* (1968) and stage productions like *Hair,* later became 'full-frontal' in Warhol's films, David Storey's *The Changing-Room*, Kenneth Tynan's *Oh! Calcutta* and in mass unrobings at pop festivals. Tynan also made history by saying 'fuck' on television, in a programme called BBC3 on 13 November 1965: for a time, signs such as 'Shut the Tynan

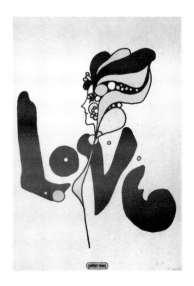

Peter Max, 'Love' poster, 1970

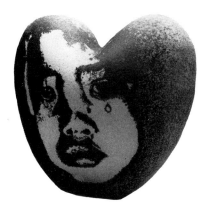

'Broken Heart II', pottery by
Valerie Charlton, 1970:
a poignant reminder of
the misery caused by
the Vietnam War

OPPOSITE

'No More War' poster by the
Japanese designer Keiichi
Tanaami, 1970

door' appeared, recalling the expression 'Not Pygmalion likely' which followed Bernard Shaw's equally shocking use of the word 'bloody' in *Pygmalion* (1913). In 1967 homosexuality between consenting adults in private was made legal in Britain (as recommended in the Wolfenden Report of 1957); and Gay Lib crusaded for further parity with heterosexuals. Overt homosexuality entered art with David Hockney, as it had already entered films with the Dirk Bogarde movie *Victim* (1961) and literature with Gore Vidal and Angus Wilson. Gillian Freeman's *The Leather Boys* (1961) was turned into a film in 1963; and the Beryl Reid/Susannah York movie *The Killing of Sister George*, with its lesbian theme, was screened in 1968. A general breaking-down of 'sex roles' was seen in 'unisex' haircuts and clothes. Why, it was asked, should boys not learn cookery in class, with metalwork for girls? Boys could even play with dolls now, albeit militaristic ones called 'Tommy Gunn' or 'Action Man'.

The two main new ideas which segregated the late sixties from the early sixties were, first, the idea of establishing an 'alternative society'; and second, the concept of 'identity'. The two were linked: only by 'dropping out' of regimented Establishment life into the alternative society, where you could 'let it all hang out' and 'do your own thing', could you discover, recognize, isolate, nurture and develop your own identity. Failure to do so could result in an 'identity crisis' or 'alienation': 'I don't know who I am, any more' was a movie cliché of the time. Companies sought a 'corporate identity'. Countries could have identity crises, too. Britain had one because it could not make up its mind, after Suez, whether the imperial lion still had a tail to wag. America had a different kind: though it unquestionably had the means of asserting imperial ambitions, its young people were increasingly out of sympathy with the military action taken by their Government. The Beatles' 'All You Need Is Love' was the slogan of this generation. 'Make Love, Not War' said their banners; though Ronald Reagan sourly commented that those carrying them looked as if they could not do either. Bob Dylan, the voice of the alternative society in America – he was well in the vanguard in writing about dropoutism and alienation in his songs of the *early* sixties – expressed the anti-war feeling which was to become so vocal in the late sixties, in his Whitmanesque song *Masters of War* (1963):

Come you masters of war
You that build all the guns
You that build the death planes
You that build the big bombs
You that hide behind walls
You that hide behind desks
I just want you to know
I can see through your masks.

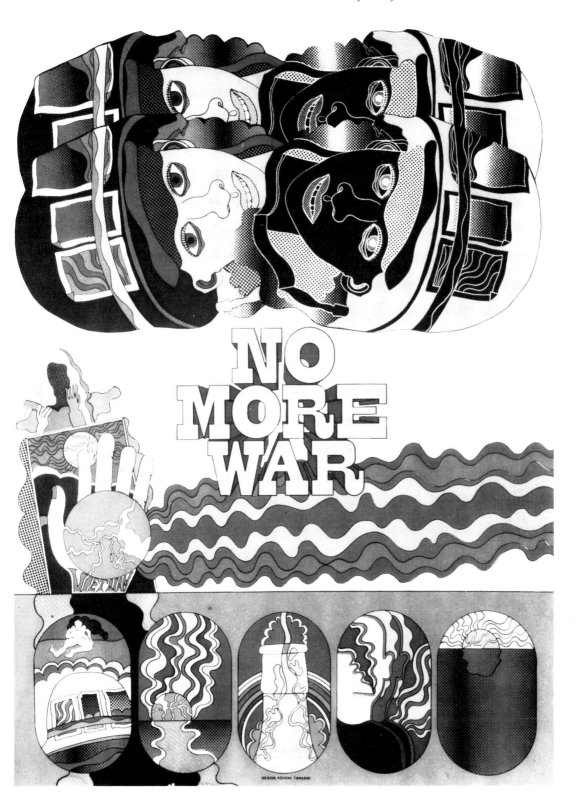

There was a vicious side to the alternative society of the late 1960s and a highly – almost priggishly – moralistic side. Sometimes the two were found in coalition, just as revolutions always draw together high-principled idealists and opportunist selfseekers under the same banners. The vicious side was hard drug peddling and consumption; theft (lack of respect for property was central to dropoutism; and, anyway, people without jobs had to get food or the money for food from somewhere); brainwashing and financial exploitation by religious leaders; and perverted 'communes' such as that run by Charles Manson, which combined all these traits, and added to them casual murder 'for kicks'.

The moralistic side, which had some common ground with the vicious in its contempt for the harmful effects of capitalist exploitation, was concerned for the environment and 'ecology' (a word which now entered common usage for the first time.) It was anti the pollution of rivers by industrial waste, of vegetation and wildlife by pesticides and of the air by factory and motor fumes. ('Let us get one thing perfectly clear' was a Los Angeles poster slogan, referring to the industrial 'smog' polluting the LA air.) It believed in 'organic foods' and was against 'additives'. It was also agin unnecessary 'packaging' which led to pollution by litter. It was in favour of 're-cycling' paper and glass waste into new products; alternative sources of energy; and Ralph Nader, scourge of the motor industry. Some of these wholesome outdoor folk were reminiscent of the hairy-suited vegetarian Fabians of the 1930s, but most of their ideals, like those of the Fabians, were high-minded and valuable, including their concern for 'disadvantaged minorities' and 'ethnic minorities' such as the Red Indians. (An early Jimi Hendrix poster showed him as a Red Indian in a feathered headdress.) Films now gave a quite different picture of the Indians than the old Westerns in which they were illiterate baddies; and Dee Brown's *Bury My Heart at Wounded Knee* (1971) was the culmination of a long campaign to celebrate Indian achievement and atone for the exploitation of Indians by the white pioneers. Black Power represented the same kind of feeling; and again there was a vicious and a moral side, exemplified by the contrast between Malcolm X and Dr Martin Luther King.

The move away from the country to the city, which Andy Warhol had observed and applauded in the early 1960s, was now reversed. If you were going to drop out and give up regular work, it made sense to drop out to the country rather than live as a 'squatter' in a derelict city house – since the main reason for staying in the city was to get work. In the country you could grow your own produce (including, in some cases, marijuana); and whereas local councils might cut off your water supply in cities, in the country you could use all nature as your bathroom and lavatory. Once again, folk, folksiness, folk music and folk art were in favour. Some of the Pop artists who had been most smitten by urban culture now retreated into the coun-

Anti-racists introduced the white-faced golliwog. Advertisement in *British Toys Daily News*, 2 February 1966

tryside. In 1969 Peter Blake and his wife Jann Howarth moved into Wellow station, on the old Somerset and Dorset main line, and founded the Brotherhood of Ruralists with friends. (The obvious historical parallel is the Pre-Raphaelite Brotherhood, with their Kelmscott and Merton Abbey – and indeed the gruff, bearded Peter Blake resembles William Morris both in appearance and in the dedication of his fastidious craftsmanship.) There was a big sale for Laura Ashley's pretty, countrified fabrics, with their irises and forget-me-nots.

The decorative art style of the drug culture and the alternative society was called 'psychedelic', a word derived from the Greek *psyche*, breath, soul, the human mind; and *delos*, visible. The use of the word was well established for decorative effects by the end of the seventies, when *Collins' English Dictionary* (first published 1979) gave these three definitions of it:

1. Relating to or denoting new or altered perceptions or sensory experiences, as through the use of hallucinogenic drugs;
2. Denoting any of the drugs, esp. LSD, that produce these effects;
3. *Informal* (of painting, fabric design, etc.) having the vivid colours and complex patterns popularly associated with the visual effects of psychedelic states.

John Lennon's psychedelically painted Rolls Royce, 1967

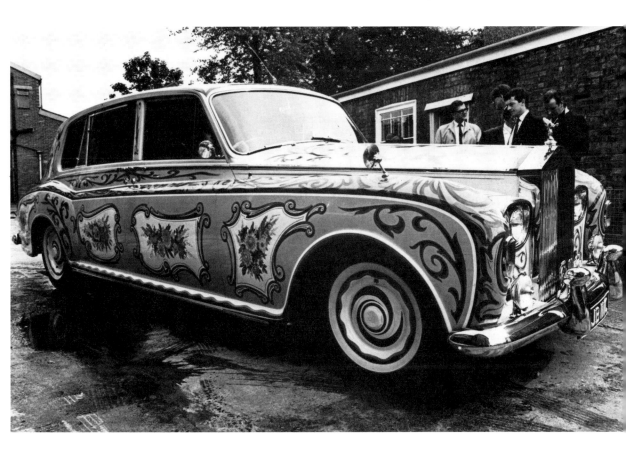

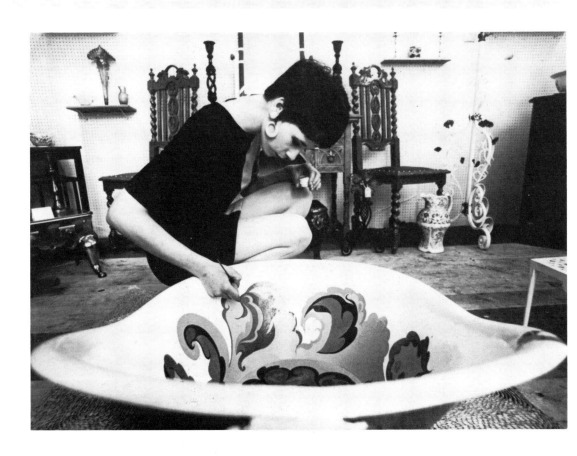

The most famous use of 'psychedelic art' was the coloured squiggles painted on John Lennon's Rolls Royce in 1967. 'In Psychedelic Color' read the advertisements for *The Trip*, the 1967 Peter Fonda movie, with which American International Pictures cashed in on the drugs craze which was sweeping the college campuses of America. (Timothy Leary's 'Tune in – turn on – drop out' was the catchphrase of the time.) By 1967, 'psychedelic' was the natural style to use if, like Sandra Paine, in the 'Serenity Room' of the newly-opened Hampstead Antiques Emporium, you wanted to tart up an old footbath into a saleable 'antique'. Alexander Calder, the mobiles artist, painted psychedelic squiggles on the aircraft of Braniff International – 'Flying Colours', as the slogan went. The style was also seen in the underground magazine *International Times*, the American journal *Yarrow Roots*, and the Australian magazine *OZ* (of which the allegedly pornographic Skoolkids Issue was to provoke one of the legal *causes célèbres* of the Permissive Society).

International Times (IT) was the Underground paper with the widest circulation

Poster by Rick Griffin, produced by Berkeley Bonaparte, 1967

OPPOSITE

'Flying Colours': Alexander Calder's aircraft decorations for Braniff International

Sandra Paine in the 'Serenity Room' of the Hampstead Antiques Emporium, London, in 1967, painting 'psychedelic' motifs on an old bath-tub

Above all the style was rampant in poster art. The main poster artists of the style were Michael English and Nigel Waymouth, both associated with the *International Times*, and the Australian artist Martin Sharp, who designed some open-out posters in the early issues of *OZ*, such as 'Toad of Whitehall' (Harold Wilson) and generally designed the magazine. (He also designed the jacket of Richard Neville's book *Play Power*, 1970.) In December 1967 the *Observer* published an article on 'Poster Power' by George Melly, together with a pen-portrait by Austin John Marshall of Jimi Hendrix, who became a 1960s icon in the pictorial rhapsodies of the psychedelic posterists.

Melly's article included an interview with English and Waymouth, who were working under the curious trade-name 'Hapshash and the Coloured Coat' – which suggested both 'hash' (marijuana) and psychedelic patterning (*Joseph and the Amazing Technicolor Dreamcoat*, the Rice-Webber collaboration of 1968 was part of the same 'scene'). After pop groups, why not art groups: Pushpin Studios and Mouse Studios were doing the same thing in the United States. Melly described how English, who had been at Ealing Art School, had met Waymouth when the latter was painting the façade of the King's Road, Chelsea clothes boutique, 'Granny Takes a Trip' in December 1966:

> By March, 1967, they had decided to join forces and design posters. But what were these posters for? Superficially the answer was: to advertise the activities of UFO, which stands, among other things, for 'Unlimited Freak Out', and which was the first spontaneous and successful attempt to produce a total environment including music, light and people.
>
> What interested 'Hapshash' was *using* the environment as a launching-pad. Unlike the conventional poster-designers they weren't concerned with imposing their image on a product, but with taking their product out of the environment. It must be emphasized here that the aim of UFO was mind-expansion and hallucination at the service of the destruction of the non-hip and the substitution of 'love', in the special, rather nebulous meaning that the word holds for the Underground.

English and Waymouth revived the use of 'Dayglo', a kind of luminous paint which gives weird effects in artificial light. Their lettering was described by Melly as 'a rubbery synthesis of early Disney and Mabel Lucy Attwell carried to the edge of illegibility'.

The psychedelic style did not spring like a nest of writhing serpents straight from the subconscious of junkies under the influence of hallucinogenic drugs. Its mazes and whorls and arabesques were in fact a none too subtle adaptation of Art Nouveau – an Art Nouveau drained of its anaemic hues and flooded with brilliant Dayglo colours. As such, it was the first manifestation of the 'Nostalgia' craze (later known as 'retro') which was to dominate the decorative arts in the late sixties and early seventies. 'Everyone's redoing it!' an American magazine proclaimed; and the article which followed spoke of 'the Old Rush'.

The Nostalgia movement began with the Art Nouveau revival; and

OPPOSITE

From nostalgia to punk: changing fashions in T-shirts

SOME
LIKE
IT HOT

VICIOUS
LETTER FROM BRITAIN

I

empty feeling; you know, when you're kind of lying dead.'

Sid Vicious dead at 21

reality...
what a
concept

Strike!

N ext to
sex, there's nothing bet-
ter than ditching a cop
when you're high.'

SEX
PISTOLS

YOU'RE PROBABLY
TOO LATE ALREADY

la
mode

RAOUL

crée

et
lance
la
mode

RAOUL

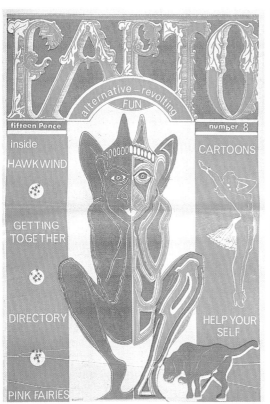

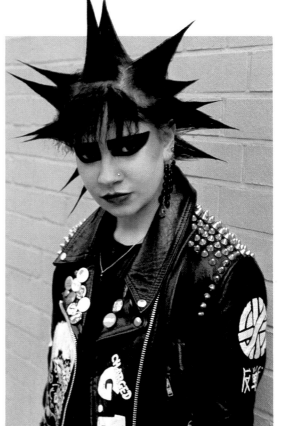

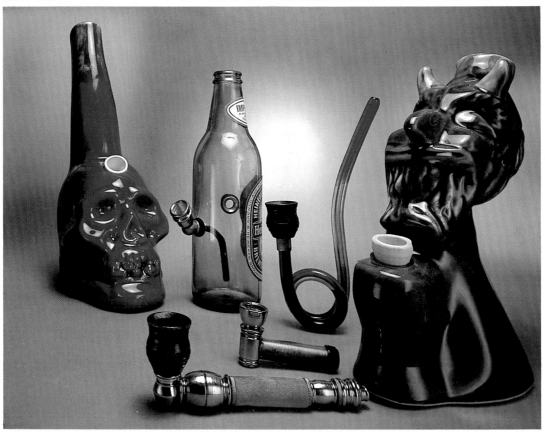

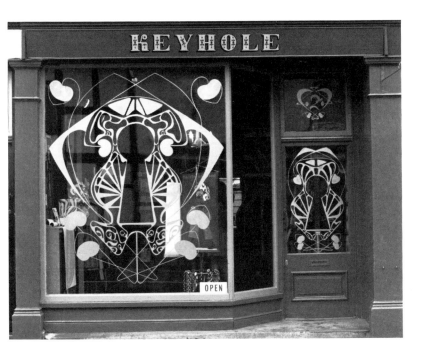

Art Nouveau revival: Keyhole boutique, Weybridge, Surrey, 1968

the Art Nouveau revival began with the Mucha exhibition (May–July 1963) and the Beardsley exhibition (May–September 1966) at the Victoria and Albert Museum, London. The decadent sinuosities of both artists were as captivating as in the 1890s; and Beardsley in particular – 'the Fra Angelico of Satanism,' as Roger Fry had called him – appealed to the Permissive Society. It is difficult, today, to recall how shocking were the phallic drawings of the *Lysistrata* series by Beardsley, first reissued in a portfolio which was on sale among the clothes at 'Granny Takes a Trip'.

Beardsleyan motifs began to appear on objects as lowly as a carrier bag; Mackintosh furniture was copied; *Jugendstil* bridge cards were issued. Less ephemerally, Art Nouveau was imaginately pastiched on the outer wall of the Central Office of Information; Mario Amaya also claimed to recognize an Art Nouveau 'whiplash' line in Eero Saarinen's TWA terminal at Kennedy Airport, New York. Amaya's Dutton Vista pictureback *Art Nouveau* (1966) was one of several books which helped to spread the revival, including Robert Schmutzler's *Art Nouveau* (translated by Edouard Roditi, 1964), Maurice Rheims's *The Age of Art Nouveau* (1966), and books on Beardsley by Brian Reade (1967), Stanley Weintraub (1967) and Brigid Brophy (1968). Jiri Mucha's book on his father was published in 1967. (Stephen Tschudi Madsen and Nikolaus Pevsner had explored the origins of Art Nouveau in the late 1950s – but the time was not yet ripe for a revival.)

It was inevitable that the nostalgics and revivalists would fasten on to the 1920s and 1930s as the next period to resurrect. This revival

OPPOSITE

Cover by Rodney O. for *Fapto*. Billed as 'alternative-revolting', it was a typical Underground magazine. Early 1970s

Shelley, punk girl, Chelsea. Photograph by Derek W. Ridgers

The drug culture of the late 1960s and early 70s led to the manufacture of elaborate pipes, some with water-cooling containers on the hookah model

Art Nouveau revival: men's shop placard, Geneva, 1968

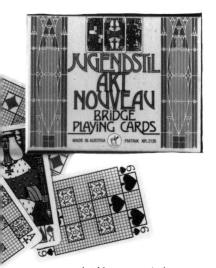

Art Nouveau revival:
'Jugendstil' playing cards,
1970s

Early evidence of the Art Deco
revival, 1965–7

began in earnest with a commemorative exhibition staged at the Musée des Arts Décoratifs, Paris, in 1966, titled *Les Années 25*. It was the sub-title of this show – Les Arts Déco – which gave the style its modern name of Art Deco. On 2 November 1966, *The Times*, London, devoted almost a full page to an article titled 'Art Deco' by Hilary Gelson, in which she spoke of 'the style now known by connoisseurs as Art Deco'. Exactly a year later, on 2 November 1967, the French magazine *Elle* gave twenty-two pages to 'Les Arts Déco', with articles on Van Dongen, Chanel and André Groult furniture.

In 1968 Martin Battersby (a great Art Nouveau collector who now became an Art Deco collector) organized the exhibition 'The Jazz Age' at the Brighton Museum: an aged barman dispensed bizarre cocktails throughout the run of the show. My own Dutton Vista pictureback, *Art Deco of the 1920s and 30s*, appeared the same year. Battersby's books, *The Decorative Twenties* and *The Decorative Thirties* were published by Studio Vista in 1969 and 1971 respectively; and many more books were to follow, some on special aspects of the style, such as Clarice Cliff pottery and chryselephantine statuettes. Further exhibitions also helped to spread the revival, beginning with that organized by Elayne Varian at Finch College, New York, in 1971, and the big exhibition organized by David Ryan and myself at the Minneapolis Institute of Arts in 1971, the catalogue of which was republished under the title *The World of Art Deco*. Films such as *Bonnie and Clyde* (1967), the shamelessly nostalgic *The Boyfriend* (1971), starring Twiggy, *The Sting* (1973), *Murder on the Orient Express* (1974), *The Great Gatsby* and *Julia* (1977) also promulgated the style. Roy Lichtenstein made sculptures which were pastiches of 1930s cinema design. Art Deco prints were used on women's clothes (see Ann Ryan's article 'A glorious new feeling – right out of the twenties', *Daily Express*, 15 May 1969); and double-breasted suits became fashionable for men once more (see the *Observer* colour magazine, 7 April 1968). Bentley-Farrell-Burnett Designs, who designed the catalogue cover of the 1971 Minneapolis exhibition, produced a series of stylish placards advertising Achille Serre dry-cleaning, and a brilliant jacket design for Anthony Gibbs's autobiography *In My Time* (1969). They were also commissioned by Penguin Books to design covers for a reissue of Evelyn Waugh novels; and in late 1969 they designed a nostalgic cover for *Design* magazine's 21st anniversary issue. Also in 1970, some London buildings of the 1914–1939 period were at last given statutory protection: four Underground stations by Charles Holden, two departmental stores (Peter Jones, Chelsea, and Simpson's of Piccadilly), and the gorilla house and penguin pool at London Zoo. In May 1970 the *New York Times* carried several Art Deco-style advertisements for Broadway shows, including a revival of Noël Coward's *Private Lives*, Judy Carne in *The Boy Friend*, George Kaufman and Marc Connelly's *Beggar on Horseback* and the Who's rock opera *Tommy*. There were now big Art Deco collectors such as Berenice H. Kent of Cleveland, Ohio; and Sotheby's and Christie's both opened separate auction rooms to sell nineteenth- and twentieth-century art and *objets*. At the Hotel Drouot, Paris, sale of the Deco collection of the couturier Jacques Doucet, a Deco *canapé* (sofa) by Maurice Dufrêne made £14,000. (*c.* $28,000). A Chiparus bronze and ivory figure group, identical to one I was offered for £8 at a theatre hire depot in 1964, fetched £200 at Phillips' auction room in 1972 and £5,200 when resold at Sotheby's, Belgravia, in 1976.

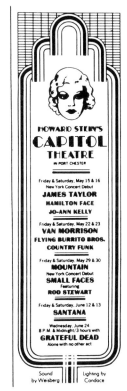

Art Deco revival: shows in New York in 1970

the village VOICE, May 14, 1970

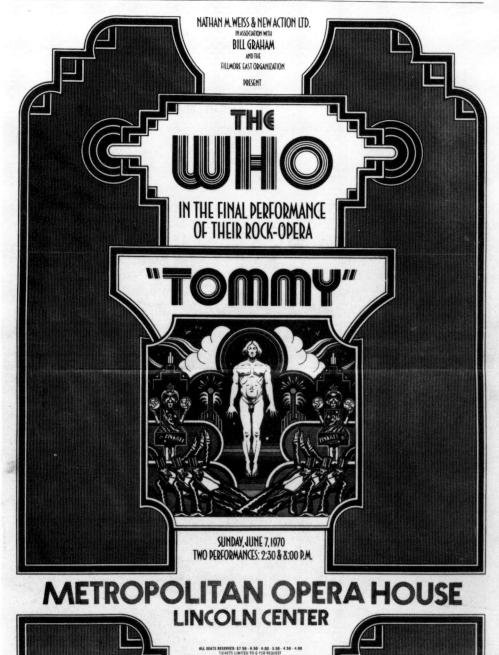

Advertisement for the rock musical *Tommy*, in *Village Voice*, New York, 1970

The zenith of the nostalgia craze was the reopening of Derry & Tom's store, Kensington, London, as Biba in 1973. Derry & Tom's had been a high-class department store since 1933. It was designed between 1929 and 1933 by the English architect Bernard George and the French architect Marcel Hennequet (who was responsible for the famous Rainbow Room, 1932) with bronze panels by Walter Gilbert, carved Portland stone reliefs by C. J. Mabey, hydraulically operated sunblinds and window surrounds of polished Hopton wood. Biba's designers, Steve Thomas and Tim Whitmore, had left most of the Deco structure intact; but everything else was a camped-up pastiche of Art Nouveau and Art Deco, right down to the shop's logo of two dancers, a straight copy from an Italian music sheet (of Franz Lehar's *Fox-Trot delle Gigolettes*) illustrated in the Minneapolis Art Deco exhibition catalogue.

I was commissioned by *The Sunday Times* to write a three-page report on the new Biba store, which appeared in the issue of 9 September 1973. It was in the design of the showcases, I found, that the designers had had their fling.

Biba party invitation. The Biba logo of the dancing couple was adapted from an Italian music-sheet cover, *Il Fox-Trot delle Gigolettes* illustrated in Bevis Hillier's *The World of Art Deco* (1971)

The launch of *Austerity/Binge* in the roof-garden of Biba (formerly Derry & Tom's), 18 June 1975. *Left to right,* Janet Street-Porter, Bevis Hillier, Little Nell (star of the Rocky Horror show) and Professor P. Reyner Banham

There is a skinny black skyscraper in the style of Rennie Mackintosh to contain slimming foods like Energen and Limmits; next to it is a chubby, ballooning showcase in Gaudi style for fattening farinaceous foods. A giant soup-can, labelled 'Warhol's Condensed Soup', contains what you'd expect. . . .

On the ground floor (accessories) you come face to face with the first of the triumphant Deco pastiches by Thomas and Whitmore – the book-stall, in fan-shaped tiers of maplewood set off with black paint. There are plastic palm trees everywhere. . . .

The carpet is re-woven from an old design, which includes a rather ominous 'SS' motif. . . . On this floor, too, is the Casbah, with exotic merchandise like Nestlé's Egyptian Henna, jewelled scimitars, rose-water, Chambeli hair oil (for that greasy dago look), Maja soap, rearing wooden cobras, brass hooters from maharajahs' motors, large furry toy lions . . . and leopardskin waste-paper baskets.

The Biba roof garden (always a favourite venue at Derry & Tom's) was the setting for a cocktail party held to launch my 1975 book *Auster-*

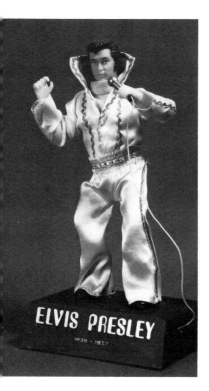

Presley's death caused a new outbreak of Elvis-worship, quickly exploited commercially as in this radio set; the figure of Elvis sways realistically, gyrating the famous pelvis

ity/Binge: Decorative Arts of the 1940s and 50s. The book was the first to analyse the decorative arts of the 1940s and 50s; a further fillip to 1950s revivalism was given in the following year by a Victoria and Albert Museum exhibition 'A Tonic to the Nation', celebrating the 25th anniversary of the Festival of Britain. Jane Dorner's *Fashion in the Forties and Fifties* appeared in 1975; Alan Jenkins's *The Forties* in 1977, and Peter Lewis's *The 1950s* in 1977. The stage and screen versions of *Grease* and the film *That'll be the Day*, with Ringo Starr and David Essex, conveyed the pop attractions of the period to the generation born from 1955 onwards, who were too young to remember it. The death of Elvis Presley, in 1977, brought another surge of fifties nostalgia; and pastiche rockers such as Shakin' Stevens kept the legend alive, while Cliff Richard perpetuated his own, celebrating twenty-five years in showbusiness. The big auction rooms moved into forties and fifties 'antiques', such as stylish jukeboxes and early electric clocks and watches.

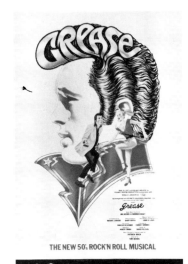

Handbill for the rock 'n' roll musical *Grease*, London, 1973

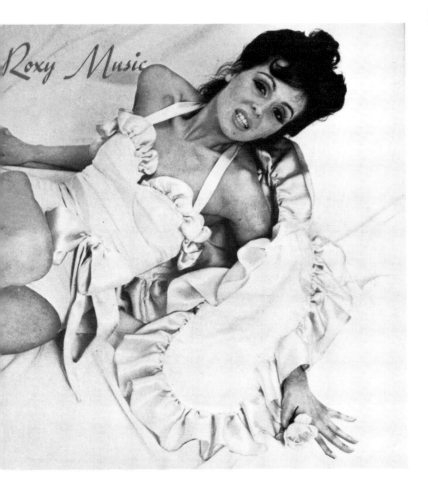

Roxy Music record sleeve, 1972

HAIRCUT 100
not a trace of brylcreem

The 1982 brochure for the English pop group Haircut One Hundred (Medusa Publishing Ltd, London) played on nostalgia for the 1950s

By 1980, nostalgia was catching up with its own tail. History was being recycled as nostalgia almost as soon as it happened. In January of that year, the enterprising Preston Polytechnic Libary held a show called *The Seventies*. The catalogue began with an alphabetical list of people and things the organizers associated with the seventies:

Adidas bags ☐ Art deco ☐ Action man ☐ Air brush Allende ☐ Anti-Nazi League ☐ Anti-abortion ☐ An gela Rippon ☐ Princess Anne ☐ Ayatoll ah ☐ Amin ☐ Anna Ford ☐ Badges ☐ Blue Peter ☐ Boat people ☐ Blunt ☐ Bean bags ☐ Bjorn Borg ☐ Babybug gies ☐ Baby gro's ☐ Bay City Rollers ☐ Blair Pe ach ☐ Begin ☐ Biggs ☐ Bokassa ☐ Bhutto ☐ Mrs Bridge s ☐ Coloured tissues ☐ Coloured television ☐ Co ncorde ☐ Calculators ☐ Chile ☐ Clockwork Orange Maria Colwell ☐ Clackers ☐ Common Market ☐ Cass ettes ☐ Captain Phillips ☐ Mr Carter ☐ Duvets ☐ D ecimalization ☐ Digital watches ☐ Disposable knickers ☐ Devolution ☐ Ethnic ☐ Ecology ☐ Electi ons ☐ Elton John ☐ Felt-tip pens ☐ Fast food ☐ An na Ford ☐ French skipping ☐ Freddie Laker ☐ Gru nwick ☐ Gay lib ☐ Geoffrey Boycott ☐ Gary Glitt er ☐ Habitat ☐ High-tech ☐ Hi-jacks ☐ Incredible Hulk ☐ Hang-gliding ☐ High speed trains ☐ Hand-made paper ☐ Patty Hearst ☐ Hugh Scanlon ☐ Idi Amin ☐ IRA ☐ Tom Jackson ☐ Jaws ☐ Jogging ☐ Kites ☐ K ung-fu ☐ Kevin Keegan ☐ Kagools ☐ Kissinger ☐ Lilt Roddy Llewellyn ☐ Make children happy ☐ Mizz Lillian ☐ Mohammed Ali ☐ Mountbatten ☐ Muppets ☐ M onty Python ☐ Mao ☐ Mr Men ☐ Museum charges ☐ Men 's handbags ☐ National Front ☐ No 7 makeup ☐ Ol ga Korbut ☐ OPEC ☐ Oxfam ☐ Oil slicks ☐ Public Le nding Right ☐ Punk ☐ Padded anoraks ☐ Peanuts ☐ P ost-modernism ☐ Platform shoes ☐ Plain & simp le packaging ☐ Patches ☐ Pine furniture ☐ Polys tyrene ☐ Pope John Paul I ☐ Pope John Paul II Poulson ☐ Quentin Crisp ☐ Range Rovers ☐ Real A le ☐ Johnny Rotten ☐ The Ripper ☐ Save the whal e ☐ Save a tree for 73 ☐ Sadat ☐ Stonehouse ☐ Son of Sam ☐ The Shah ☐ Silver Jubilee ☐ Solzhenits yn ☐ Skateboards ☐ Streakers ☐ Skinheads ☐ See-th rough umbrellas ☐ Silicon chips ☐ Stardust ☐ Se als ☐ T-shirts ☐ John Travolta ☐ Tracey Austin Margaret Trudeau ☐ Torness ☐ Tony Benn ☐ Thorpe John Tyme ☐ Teddy boys ☐ TR7 ☐ Margaret Thatche r ☐ Troops out ☐ Upstairs Downstairs ☐ Sid Vic ious ☐ Vietnam ☐ Virginia Wade ☐ Windscale ☐ Wate rgate ☐ Dr Who ☐ Wings ☐ Wilson ☐ Wombles ☐ Watersh ip Down ☐ Women's lib ☐ Whales ☐ Guinness ☐ XXX

Mick Jagger by Bob Cosford, 1979

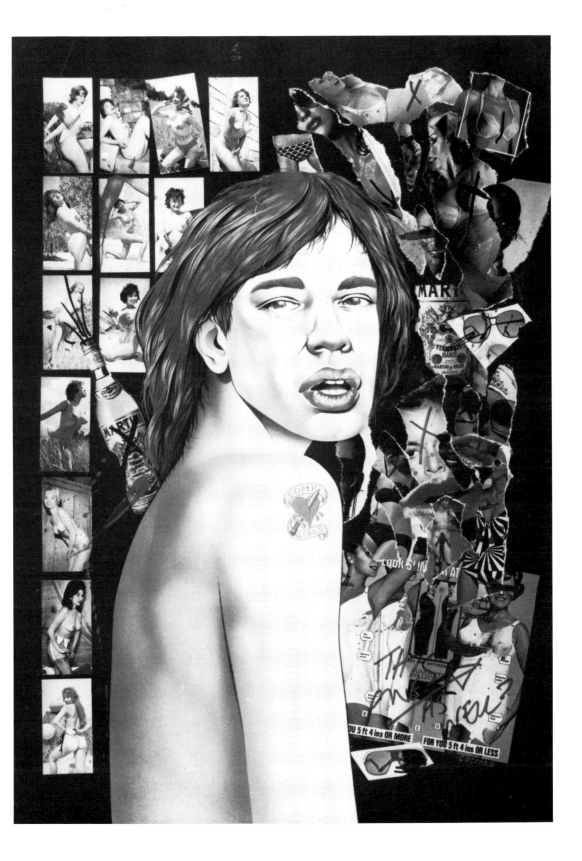

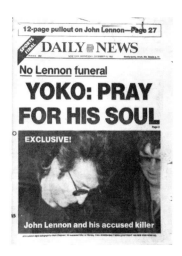

John Lennon was shot dead in December 1980

By a pattern which we have seen repeating itself – the hard-faced, political 1930s succeeding the frothy, escapist twenties; the good-time, whimsical 1950s clambering back to affluence after the wartime and austerity forties – the 1970s, too, had a character contrapuntal to that of the sixties. If the 1960s were Swinging, optimistic, full of innovation, the seventies brought disenchantment, stagnation, a negative feeling, and finally the baying, destructive anarchy of Punk. If one is looking for an alliterative sobriquet for the 1970s, 'the Cynical Seventies' probably comes closest to the truth. 'Where have all the flowers gone?' sang Marlene Dietrich – and one could ask the same of the Flower Children of Haight-Ashbury and Hyde Park. The drop-outs were running out of cash. The Beatles were disillusioned with their sly old Maharishi. The drug culture may have expanded some minds but it had also reduced some lifespans, including those of the pop idols Jimi Hendrix, Janis Joplin and Brian Jones. The silver sheen had worn off the Chelsea Drug Store, and it was hideously repainted. The editor of *OZ* was arrested. Lenny Bruce committed suicide. Andy Warhol was shot. The Establishment was twitching the reins of society again and calling its strays to heel. David Frost, a leader of the 1960s satirists, had become a pouchy interviewer: the ex-satirist exchanged sycophancies with the ex-Shah of Iran and with ex-President Nixon. ('He rose without trace,' as somebody remarked.) Jane Fonda began accepting her oscars again. Dudley Moore, another sixties satirist, was assumed into Hollywood. Even Mick Jagger was becoming respectable. There were few people still capable of being shocked; and even if there had been more, novel means of shocking them had been mostly exhausted by the end of the seventies – by *Flesh, Trash, Heat, Last Exit to Brooklyn, Sebastiane, Oh! Calcutta, Portnoy's Complaint* and *Deep Throat*. The Underground had become a flyover.

The move away from city culture, begun in the late 1960s, continued. Richard Adams' *Watership Down* (1972), an epic about bunny-rabbits, and *The Country Diary of an Edwardian Lady* (1977) were both, to the surprise of the many publishers who had rejected them, runaway bestsellers. In the catalogue to the exhibition 'Homespun to High Speed' held at Sheffield City Art Galleries in 1979, Fiona MacCarthy wrote:

> The new idealism [of the 1970s], like the old idealism of the Arts and Crafts movement of the 1880s onwards, was an anti-urban movement. The seventies saw a great migration out from London by RCA [Royal College of Art] trained craftsmen (the designer now was passé), grant-aided by the Crafts Advisory Committee, to set up their own workshops in East Anglia, the Cotswolds, in picturesque Welsh valleys or on distant shores of Cornwall. Here, as well as making jam and knitting socks and rearing children – for the life-span of this movement was ineffably vernacular – they wove and hammered metal, made pots and cushion covers which, illogically enough, were then transported back to London to be sold in the V & A

Seventies revival: this special issue on the 70s was printed by the *Sunday Mercury* in 1980

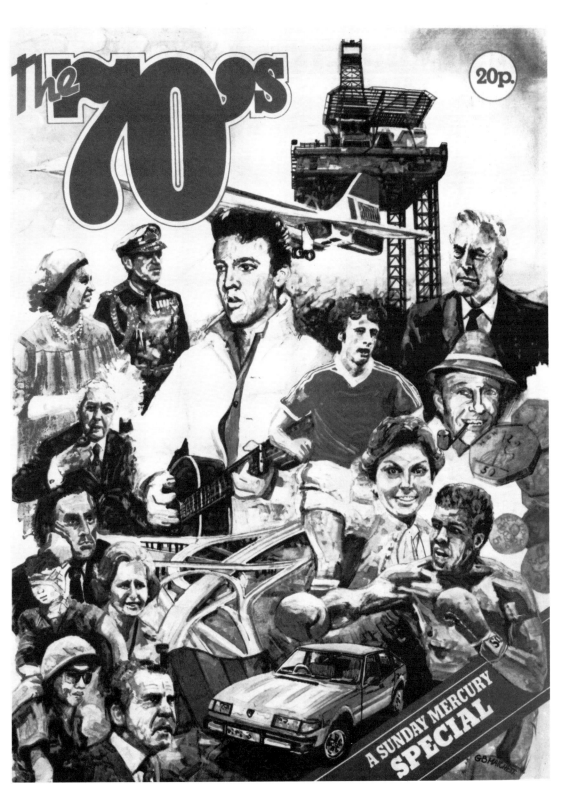

Italian laminate bureau, 1978

Craft Shop or at Heal's. Vernacular Idyllic was a style which made a great impact on progressives of this period, in their solar-heated houses. . . . Bread crocks by Richard Batterham, a rag rug by John Hinchcliffe, a bowl by Richard Raffan, a box by Lucy Goffin.

But other progressives were more attracted by 'High Tech' – the use of industrial furniture in the home, such as metal 'factory' shelves and tubular steel bunk beds (Habitat offered one), of which the architectural equivalent was the new Pompidou Centre in Paris, whose mechanical innards seemed to have been grafted on to its outside. High Tech went with Concorde, the high speed train, micro-chips, television video games and shiny plastic clothes.

But something else entered 1970s design which was neither rural nor high-tech, but a calculated insult to both: kitsch. Fiona MacCarthy's opinion of the seventies was not that they were a cynical, disillusioned time after the wonderful Swinging Sixties; rather, that they were 'stiller and serener' than the 'shrill and blatant sixties' – 'Ambitions were more low-key, concerns more idealistic, and much time was expended in debating earnest topics centred on the real needs of the real world, the real world being almost always south of the Equator and the real needs being those of the deprived and afflicted.' But even she was obliged to take account of something rather disconcerting in the woodshed.

> There was also, in this period of cop-out and retrenchment, a considerable vogue for the surreal and satiric. Designers were entranced with witticisms and pretences and developed what became a rather tedious obsession with exploring the idea that nothing is but what is not. Hence an awful lot of double-entendre designs like china running shoes and fried eggs made of plastic which were possibly intended, in those days of anti-function, as an onslaught on society. Or could they have been simply a last return appearance of old-fashioned British whimsy in a rather thin disguise?

Gillo Dorfles's book *Kitsch* (1969) appeared in English in 1970 in what Hugh Honour described, in a *Sunday Times* review, as 'an only too suitably bad translation'. Jacques Sternberg's *Kitsch* was published by Academy Editions, London, in 1972. In my 1973 *Sunday Times* article on the opening of Biba, I noted that 'A "Kitch" room (write out "Kitsch" 500 times) sells frilled plastic boxes, ash-trays like miniature loos, school of Tretchikoff paintings, nude plastic babes rising from plastic roses, urinating cupids who perform when you warm a glass bulb with your hand, and framed poems apostrophizing granny.' So kitsch was already being commercially exploited; and by 1980 the Design Centre itself would be full of the kind of object Fiona MacCarthy reprobated.

The two *clichés* of kitsch which seemed to fascinate most people were garden gnomes and plaster flying ducks. The gnome craze led to a long correspondence in *The Times* about the first garden gnome; to a television series in which actors played garden gnomes; and to

'Disco' mugs, English 1980. The disco-dancing craze was popularized by the film *Saturday Night Fever*, starring John Travolta

a book on gnomeography and gnomeology. Infinite variations were worked on the flying duck theme, including flying nuns, flying Hitlers and winged penises, perhaps a visual pun on the phrase 'flying fuck' (as opposed to flying duck).

It is possible that the new popularity of kitsch represented boredom with the po-faced worthiness of the Modern Movement type of design which had managed to survive all the novelties and freaks and happenings of the 1960s and was still being sold by firms such as Habitat and Heal's – scrubbed pinewood cots; glass-topped coffee tables on square legs; leather cushions in tubular steel frames. The embracing of kitsch was a snook-cocking at the design Establishment. It prepared the way for a clearing of the decks.

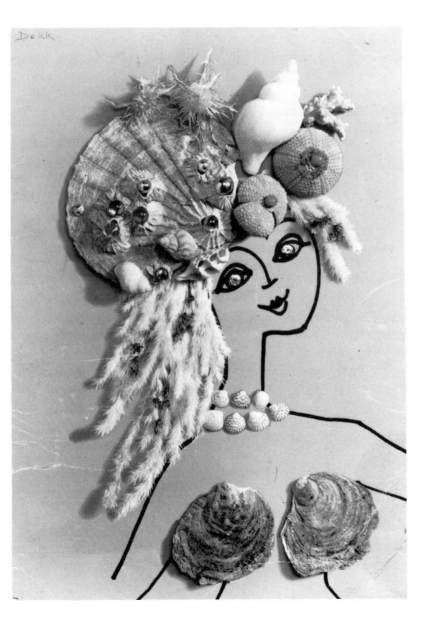

1970s kitsch: decoration for menu on board SS *Canberra*, 6 August 1972. Specially designed for P & O by Dorrit Dekk FSIA and printed in England by Brown, Knight & Truscott, Ltd

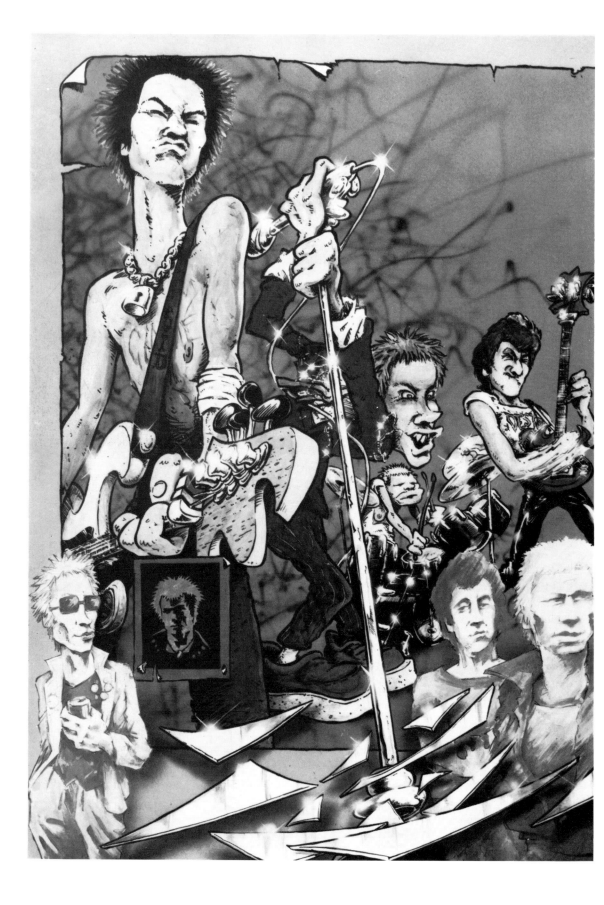

Revolutions are seldom achieved without violence; and though in the case of design this does not usually mean blood-letting, some kind of definitive assault on established values had to precede the regeneration of design and the decorative arts. That assault came from Punk, the most original and influential stylistic development of the seventies. Here for the first time was a popular movement which was too hot for commerce to handle. EMI gave the Sex Pistols, headed by Johnny Rotten, a contract – but were forced to cancel it, with a big payoff for the Pistols, because of the damage to their own 'corporate identity' by the Sex Pistols' outrageous behaviour on and off stage. This was a tiger not for taming. The stage punks swore and spat and puked. The street punks mortified their flesh with safety-pins, wore extraordinary uniforms hobbled with straps and slashed with zip-pockets; and shaved and dyed their hair into Mohican styles. Punk combined violence and kitsch. The intelligentsia of the young generation had already had their baptism of brutality in the Paris May Revolution of 1968, which had precipitated its own superb art-form, the silkscreened and lithographed posters by which, as Jean Cassou wrote, the walls of Paris were 'magnificently profaned'. (When the Russians invaded Czechoslovakia in August 1968, the students of Prague used the same summary poster techniques in their 'cold resistance'.) Now it was the turn of the non-university youth. Their revolt was also attended by violence. They had already expressed violence in the Hells Angels of America and England, the Mods versus Rockers battles of England, the 'aggro' ('aggravation') of the skinheads, the fascination with Chinese martial arts and Bruce Lee films. In 1979 the punk rock star Sid Vicious died from an overdose of heroin in Greenwich Village, New York, while out on $50,000 bail after being accused of murdering his American girlfriend Nancy Spungen in October 1978. A film glorifying him was made; and the front page of *The Sun* newspaper of 3 February 1979, headlining his death, was still being printed on T-shirts four years later.

If the psychedelic style of the 1960s was an adaptation of Art Nouveau, the basis of Punk is to be found in the 1950s – not just in hard rock style, but in the spatterings of Jackson Pollock, the leopardskin patterns of starlets' coats and Lady Docker's car seats and the elliptical frames of Holiday Inn signs. The style is seen at its most fully formulated in the magazine *i-D* (*identity* again!) – though that already represents an intellectual sophistication of Punkism; the Punks' own magazines, the so-called 'fanzines' such as *Sniffin' Glue, Rising Free, Moron, Gun Rubber, Scum, Crash Bang, Ghast Up, Ripped and Torn* and *White Stuff* are more rudimentary in design. As Val Hennessy wrote in her book on Punk, *In the Gutter* (1978): 'Photocopied sheets, headings scrawled in thick felt-tip, sentences punctuated with four-letter words, the trait they all share is their utter disposability.' But then that is the point of Punk, in whose book anarchy itself is too structured a system.

The Sex Pistols by Hunt Emerson

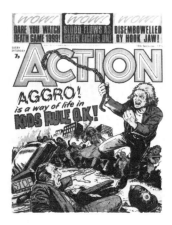

Violence: this comic of 1976 was condemned in the press for its encouragement of 'aggro'

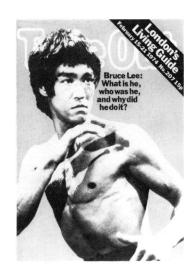

Magazine cover of 1974 depicting Bruce Lee

The Punk star Sid Vicious died in New York in 1978, but this T-shirt was still being sold in Chelsea, London, in 1983

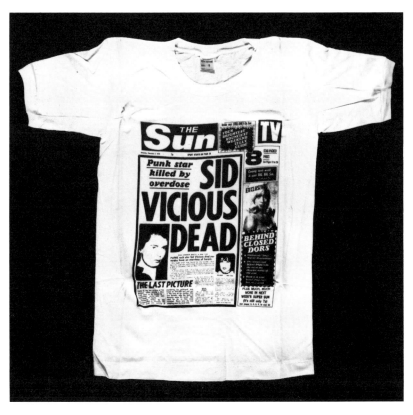

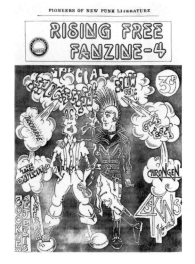

One of the many 'Fanzines' of the Punk movement

Some of the Punk performers might sell out to the record companies (as the Sex Pistols seemed set to do with EMI before, Cranmer-like, they recanted their recantation). But most shared the philosophy of Danny, one of the Punks interviewed by Val Hennessy:

> 'All punks are working-class and proud of it, except we're not *working* any more seeing as how there's no jobs and the ones we're offered are a load of shit, monotonous, garbage jobs. I fought the system from behind the bog door at school, might just as well sit there reading the graffiti as learning about Henry the Eighth and other rich bastards. . . . Who wants to spend the best years working at some wet job saving up for a semi and watching trash telly all evening? . . . Anyhow, what's the point of saving up, planning for the future when we might all be blown up by a fucking H-bomb tomorrow?'

The rebel who turns into bank manager is a comforting cliché for reactionaries. But Vick Vomit, another Punk interviewed by Val Hennessy, promised that Punk would not be allowed to atrophy like that: 'I tell ya this, no way will the punk movement end up like the 50s rock 'n' roll scene with loads of middle-aged cruds called Ron and Ray running around in Cortinas and Zephyrs, or like the hippie brigade who all own antique shops now or work as social workers.'

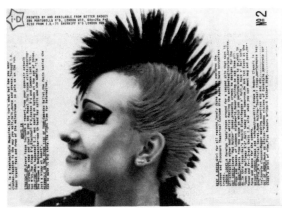
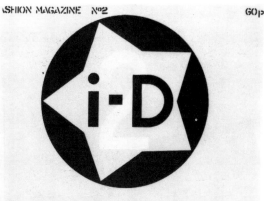

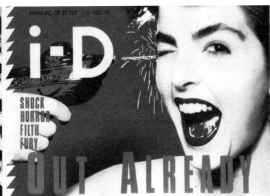

The *Evening Standard* (19 August 1977) used the funeral of Elvis Presley as a chance to rail against Punk: 'Presley's death like his life is inevitably attended by much that is ersatz and professionally staged – an extravaganza of *kitsch* of every variety. But there is no mistaking the real shock, bereavement and desolation on thousands of those faces pressed against the gates of his house and queuing for the memorial service. WILL THEY CRY LIKE THAT FOR JOHNNY ROTTEN?'

Probably not; but perhaps there was something to be said for Punk beyond the Punks' own suggestion of a warrantable revenge on a society that had given them short shrift. In the contribution I was asked to make to the Preston Polytechnic Seventies exhibition catalogue, I tried to say it:

Many regard Punk as an evil phenomenon, something which threatens the fragile bases of our civilization. and if it means that old ladies get beaten up on tube trains, who can dissent from this view? But in the decorative arts, I cannot help regarding it as something fresh and hopeful. Before a new order comes into being, the old one must be destroyed, and Punk is nothing if not destructive. I grew up in decades, and in a section of society (the middle-middle class) where conformity reigned. When I walk along the King's Road, Chelsea, today and see that young people have had

The 1980s magazine *i-D* represented a taming of Punk by the design world

RIGHT AND OPPOSITE
Open-out cover of *Raw* comic,
by Charles Burns, 1982

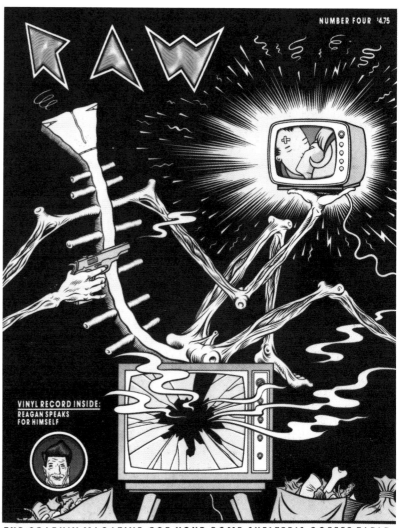

the sheer courage to turn themselves into walking works of art with pink and green hair and extraordinary trousers hobbled at the legs by straps; with weird tattoos on their arms and weirder make-up on their faces, then I feel there is hope for the arts. Good art can only begin by an act of Bad Taste – a shocking breach with the conformist past.

What is likely to follow? Punk (which reached the United States after an interval of about three years) is still with us, in a revised version: the ragged, Dickensian or 'hobo' look. And an alternative to period nostalgia is indicated by Malcolm McLaren's shop in St Christopher Place, London, 'Nostalgia for Mud' (a literal translation of *nostalgie de la boue*) and in his New York club Mud. What McLaren seems to be suggesting is that we should start from scratch – the ultimate

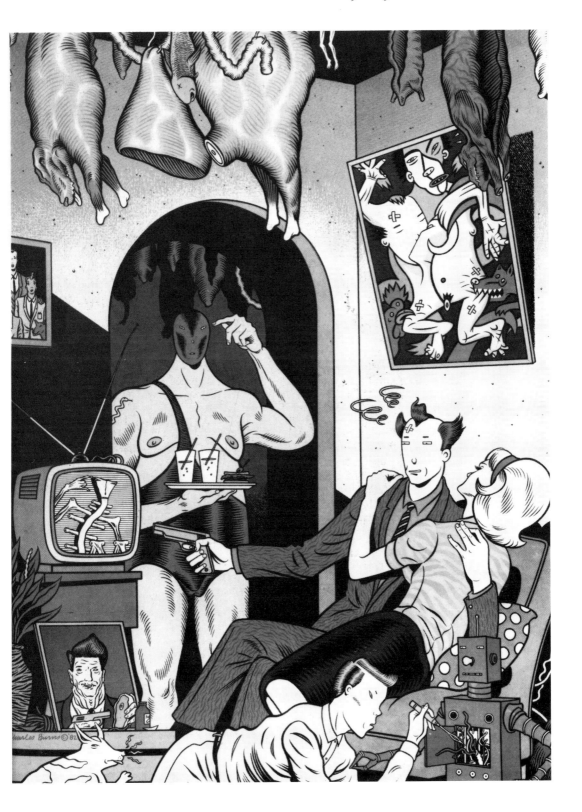

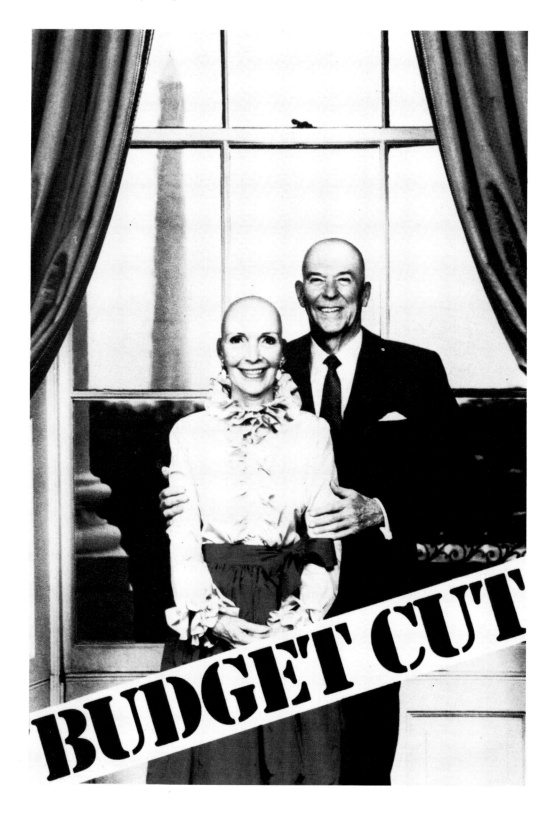

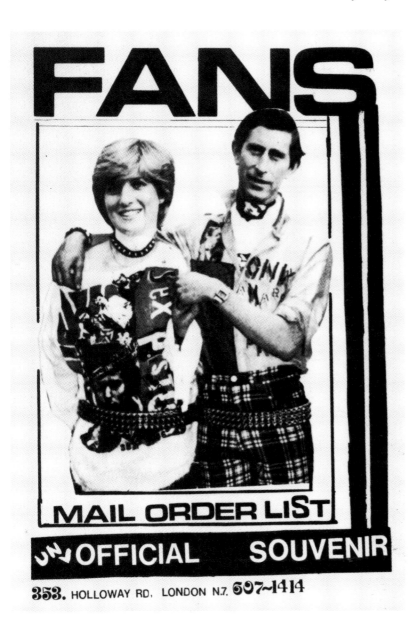

FANS

MAIL ORDER LIST

UNOFFICIAL SOUVENIR

353. HOLLOWAY RD, LONDON N.7. 607~1414

Prince Charles and the
Princess of Wales depicted in
Haut Punk gear

nostalgia for primitive man with his mud body-painting. (And perhaps
it is significant that Leni Riefenstahl, who became the darling of Hitler
for her glorification of Aryan manhood in her Nuremberg and Olym-
pics films, has recently photographed the body painting of the 'People
of Kau' in Africa.)

But this only carries the nihilism of Punk to its logical conclusion.
I am not a soothsayer, but my hesitant prediction would be that this
stage might be followed by a return to a moralistic society, perhaps
with a big Christian revival and acceptance of Edwardian codes of

OPPOSITE
'Budget Cut' by Ian G.
Martin, The American
Postcard Co. Inc., 1981

OPPOSITE

Jacket design by
Leonard Levitsky
(illustration by Jim Aplin)
for *The Boy Scout Handbook and
Other Observations* by Paul
Fussell. (O.U.P. 1982)

honour once again. This need not be inhibiting on the arts: Michelangelo, after all, was an ardent follower of the religious fanatic Savonarola. The leaders of the alternative and permissive societies (I do not say this with censorious relish) will be left floundering and beached, like Lord Steyne in Thackeray's *Vanity Fair* – despised roués left behind by the advance of public morality. There are straws in the wind. The most substantial so far is the essay which gives its title to *The Boy Scout Handbook* (1982), a book of articles by the American writer Paul Fussell, an English Literature professor at Rutgers University, New Brunswick.

Fussell's essay is a review of the latest (1979) edition of *The Boy Scout Handbook*. Instead of doing a mocking George Orwell job on it, he praises it for the ethics it lays down:

> Indeed, this handbook is among the very few remaining popular repositories of something like classical ethics, deriving from Aristotle and Cicero. . . . The constant moral theme is the inestimable benefits of looking objectively outward and losing consciousness of self in the work to be done. To its young audience vulnerable to invitations to 'trips' and trances and anxious self-absorption, the book calmly says: 'Forget yourself.' What a shame the psychobabblers of Marin County will never read it.

Reviewing Fussell's book in the *Observer* (30 January 1983), John Gross wrote:

> . . . one recognizes that [Fussell's] review is really a sermon in disguise. Essentially it reaffirms the clean-cut morality of the boy scout code; an inadequate morality for adults, no doubt, but Mr Fussell is surely right to insist that it remains the best starting-point – even in a world where innocence has to be lost. . . .'

What could accompany the reassertion of the old values is a left-wing, puritannical revolution (which would probably mean the return of some form of neo-classicism or ruthless hard-edge appropriate to the austere vision of the revolutionaries). 'Love's Pestilence' (herpes and AIDS) is already putting a curb on the sexual revolution. However, as the 1990s near their end, and the magic date 2000 approaches, there is bound to be a 'decadence' appropriate to the *fin de millénium*. What a *Götterdammerung* that will be.

ACKNOWLEDGMENTS

The author's main thanks must go to David Herbert, the English publisher of this book, and to his wife Brenda. It was David who suggested the idea for the book several years ago; and he showed confidence that it would be completed when others proved fainthearted. Both he and Brenda, and their chief assistant at the Herbert Press, Ayeshah Haleem, have put great personal effort into assembling and co-ordinating the material for publication. The author is also greatly indebted to Erica Hunningher for her help, particularly in editing the text. Mr Peyton Skipwith of the Fine Art Society, London, was particularly helpful in hunting down relevant photographs.

Appreciation and thanks are also due to the many designers whose work is represented and in particular to the following owners and photographers for the use of illustrations:

B2 Gallery, Wapping pp. 90 *below*, 95 *right*
Barling of Mount Street p.50 *right*
Berkeley Bonaparte p.205 *below*
British Insulated Callender's Cables p.136
British Museum p.44 *below*

Leo Castelli Gallery, New York pp.185 *above*, 193
Cheltenham Art Gallery and Museums p.15 *below right*
Chiu Gallery p.154
Christie's, London p.6 *below*, 11 *above right*, 14, 15 *left*, 180 *above*
Alain Cical p.69 *above*
Cincinnati Art Museum, Ohio, Gift of Theodore A. Langstrothe p.56
Clareville Studios Ltd p.177 *below right*
Cobra & Bellamy p.141 *below left*
Cold Flash Graphics, Vancouver, B.C. p.199
Communication Vectors pp.217, 222
Leland Cook p.100
Lady Diana Cooper p.67 *above*

The De Morgan Foundation p.54 *above*
The Design Council pp.164, 169 *below*, 177 *above right*, 178, 179 *above* and *below left and right*, 180 *below*, 183, 185 *below*
The late Miss Jessica Dragonette p.93
Leslie Durbin Esq, p.130 *above*

Beresford Egan p.67 *below*
Michael English p.186

The Fine Art Society pp.48 *below*, 49 *below right*, 50 *left*; photographs, pp.15 *right below*, 30 *below*, 44 *below*, 49 *above* and *below left*, 54 *below*, 58 *below*, 59, 60, 63, 76, 92 *below right*
Fiorucci, Milan p.190
Mr and Mrs Alan Fortunoff pp.59, 60
The Foulk Lewis Collection pp.65, 69 *below*, 80, 81 *left* and *right*, 85, 92 *below left*

The Geffrye Museum, London p.91
Robin Guild, Homeworks pp.189 *above* and *below*, 220 *above*

John Hadfield p.103 *above left*
Hamlyn Picture Library p.106 *below*
Harrison Cowley Photographic p.169 *above right*
Peter Hirst-Smith p.213 *below*

Island Records pp.214–5

Mr Myron Kunin p.58 *below*

Ron Laytner p.116 *below*
Alain Lesieutre pp.75 *below*, 84 *below*
Leyland Trucks p.167
Liberty & Co. p.53 *left* and *right*
Lords Gallery p.55 *right*

Félix Marcilhac p.68 *above*
John and Jennifer May p.22
Medusa Publishing Ltd p.216
Marie Middleton p.121 *below*

The Mitchell Wolfson Jr Collection of Decorative and
 Propaganda Arts, Miami, Florida p.63

Julian Nieman pp.43 *below*, 208 *above left*

Peter Owen Ltd, London p.171
The Oxford Mail & Times p.12
Oxford University Press Inc. p.231

P & O Information and Public Relations p.221
Michael Parkin Fine Art Ltd pp.73, 74 *above*
Michael Pick p.58 *above*
Private Collections pp.30 *below*, 49 *above* and *below left*,
 54 *below*, 76, 92 *below right*, 193

Roberto Rabanne p.198 *below*
Race Furniture p.166
Jasia Reichardt pp.194, 195
Derek W. Ridgers p.208 *above right*

Gilbert Silberstein p.79
Peyton Skipworth p.48 *above*
Sotheby Parke Bernet, Los Angeles pp.116 *left*, 122
Sotheby's, London *title page*, pp.92 *above right*, 137, 158
 below
Spink & Son Ltd pp.15 *above*, 24, 38
Tim Street-Porter p.102 *below*

Peggy Tearle p.127 *right*
The Times p.84 *above*
Topham Picture Library p.203

United Dairy, Frith Street, London p.86 *above*
United Press International (UK) Ltd p.175

Peter Wentworth-Sheilds p.45 *above*
Derrick Witty pp.31 *left*, 86 *below*, 103 *above right*, 104,
 214 *left*
Harriet Wynter p.23

INDEX

235

THE LIBRARY
WEST KENT COLLEGE
BROOK STREET
TONBRIDGE
KENT TN9 2PW

56693